The Fine 35mm Portrait

Jack Manning

AMPHOTO
American Photographic Book Publishing Co., Inc.
Garden City, New York 11530

All photographs in this book by Jack Manning.
Reciprocity tables and filter tables, courtesy of Eastman Kodak Company.
Line drawings designed by Vincent Battaglini.

To my wife, Marie, for her inspirational help and unending patience; and my daughter Sarah-Jeanne, whose charming presence made the going pleasurable.

Published in Garden City, New York, by American Photographic Book Publishing Co., Inc.

Library of Congress Cataloging in Publication Data

Manning, Jack.
 The fine 35 mm portrait.

 Includes index.
 1. Photography—Portraits. I. Title.
TR575.M35 778.9'2 78-8558
ISBN 0-8174-2438-5

Manufactured in the United States of America

Contents

Introduction 4

PART I: PORTRAITS 6

Black-and-White Portraits
 and Technical Information 8

Technical Information
 on Color Portraits 128

Color Portraits 129

PART II: EQUIPMENT & TECHNIQUES 138

1. Camera and Lens 139

2. Black and White 147

3. Lighting 157

4. The Print 165

5. Color 179

6. The Confrontation 187

7. Selling 193

Index 199

Introduction

In the beginning there was the view camera—a huge, cumbersome box with an enormous glass eye of a lens; and plate holders almost the size of tabletops, loaded with extremely fragile, very heavy glass plates. Portrait studios were built with glass skylights, and windowed on all sides to allow as much outside light to enter as possible. Film and lens speeds were so slow that time exposures of as much as half an hour in bright sunlight were not uncommon. The subject's head was gripped by a large iron clamp, which was invisible to the camera; and features were frozen into immobility for long periods of time, as the subject stared, trancelike into the blinding light.

Despite these intolerable working conditions, there were many successful, and sometimes great, portraits achieved—a tribute to the patience, technical skills, and undeniable talent of the portrait photographers of the period.

There were many other problems to be coped with after the photograph was taken. The images that were attained with such difficulty were often physically and chemically unstable, and would fade and vanish from view with continued exposure to the light.

More than a century has passed since Louis Jacques Mande Daguerre introduced the first successful photographic process to the world; and the chemistry and physics of photography have greatly improved since then. Cameras have become much smaller; film and lenses, faster; lights, brighter. Only the methods of the portrait photographer remain rooted in the past.

A great many photographers today are working with twentieth century tools and nineteenth century methods. The iron neck clamp is gone; blazing sun is no longer necessary; the frozen grimace is a remembrance of the past. But tradition still weighs heavily upon photographer and subject alike. In many modern portraits the subject still seems glued to his seat, a strictured smile upon his face, and an invisible iron clamp attached to the back of his neck. The photographer must free himself from the artificial constraints of a tradition that says, "This is the way it has always been done," and pursue a path delineated by his instincts as well as his tools.

The 35 mm camera is ideal for portraits. Its flexibility and ease of operation make it possible for the photographer to vary position until the best one is found, without missing a picture. Power-winders and motor drives help him pursue, and capture the elusive peak of expression that makes the difference between a picture of record and a good portrait. High shutter speeds, and the millisecond blinks of the strobe light hold the subject steadier than any kind of clamp; and the built-in quality of lenses and different films make it difficult to distinguish between 4 × 5 quality and good 35 mm quality.

Each photographer must also develop his own style. This is not to be confused with devising a formula for lighting and posing. Formulas should be avoided at all costs; they are destructive to the qualities of creativity and interpretation. Your creative instincts will work better for you than any set of printed rules.

PART I

PORTRAITS

The most significant change brought about by the 35 mm camera in the field of fine portraiture is the elimination of the studio, and the introduction of natural surroundings. The photographer is now free from the restrictions of artificial backgrounds, blinding lights, and frozen unnatural expressions. Eliminated, too, are the bulky tripod and the large, unwieldy bellows camera.

A sophisticated, easy-to-handle machine, the 35 mm camera has revolutionized the art of the fine portrait with its great technical capability and easier-to-use controls. The photographer is now able to spend more time on the creative process and less time moving the lights, adjusting backgrounds, and fussing with tripods and plate holders.

The portraits shown here demonstrate the art of capturing people, both famous and unknown, with a 35 mm camera in casual, informal settings. Techniques and methods are given so that you too can learn the essence of fine portraiture.

Ferenc Molnar

This Hungarian-born playwright, novelist, and skilled raconteur was truly a citizen of the world. He traveled constantly, and was as much at home in Singapore, Moscow, and Tokyo as he was in London, Paris, and New York. In fact he maintained apartments in half a dozen spots around the world and occupied them all at different times of the year.

The editors of a national magazine asked me to try to have Mr. Molnar's portrait reflect his sophistication and personality. Again, as with some of the other portraits in this book, the location was a midtown hotel known for its elegance and old-world charm, and one where Mr. Molnar leased a small apartment on a year-round basis. Although the hotel is elegant, and his apartment within it charming, it still reflected the similarity of so many other hotel rooms.

When I entered the room, he rose, bowed, and in a heavy Hungarian accent, he welcomed me. He had been reading prior to my arrival, and was wearing the monocle shown in the portrait. When I started photographing, he immediately removed the monocle. I begged him to wear it for the picture because it somehow conveyed the feeling of sophistication and worldliness that I was trying to present.

This complex man called for complex lighting. A multiple strobe setup of three lights was used: one light on either side of the face, the third light as fill. They were carefully placed to avoid reflections in the monocle.

The editors were delighted with the portrait, and Mr. Molnar told me when he saw it that it was his favorite of the many photographs that had been made of him.

TECHNICAL DATA

Camera and Lens:	Leica, with 90 mm Elmar lens.	**Film and Exposure:**	Kodak Plus-X; strobe setting on the camera (1/60 sec.); lens opening computed for the main light (f/11).
Lighting:	Three strobe lights: two with electronic "eyes" off the camera, on either side of the head, mounted with clamps—one on a nearby bookcase, the other on the door to the room; the third light handheld 3 feet from the camera, higher than the level of the face, and a little to one side of it to fill the shadows.	**Development:**	Normal development in Kodak D-76.
		Print:	Kodak RC paper, 11″ × 14″; developed in Kodak Ektaflo Developer, Type 1; standard dilution, 13 oz. concentrate to 115 oz. water.

Sophia Loren

Sophia, one of the most beautiful and talented actresses of our time, was in Madrid making a film. The serenity of this portrait belies the frenetic activity that was going on all around us. There were thousands of extras milling about, and assistant directors shouting directions to prop men in Spanish, English, Italian, and French.

The time allotted me to do this portrait was a 10-minute rest break at the conclusion of a big scene. The picture had to be made in whatever spot the break occurred.

To get the most out of a portrait, the photographer should be able to control most of the elements in the picture. In this setting I had no control at all. When the break finally occurred, we found ourselves in a dark, cramped corner surrounded by many people. Fortunately it was an exterior set, and the summer sun of Spain throws off a great deal of illumination.

I decided to photograph against the sun, and chose a 200 mm lens. This rather long focal length enabled me to overcome two problems: first, it would isolate Miss Loren from the masses of people around her; and secondly, it could blur the cluttered background completely out of focus.

A peripheral advantage of this focal length is its ability to secure a good size head from a distance. Most theater people do not like lenses pointed at them from too close a distance. Photographing Miss Loren with the sun shining into her face would have resulted in unfortunate shadows under the eyes, and discomfort on the part of the subject. With her back to the sun, Miss Loren was more comfortable, and thus looked more at ease.

The minutes were fast disappearing, and Miss Loren was already getting signals from the director that it was almost time for her to return to the set. It would have been nice to borrow one of the gigantic foil reflectors that were spread abundantly around the set, but the time was now too short to allow for that.

I decided a strobe fill would do the trick, and quickly calculated the proper exposure to balance against the highlight on the hair, so that it would record more strongly than the fill light on the face. There was just enough time to knock off about eight frames; and since I was working with one of the top pros in the business, each was different, and all were good.

TECHNICAL DATA

Camera and Lens:	Canon, with 200 mm f/4 Canon lens.	**Development:**	Normal development in Kodak D-76.
Lighting:	Noonday sun; backlighting; strobe fill.	**Print:**	Kodak RC paper, 11″ × 14″; developed in Kodak Ektaflo Developer, Type 1; standard dilution, 13 oz. concentrate to 115 oz. water.
Film and Exposure:	Kodak Plus-X; strobe setting on camera (1/60 sec.) at f/8.		

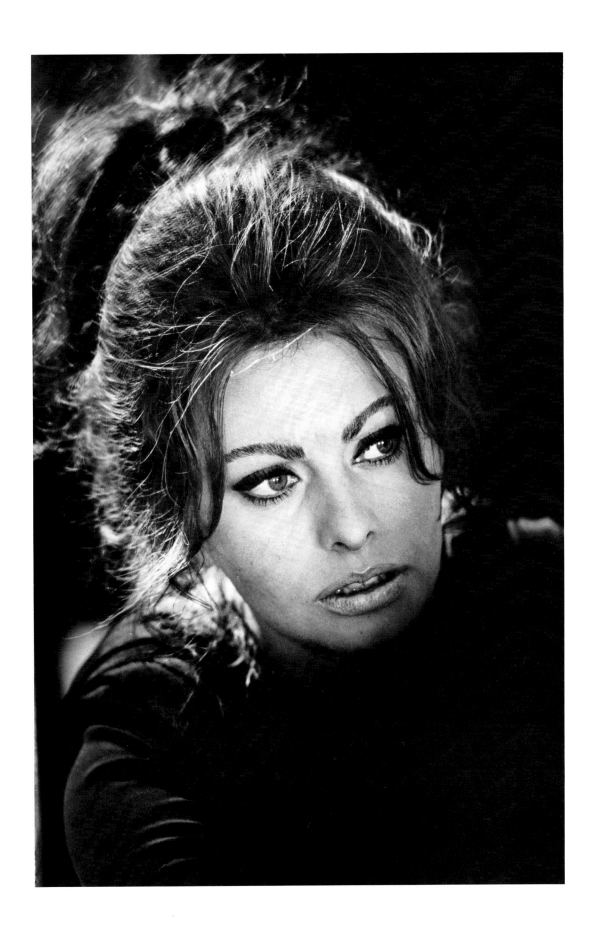

Lottery Seller, Spain

This photograph was one of a series of illustrations for a book on Spain. It was meant to be a form of social commentary on life under the Franco regime. For many of the Spanish people, this was a harsh kind of living death. I was continually on the lookout for something that would symbolize and sum up this existence in one pungent, powerful photograph.

One dark, rainy day while walking through the old quarter of Barcelona, a mournful cry pierced the air. It came from an elderly woman seated on a street corner. As I drew closer to the figure I could hear what she was saying. She was selling lottery tickets, and proclaiming the good fortune that would befall the buyer of her tickets. Her voice sounded like the wail of a mortally wounded animal in great pain.

Prematurely aged from exposure to the elements, her magnificent, lined and weathered face shone through the darkness like a death mask. It was the situation, and the face that I had been looking for.

One of the problems of photographing in Spain (or any dictatorship) at that time was a prohibition by the police against the making of photographs that showed the government in a bad light. I decided to take my chances, and made the photograph from the inner recesses of an old tenement building across a narrow street from where the subject sat.

The distance called for a 200 mm lens. The shutter speed, with the camera braced against the stone wall of the building from which I worked, was 1/8 sec. I think it works well as a portrait, and as a symbol.

TECHNICAL DATA

Camera and Lens:	Canon, with 200 mm f/4 Canon lens.	**Development:**	Push-processed to ASA 1200 in Kodak D-76.
Lighting:	Daylight; dark and rainy afternoon.	**Print:**	Kodak RC paper, 11″ × 14″; developed in Kodak Ektaflo Developer, Type 1; standard dilution, 13 oz. concentrate to 115 oz. water.
Film and Exposure:	Kodak Tri-X; 1/8 sec. at f/4.		

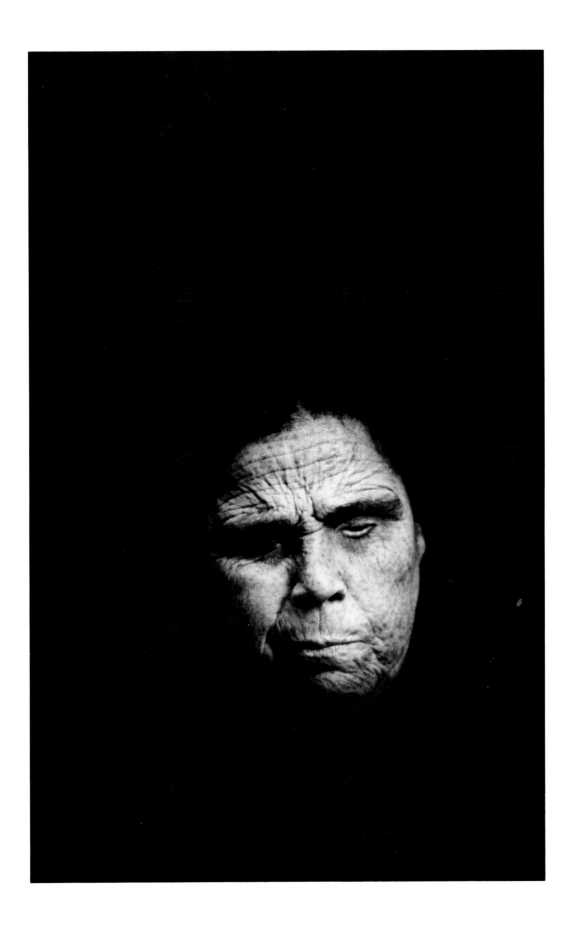

Robert Penn Warren

The appointment was made for 3 P.M. at an exclusive, private club in New York. Mr. Warren, one of America's greatest poets, showed up promptly. He apologized, because he had just learned that the house rules prohibited any kind of picture taking on the premises. However, since time was limited and he had to leave town shortly, Mr. Warren asked the club manager, as a special favor to him, for permission to have his picture taken somewhere on the premises. The manager agreed, and offered a small public room just off the main lobby, but with the stipulation that no flash or floodlighting be used. The room was grim—a barren, uninteresting expanse of blank walls, a sofa and some chairs, and very dim light.

A quick exposure reading of the available light revealed a potentially disastrous exposure of 1/4 sec. at *f*/2, with Tri-X pushed to ASA 1200. There was one possibility that might save the picture. By moving a floor lamp from the corner of the room closer to an armchair, the exposure might be im-

proved sufficiently to allow the portrait to be made. Mr. Warren was seated in the chair, and the lamp was lit. Disaster again. A deep, dark shade on the lamp effectively prevented any of the lamp light from reaching the subject's face.

Only one more possibility remained: If the lamp shade were removed, perhaps the bare light bulb would provide enough light for the picture. The 25-watt bare bulb, placed at a distance of 15 inches from Mr. Warren, gave off enough light for an exposure of 1/30 sec. at *f*/2.

Just as I was about to begin shooting, Mr. Warren requested a favor of me. He had a serious eye condition in his left eye, and he asked that the eye not be given too much prominence in the photograph. Since the lamp was now fixed in position, Mr. Warren was moved around the lamp until the desired lighting effect was reached. Several successful portraits were made under these difficult circumstances. This was the best of the group.

TECHNICAL DATA

Camera and Lens:	Canon, with 85 mm *f*/1.8 Canon lens.	**Development:**	Push-processed to ASA 1200 in Kodak D-76.
Lighting:	Bare bulb (25-watt), 15 inches from face.	**Print:**	Kodak RC paper, 11″ × 14″; developed in Kodak Ektaflo Developer, Type 1; standard dilution, 13 oz. concentrate to 115 oz. water.
Film and Exposure:	Kodak Tri-X; 1/30 sec. at *f*/2.		

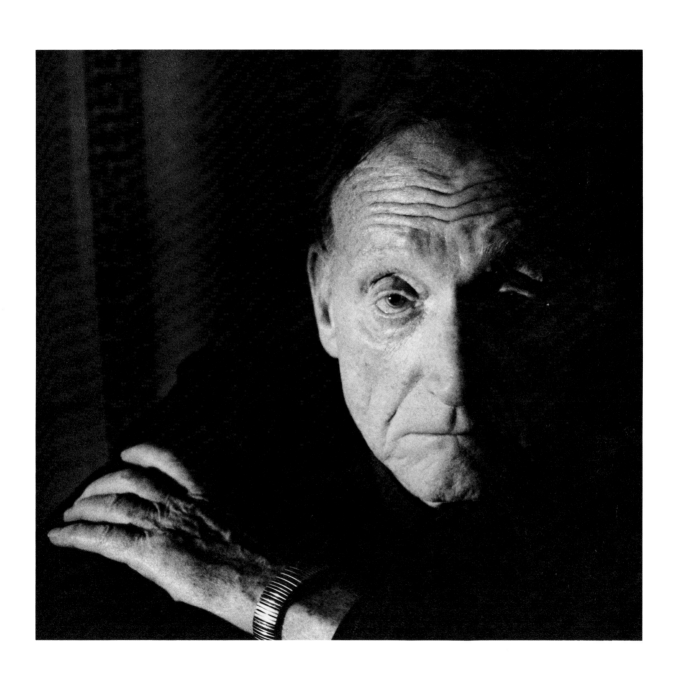

Ethel Merman and Mary Martin

A quarter of a century had passed. That was the last time these two superstars of the American musical theater had appeared together as a team in a television special. Now they were preparing to do it again for a big benefit performance.

A thick cluster of newsmen, TV film crews, and still photographers were waiting for the arrival of these two great performers. Minutes before the appointed time, there was the usual jockeying for position among the newsmen. The lighting crews were setting up their lights; the radio reporters were taping microphones to a tabletop; and still photographers were taking meter readings, and making decisions as to what lens to use for this press conference.

Suddenly, someone shouted, "Heads up!" and Merman and Martin strode into the room, their faces wreathed in smiles, as they waved to familiar people in the room.

During the interview, I tried an 85 mm lens. This was the wrong choice. The perspective put too much space between them, and the limited depth of field would have resulted in either one or the other of the subjects being out of focus. Moving farther back was impossible; the TV crews with their huge tripods and many light stands would have blocked the subjects from my view. I decided to hold my ground, and switched to a 35 mm lens. This proved to be the ideal choice.

As the interview progressed and the two stars reminisced, they became livelier. These great ladies were both top-notch musical comedy stars, skilled in facing any kind of audience; and as they remembered an interesting occurrence in their long, eventful lives, they laughed, joked, and sang snatches of the songs that had brought them both fame and fortune.

Their expressions and movements were so good that I could scarcely keep pace with them as frame after frame was clicked off in my camera. Afterwards, back at the light box, there were so many possibilities to choose from that there was no difficulty in picking the photograph that best summed up this nostalgic meeting between two great performers.

TECHNICAL DATA

Camera and Lens:	Leica CL, with 35 mm *f*/2 Leitz Summicron lens.	**Film and Exposure:**	Kodak Tri-X; 1/125 sec. at *f*/4.
Lighting:	Standard television lighting: two quartz floods equidistant from the subject at either side, at a distance of 10–12 feet; one quartz light in the center, at a distance of 16–20 feet for fill.	**Development:**	Push-processed to ASA 600 in Kodak D-76.
		Print:	Kodak RC paper, 11" × 14"; developed in Kodak Ektaflo Developer, Type 1; standard dilution, 13 oz. concentrate to 115 oz. water.

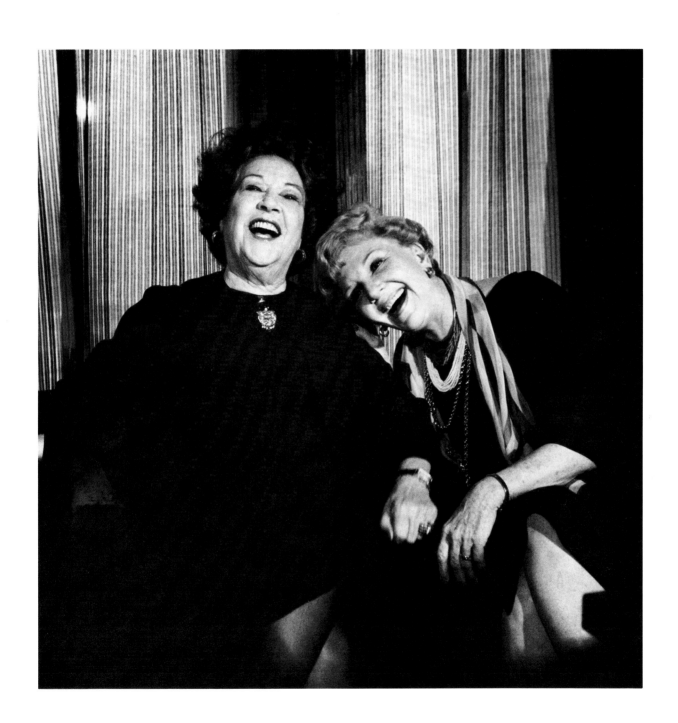

James Baldwin

James Baldwin, the noted American author, has lived in Europe for many years. There are a variety of reasons for this self-imposed expatriation. Not insignificant are the injustice, discrimination, and racism that he believes have been perpetrated upon the black people living in his native land. His decision to live in Europe was in part a personal protest against racial injustice, and he also felt an intellectual and personal freedom that made writing and living easier for him there. At the time this portrait was made, Mr. Baldwin was here on one of his extended visits.

He has a handsomely sculptured head, with a richly textured, dark skin. His face mirrors some of the anxieties and problems that have beset him in the course of his life, and his race.

The setting was the apartment of a friend. It was a very cloudy day; and the living room we sat in was a cave of darkness. Fortunately, just outside the room there was a small outdoor garden. The exterior brick walls were painted white, and I knew as soon as I saw them that they would make a good background, both technically and psychologically.

Mr. Baldwin had mentioned the difficulty of a black man living and working in a white world. Here was the perfect symbol. By posing Mr. Baldwin's strong black face against the stark whiteness of the wall, and further whitening the wall in printing, the contrast of black and white was increased and the symbolism heightened.

Some of the photographs showed Mr. Baldwin smiling, but the incongruity of that smile seen in retrospect against the suffering that this man has experienced simply didn't work. The portrait that did is the one shown here.

TECHNICAL DATA

Camera and Lens:	Canon F-1, with 100 mm *f*/2.8 Canon lens.	**Development:**	Push-processed to ASA 600 in Kodak D-76.
Lighting:	Cloudy, overcast, late morning light.	**Print:**	Kodak RC paper, 11″ × 14″; developed in Kodak Ektaflo Developer, Type 1; standard dilution, 13 oz. concentrate to 115 oz. water. White brick wall held back considerably in printing to heighten the effect of the background.
Film and Exposure:	Kodak Tri-X; 1/250 sec. at *f*/2.8.		

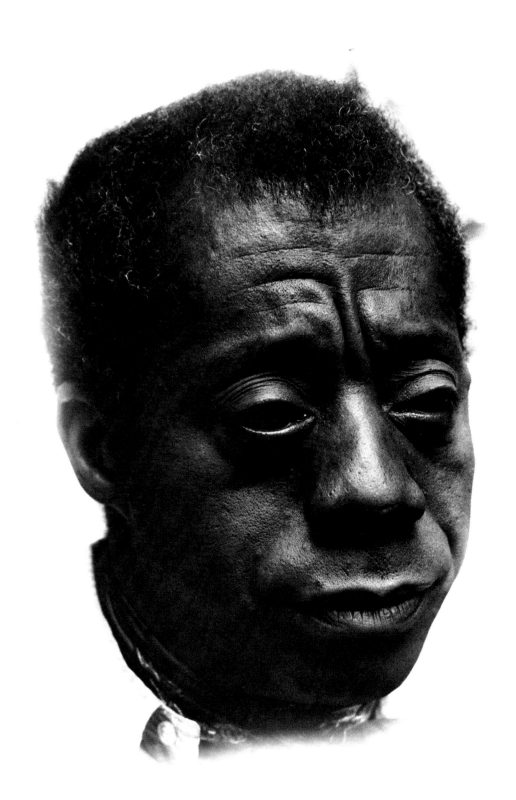

Beame, Carey, and Goldin

New York City was in dire circumstances. Millions of dollars in bonds owned by small investors and big banks were due, and the city lacked the necessary funds to meet its debt. The city was beset with pressures from all sides. The federal government refused to help in any way, maintaining that since the city had gotten itself into the mess, it would have to get itself out. There was no help in sight from the state, which more or less took the same position as the federal government. Unless something concrete was done, and done quickly, the City of New York would go under.

The Emergency Financial Control Board called a meeting with the Mayor, the Governor, and the City Comptroller, along with a coalition of private companies that did business in and with the city, and some of the big banks. This was going to be the "big try" to save the city from bankruptcy.

Under the newly enacted Sunshine Law, the public and press were for the first time permitted to attend this crucial meeting. The photographic problem was complex. First, the feeling of impending doom had to be depicted, along with the frenzied efforts of government officials trying to stave off imminent financial ruin. There were five or six rolls of film exposed at this session, of officials conferring before the start of the meeting, and reactions of the public attending the meeting. The sense of urgency and impending doom was an open, palpable feeling in the room.

The one picture that told the whole story was made before the meeting actually began. The picture succeeds as a news picture because feelings of urgency and disconcertion are clearly communicated to the onlooker. It also succeeds as a multiple portrait, because it is structured in the same manner as some of the great group compositions by Rembrandt, with the heads alternated in various positions, yet holding together as a group. It illustrates, too, that the right moment for any portrait may arise at any time; it must be carefully watched for, and it must be recorded at exactly that moment.

TECHNICAL DATA

Camera and Lens:	Canon AE-1, with Canon 80–200 mm zoom lens used at 200 mm.	**Development:**	Push-processed to ASA 600 in Kodak D-76.
Lighting:	Bright daylight, and TV lights.	**Print:**	Kodak RC paper, 11″ × 14″; developed in Kodak Ektaflo Developer, Type 1; standard dilution, 13 oz. concentrate to 115 oz. water.
Film and Exposure:	Kodak Tri-X; 1/125 at f/4.		

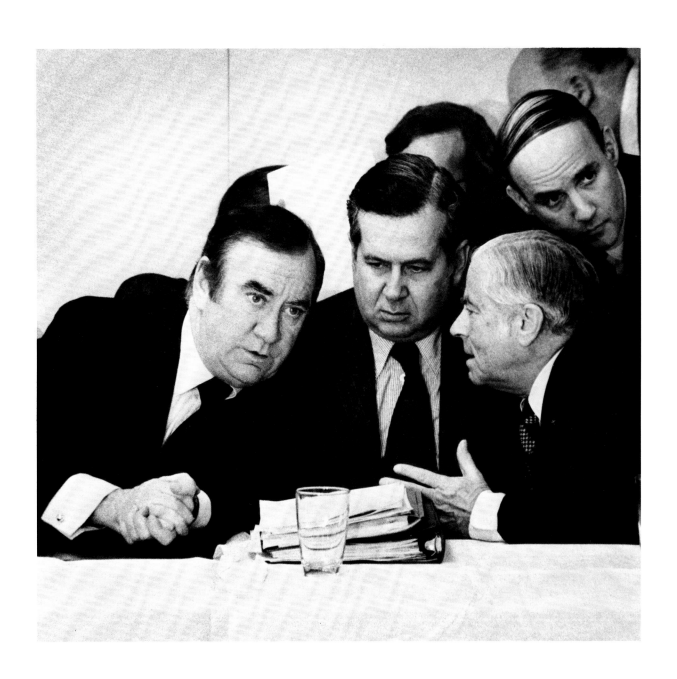

Brazilian Girl

Brazil, one of the largest countries in the Western Hemisphere, has a very sparse population for its size. It is, like the United States, a melting pot of races from many parts of the world. Some of the vast interior parts of the country are inhabited by primitive Indian tribes who live in much the same style as did the people of the Stone Age. These Indians of the Amazon still hunt their food with spear, and bow and arrow; and they cut off the heads of their enemies, shrinking them to the size of small oranges, and stringing them from the thatched roofs of their huts.

In cosmopolitan cities such as Sao Paolo, the people are for the most part sophisticated, urbane, and very much a representative part of the twentieth century. The industrialists of these larger cities, by way of contrast to the Indians, jet around the world several times a year, and spend as much time in Paris, Singapore, and New York as they do in Rio, Sao Paolo, and Bahia.

I wanted to do a portrait of a "typical" Brazilian. My final choice was this young schoolgirl, who I found playing in a schoolyard in the city of Belem. Her richly colored, dark skin contains elements of her ancestral people, the Indians and black slaves who were brought in from Africa. The fairness of her features hints at the mixture of European and American in her bloodlines. Her evident youth, coupled with that knowing smile, draws a parallel with her country, which is also young in years but sophisticated in her ways.

Since the portrait was made for a children's book that I was doing on Brazil, the choice of a children's schoolyard was most appropriate to the subject. The child, like the country, seems to be filled with great promise for the future.

TECHNICAL DATA

Camera and Lens:	Contarex, with 135 mm *f*/2.8 Zeiss Sonnar lens.	**Development:**	Normal development in Kodak Microdol-X.
Lighting:	Daylight; bright, open shade.	**Print:**	Kodak RC paper, 11″ × 14″; developed in Kodak Ektaflo Developer, Type 1; standard dilution, 13 oz. concentrate to 115 oz. water.
Film and Exposure:	Kodak Plus-X; 1/500 sec. at *f*/5.6.		

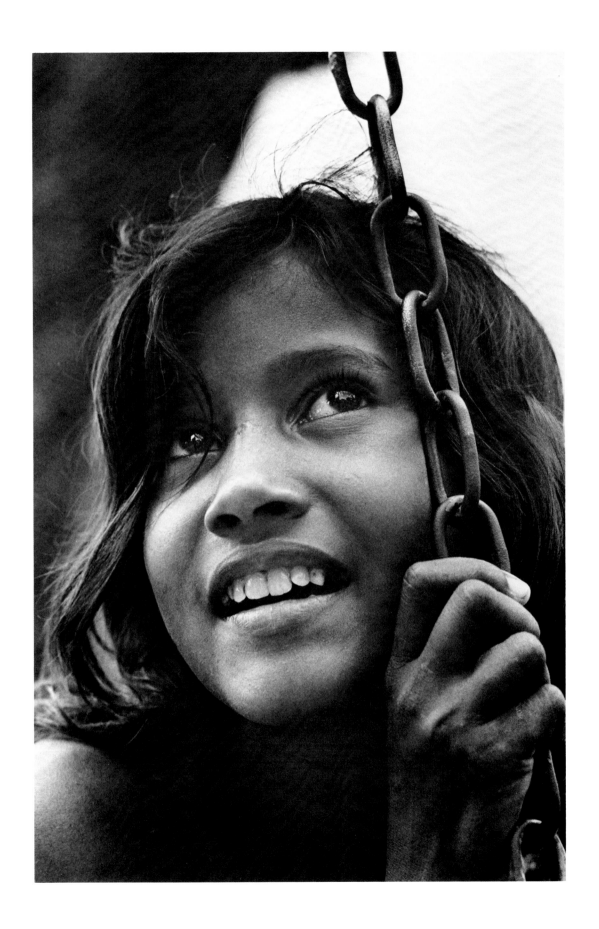

Jacques Barzun

Mr. Barzun is a noted man of letters, an intellectual giant among his peers, with a worldwide reputation for his questing and probing analyses of accepted theories and values. He made it plain to me from the moment of my arrival that having his portrait made was not the most pressing event of the day for him, and that he would appreciate my getting the sitting over with as quickly as possible.

His office presented a formidable visual challenge. It was small, dark, and relatively bare. There was little room to maneuver, and no background material that could be worked into the picture. On the other hand, there was nothing in the room that would interfere with the composition.

My strongest ally in making this portrait was Mr. Barzun's face, which tells the whole story of the man. An imposing forehead with a broad, sweeping brow, keen and piercing eyes, and a commanding profile completed the ingredients with which I had to work. Lighting was ex-tremely important here. The dignified profile, strongly shaped head, and fine skin texture all had to be carefully delineated to create the total effect.

A single powerful quartz lamp in a concentrating reflector was used to bring out details of skin, eyes, hair, and profile. A fiberglass diffuser was placed over the front of the light to prevent strong highlights from washing out; and barn doors were attached to the reflector to prevent the light from spilling over to the walls, and to keep the background dark. The light was clamped to a nearby bookcase, and exposure was carefully metered for the lighter areas of the face.

A small 35 mm camera (Canon AE-1) with an 85 mm f/1.8 lens was used to give utmost mobility in the small, cramped confines of the office. The power-winder on the camera (enabling exposures as fast as two frames per second) was used to give maximum output of photographs in the minimum time allotted to me.

TECHNICAL DATA

Camera and Lens:	Canon AE-1, with 85 mm f/1.8 Canon lens.	**Development:**	Normal development in Kodak Versamat, with FR chemicals.
Lighting:	Single quartz lamp equipped with barn doors, and fiberglass scrim; 500-watt bulb.	**Print:**	Kodak RC paper, 11" × 14"; developed in Kodak Ektaflo Developer, Type 1; standard dilution, 13 oz. concentrate to 115 oz. water.
Film and Exposure:	Kodak Tri-X; 1/250 sec. at f/5.6.		

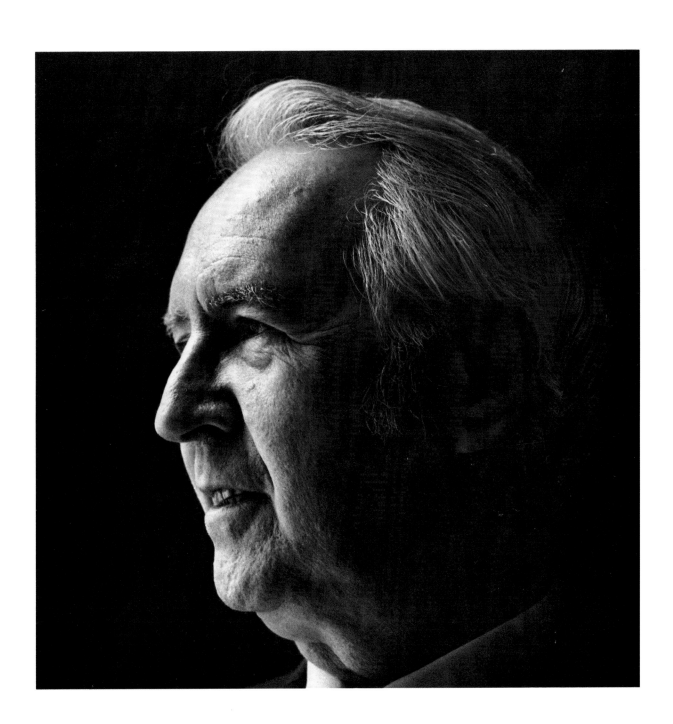

John D. Rockefeller

One has to be impressed when coming face to face with the man that carries that legendary name . . . I was impressed. Mr. Rockefeller is a tall, rather quiet man who shuns personal publicity. He pours his considerable energies into the many charities and worthy causes that he espouses, and backs his efforts with the necessary financial assistance.

His office is very much like the man who works there—simple, solid, and unpretentious. He was seated at his desk, and that is where I was to take his picture. Two technical problems immediately stared me in the face. One was in the form of the large windows on either side of the desk, pouring great amounts of light directly into the camera lens. The second problem facing me was to try to capture the sense of humor, and the well-known Rockefeller smile.

Floodlighting would not have been bright enough to overcome the intensity of the daylight coming in the window. Strobe light, with its attendant 1/60 sec. exposure would mean risking a double, or ghost image. I decided to use flash. The strobe unit would have to be close enough to the subject to enable stopping the lens down to *f*/22, thereby overriding the brightness range of the daylight. There was still enough ambient light to give the effect of sidelighting to the face, despite the fact that only a single strobe light source was used.

With the technical problems solved, I turned to the portrait itself. In conversing with Mr. Rockefeller about a trip he had made to the Far East, he smiled broadly and tilted his head to one side, as he recounted an amusing incident that had occurred there. I instantly activated the motor drive on my Canon, and fired a long burst of about 20 frames. The assignment was completed at that instant.

TECHNICAL DATA

Camera and Lens:	Canon F-1, with MF motor drive, and 100 mm *f*/2.8 Canon lens.	**Development:**	Normal development in Kodak Versamat, with FR chemicals.
Lighting:	Small strobe unit at 3-foot distance.	**Print:**	Kodak RC paper, 11″ × 14″; developed in Kodak Ektaflo Developer, Type 1; standard dilution, 13 oz. concentrate to 115 oz. water.
Film and Exposure:	Kodak Tri-X; *f*/22 strobe exposure.		

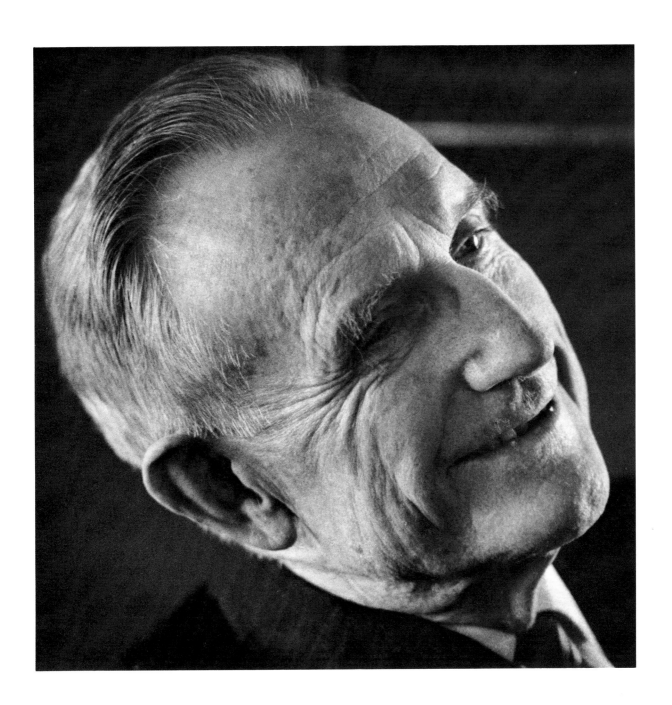

Modern Dancer

It was a spectacular early fall morning. The sky was that beautiful deep shade of blue, verging on violet. I was to meet a ship coming into New York Harbor. Aboard the ship was a modern dance troupe returning from a successful trip on the Continent. They had wowed audiences from Spain to Sweden, and from Paris to Portugal. Foreign audiences were fascinated with the depiction by the dancers of the new American life-style. This was the 1960s, and the hippie had just made an appearance as the forerunner of the counterculture.

I singled out this dancer from the rest of the troupe as soon as I saw her. Her costume, the grace with which she carried herself while walking, and her strong, mobile face made an immediate impression upon me. Her person seemed to reflect everything that was dynamic, colorful, and talented about the company.

We set out looking for a suitable background for a portrait on board the ship. With that spectacular costume and hairstyle, the background chosen would have to be as simple as possible. We finally found a patch of clear space that looked right. The dancer was tired, understandably so after many weeks of arduous travel and performances all over Europe. The last thing she expected to find at the conclusion of her trip was a portrait photographer. But she was a trouper—completely at ease in front of the camera.

She started to pose, but somehow none of the first poses was quite right. Finally, I asked the model, who was a superb interpretive dancer, to try to interpret for the camera exactly the way she felt—to externalize her inner feelings at that moment. Without hesitation, like an instantaneous reflex, her face assumed this expression.

TECHNICAL DATA

Camera and Lens:	Canon F-1, with 85 mm f/1.8 Canon lens.	**Development:**	Normal development in Kodak D-76.
Lighting:	Natural backlight.	**Print:**	Kodak RC paper, 11″ × 14″; developed in Kodak Ektaflo Developer, Type 1; standard dilution, 13 oz. concentrate to 115 oz. water.
Film and Exposure:	Kodak Tri-X; 1/500 sec. at f/5.6.		

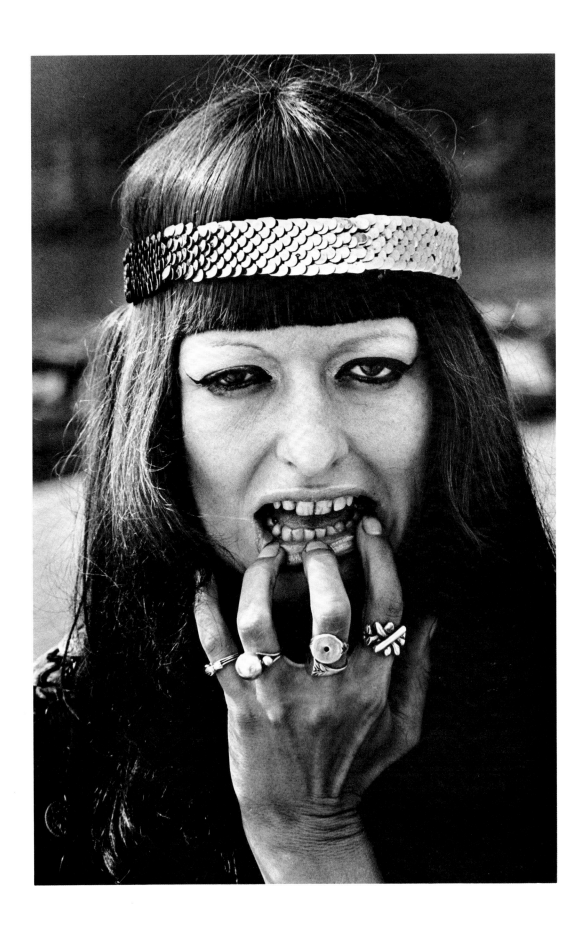

Carl Gossett, Fisheye Portrait

The possibilities of the caricature and satirical portrait have not yet been fully explored in photography. In the beginning, photography tried to imitate painting, and was for the most part fairly successful. As the quality of film and lenses improved, photographers realized that the photographic process had many qualities of its own that were different from painting, and in some areas even superior to that art form. The ability of the camera to capture, in a fraction of a second, precise detail on a large scale was unique.

But what the camera sees depends entirely on the lens the photographer uses. Any lens placed in the camera will modify, in its own particular way, what it sees; and in most cases it will see a scene the way the eye sees it. The fisheye lens is the exception to this rule.

There are fisheye lenses that will literally see around corners, and in effect will photograph some of the scene behind the camera. All fisheye lenses have a common characteristic: The farther the image is from the center of the lens, the more pronounced is the distortion that is inherent in these lenses. Straight lines that appear at the edge of the picture area will have a pronounced bow or bend.

When using these lenses for a portrait (a use never intended by the lens designers), the amount of distortion becomes so gross as to bring forth a totally new kind of image. This image is truly unique to the art of portraiture. By moving selected parts of the face (nose, chin, or ears) to the farthest edge of the lens, the utmost distortion occurs. The resulting portrait becomes a caricature, or satirical portrait of a kind unique in the field of art. As such, this kind of portraiture is well worth exploring as a new technique to be used when the photographer wishes to evoke surprise or shock, or to make a great impact on the viewer.

TECHNICAL DATA

Camera and Lens:	Canon F-1, with 50 mm Canon lens, and Spiratone fisheye attachment.	**Development:**	Normal development in Kodak D-76.
Lighting:	Daylight; sun.	**Print:**	Kodak RC paper, 11″ × 14″; developed in Kodak Ektaflo Developer, Type 1; standard dilution, 13 oz. concentrate to 115 oz. water.
Film and Exposure:	Kodak Tri-X; 1/125 sec. at f/22.		

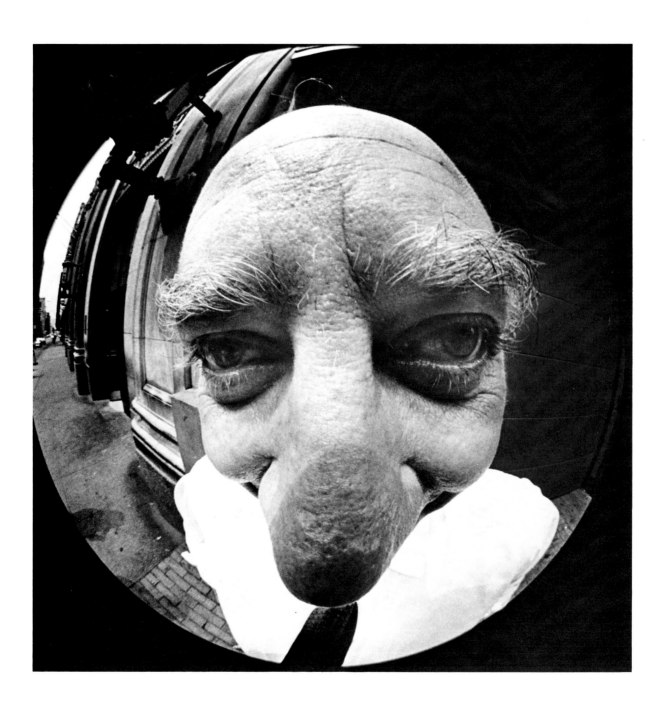

Manning/Beethoven Head

New ways of expressing people's personalities are constantly being sought in the field of portraiture. Not every technique is applicable to every subject, but a command of many techniques prepares the photographer to successfully cope with most subjects that come before his camera. As your range of skills increases, so too do the chances of your success. As your abilities broaden in scope, your interpretive portraits become more interesting.

The truly creative photographer must follow his instincts, and must continually try new ideas and new ways of doing things. Failure at one experiment often leads to success on the next try; and as you broaden the base of your experience and your versatility increases, your failures lessen and your range of experience enables you to meet all new challenges, and solve the attendant problems.

In my own continual search for new approaches in portraiture, I tried this interesting double-negative technique. This photograph comprises a portrait of myself and a photograph of the death mask of Beethoven. Both negatives (slightly under-exposed to make printing a little easier) were sandwiched together and viewed over a light box. The negatives were moved around to find the best printing position. When the most interesting juxtaposition of head and mask were achieved, they were fastened together with thin strips of Scotch tape placed only on the transparent edges of the negatives. This done, the negative sandwich was then placed in a glass carrier to insure flatness.

There are many subjects with which to experiment. You might try combining two different photographs of the same person, two photographs of different people, people and masks, or people and animals. The range of variations is infinite, and many are interesting.

TECHNICAL DATA

Camera and Lens:	Canon F-1, with 50 mm Canon lens for both heads.	**Development:**	Normal development in Kodak Microdol-X.
Lighting:	Flood lamps.	**Print:**	Kodak RC paper, 11″ × 14″; developed in Kodak Ektaflo Developer, Type 1; standard dilution, 13 oz. to concentrate 115 oz. water.
Film and Exposure:	Kodak Plus-X; 1/30 sec. at f/16 for Beethoven head, and 1/30 sec. at f/4 for Manning head.		

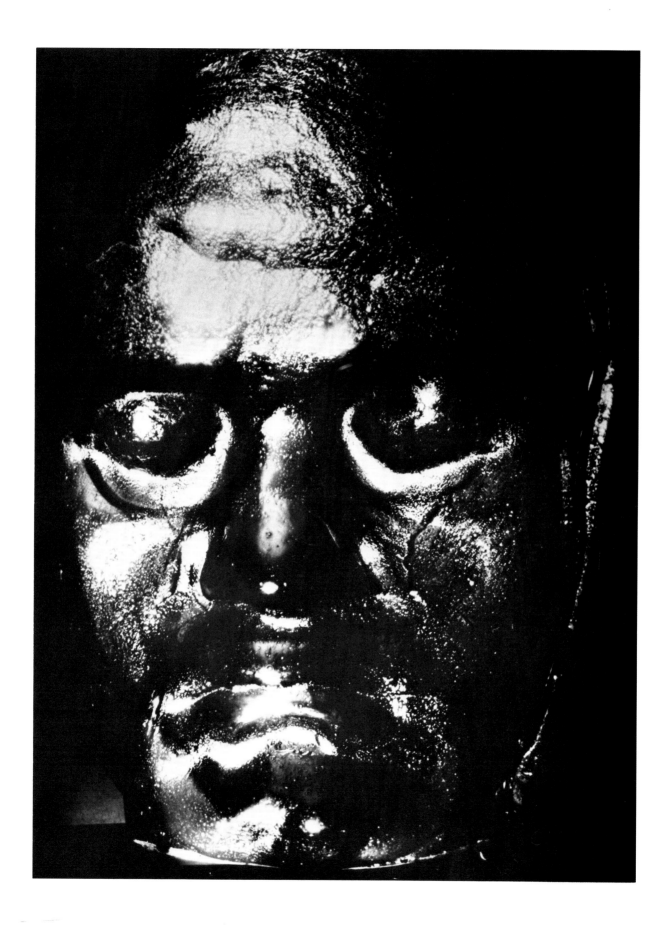

Balanchine

A legendary figure in the world of ballet, Balanchine is a master of the art and is famous in every country of the world. He has a genius for bringing together the great dancers of our time and creating spectacular new ways of showing off their talents, while at the same time breathing new life into old musical favorites. He is a crowd-pleaser who has delighted audiences everywhere, and whose skill has brought him to the peak of his field. Countless nuances of expression seem to be displayed in his marvelous, mobile face.

My initial try for a portrait showed him on stage surrounded with dancers, musicians, and stagehands. I was working from the orchestra section of the theater with a 500 mm lens and camera mounted on a tripod. The light on stage was excellent. Balanchine moved around constantly, demonstrating the manner in which he wanted the piece played, danced, and interpreted. He flattered, cajoled, demanded, smiled, frowned, laughed, pouted; his repertoire of expressions was unending. But I wasn't satisfied.

There seemed to be some vital element of his personality that lay just beneath the surface of his face and never quite surfaced. Still, I kept shooting away, reaching for that elusive frame that would wrap it all up. The motor drive buzzed off frame after frame as I tried to capture on film that extra dimension of his personality that makes the difference between a good portrait and a great one.

Finally, Balanchine left the stage, and seated himself in the orchestra to watch the company go through its paces. I don't know what instinct prompted me to take a seat near him in the darkened theater. My exposure-meter needle did not respond when I tried to take a reading. The only light on Balanchine was that being reflected from the stage. My guess at an exposure was 1/4 sec. at $f/2$ with Tri-X film rated at ASA 1200. I kept the camera carefully focused on his face, and braced myself against the back of one of the theater seats.

Finally, as music and dance on stage blended into a perfect balance of form and sound, you could see him visibly relax and sink back into the seat. His face was suddenly transformed by the wonderful expression in the portrait shown here.

TECHNICAL DATA

Camera and Lens:	Leica M4, with 90 mm $f/2$ Summicron lens.	**Development:**	Push-processed to ASA 1200 in Kodak Versamat, with FR chemicals.
Lighting:	Available light.	**Print:**	Kodak RC paper, 11″ × 14″; developed in Kodak Ektaflo Developer, Type 1; standard dilution, 13 oz. concentrate to 115 oz. water.
Film and Exposure:	Kodak Tri-X; 1/4 sec. at $f/2$.		

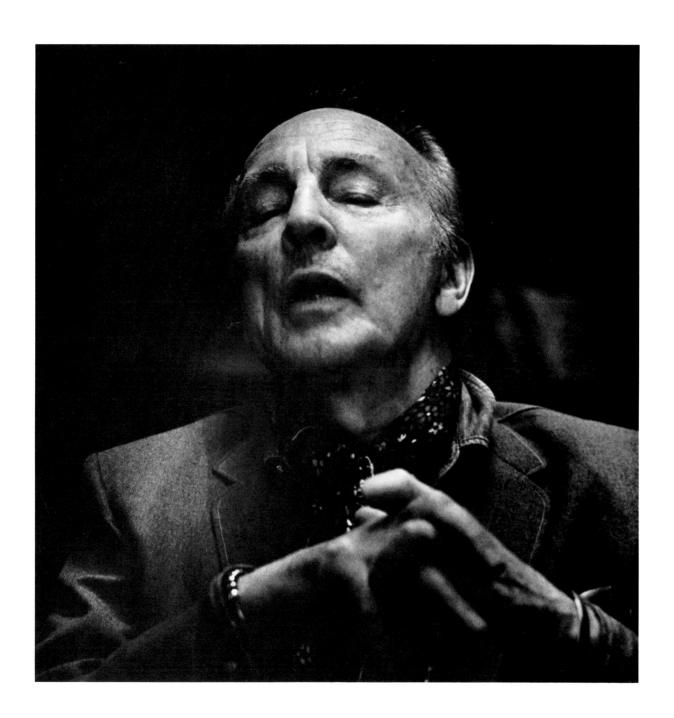

Edward Albee

Edward Albee is one of the contemporary masters of modern American theater. His plays are complex, multifaceted dramas that mirror the psychological anxieties of people enmeshed in troubles of their own making. We see their hopes and dreams being slowly eroded by the abrasiveness of their relationships with one another; and whatever is good and worthwhile slowly dissolves before our eyes as these people become primal figures fighting for their lives in an urban jungle filled with psychosis and neurosis.

Albee's face, like his plays, is a fascinating study in complexity. He is personable, soft-spoken, and has the assured manner of a man who knows exactly what he is doing, as well as the confidence that comes from wide public acceptance of his dramatic works.

This portrait was made at his home. Outside, the typical Manhattan streets were crowded and noisy—a proliferation of garishly lit bars, restaurants, and supermarkets. As soon as I crossed the threshold of his home and the door closed behind me, the street noises ceased, and the neon signs were transformed into a hushed quiet interior. Crystal chandeliers shone against lustrous black walls, the light was broken into a thousand colors by the crystal prisms.

The setting was perfect in its theatricality. In order for the portrait to work, it had to have the same feeling as the room. Adding any sort of artificial light to the existing illumination would have destroyed the feeling engendered by the existing light. To frame the subject with the crystal chandeliers, I stood on an 8-foot ladder to get the desired result.

TECHNICAL DATA

Camera and Lens:	Leica M2, with 35 mm $f/2$ Summicron lens.	**Development:**	Normal development in Kodak D-76.
Lighting:	Available light.	**Print:**	Kodak RC paper, 11″ × 14″; developed in Kodak Ektaflo Developer, Type 1; standard dilution, 13 oz. concentrate to 115 oz. water.
Film and Exposure:	Kodak Tri-X; 1/30 sec. at $f/2$.		

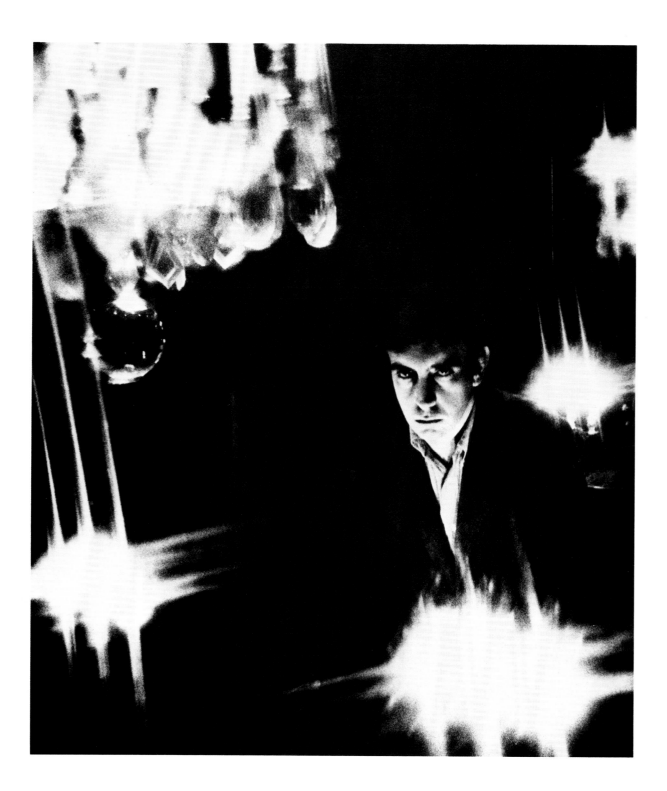

Aleksandr Isayevich Solzhenitsyn

Russia's greatest living author and most controversial one has led a turbulent and chaotic life. For his outspoken defiance of governmental censorship and restriction, he has spent years in exile, and some of that time in the dreaded prison camps. He successfully fought the Germans in World War II, and a malignant cancer that almost took his life in the early 1950s; but he lost most of his battles against the Russian bureaucracy.

Despite his great love for his native country, Solzhenitsyn finally decided that voluntary exile was preferable to the oppressive life of a harshly dictatorial society. His government would not at first allow him to leave the country, but worldwide public opinion finally forced the Russians to allow him to depart. He chose voluntary exile in Switzerland.

This picture was made while the author was on a brief visit to the United States; he was being honored at a luncheon at the Waldorf Astoria Hotel. The circumstances involved in the making of this portrait were very trying. The author was seated on a dais surrounded by 50 VIP's. There were an additional thousand people crammed into the grand ballroom; and waiters continually darted back and forth making an unobstructed view quite difficult. Illumination in the room was not very good; and for security reasons, the media was kept at a distance of 100 feet from the dais.

In order to attain a decent size image on the film, I was forced to fall back on a 500 mm mirror lens with a 2× tele-extender. The maximum lens opening was $f/5$, which became $f/10$ with the addition of the lens attachment. The resultant exposure was 1/8 sec. at $f/10$. Although the camera and lens were mounted on a good solid tripod, none of the photographs were extremely sharp.

The advantages of the setup were many: The long-focal-length lens isolated the subject from the rest of the people in the room; and he was unaware of the camera, which made it easy to get a fairly good portrait of this difficult-to-photograph author.

Despite the crowds of people, the noise, and other distractions, the long lens made it possible for me to capture a portrait of the "private" man, deep in thought.

TECHNICAL DATA

Camera and Lens:	Canon F-1, with 500 mm $f/5$ Nikon lens (special adapter), and 2× tele-extender.	**Development:**	Push-processed to ASA 1200 in Kodak Versamat, with FR chemicals.
Lighting:	Overhead ballroom and dais lights.	**Print:**	Kodak RC paper, 11″ × 14″; developed in Kodak Ektaflo Developer, Type 1; standard dilution, 13 oz. concentrate to 115 oz. water.
Film and Exposure:	Kodak Tri-X; 1/8 sec. at $f/10$.		

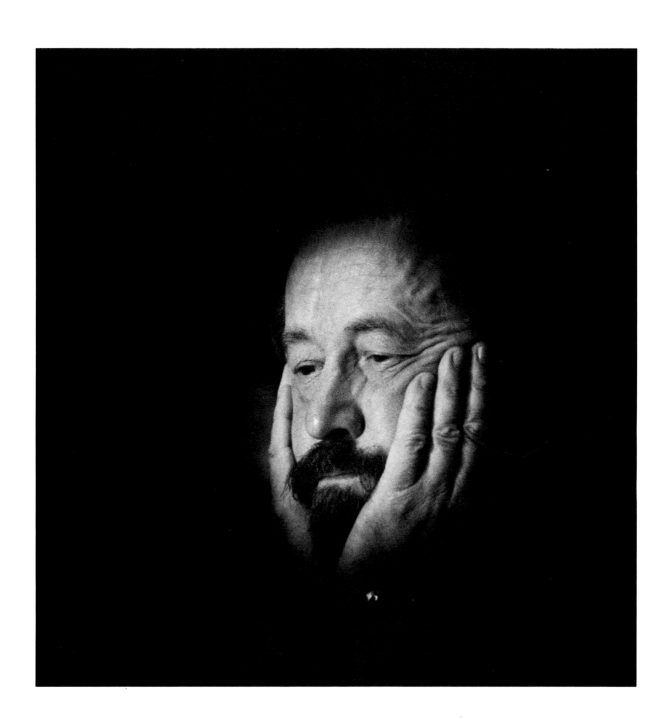

Chinese Woman

New York City had just instituted a program to screen and inoculate residents of the Lower East Side of Manhattan. Whenever necessary, people were given shots against some of the more common diseases and some literature on good nutrition. The area selected for me to document was a section of Chinatown near Mott Street. The auditorium of a public school had been hastily converted into a temporary health clinic. Doctors and nurses from nearby city hospitals set up several areas within the auditorium where individuals were screened off from others, and given diagnostic tests and shots where indicated.

Many of the residents of the area were wary of the program at first, but as word of mouth spread in the community, people started to drift in, in ever-increasing numbers. By early afternoon the place was jammed with hundreds of people, eager to take advantage of the valuable health service being provided by the city.

There was a good deal of commotion; most of the conversations and questions were in Chinese, and long lines of people soon formed at each of the "treatment" centers. Doing a portrait under these less-than-ideal circumstances was not the easiest task. The existing light was much too dim. Any kind of lighting setup was virtually impossible. People rushing around the darkened auditorium would inevitably bump into lights or trip over wires.

I decided to use a small strobe unit on an extension wire, clamped to a monopod. One of the nurses' aides graciously volunteered to hold the light for me, and to simultaneously act as translator. The light was held off to one side to avoid illuminating people near the subject, and the portrait was finally accomplished without incident.

TECHNICAL DATA

Camera and Lens:	Canon F-1, with 85 mm *f*/1.8 Canon lens.	**Development:**	Normal development in Kodak Versamat, with FR chemicals.
Lighting:	Single strobe unit on extension cord, clamped to monopod.	**Print:**	Kodak RC paper, 11″ × 14″; developed in Kodak Ektaflo Developer, Type 1; standard dilution, 13 oz. concentrate to 115 oz. water.
Film and Exposure:	Kodak Tri-X; 1/60 sec. at *f*/11.		

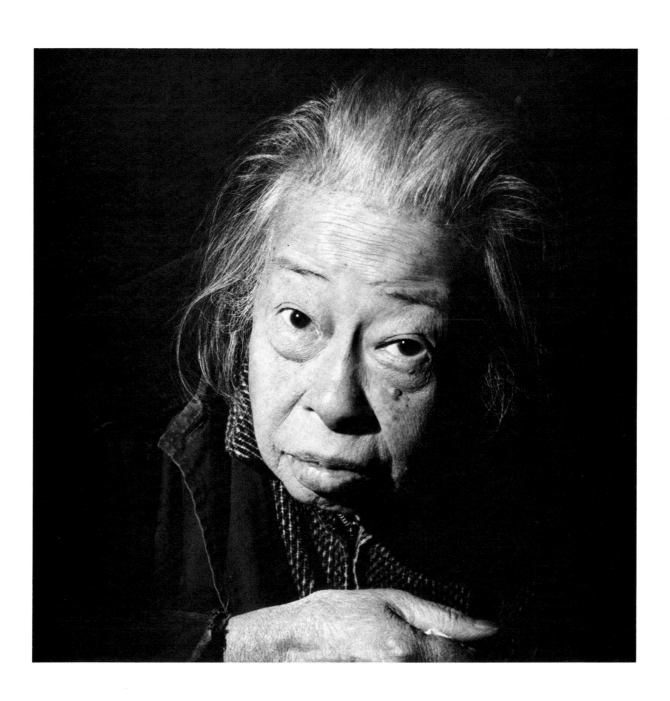

Joseph Papp, Producer

Joe Papp is a phenomenon in the theater world. An innovator with sweeping imagination, this producer has inspired playwrights to create new dimensions, and actors to perform within these dimensions with such power and conviction that the combined product has occasionally resulted in new drama forms. His unique versions of classic drama have been produced with such audacity and bold imagination that he has influenced many other producers in the theater world.

The enormous theater complex that Papp founded on the outskirts of the East Village was to be my "shooting ground," and it was with some degree of trepidation that I faced the master showman on his home turf. When I came upon him, he was conferring with some lighting technicians on a bare stage, sparsely lit by a few spot-lights. The rest of the house was dark; there was no interesting background to work into the picture, and no foreground props to alleviate the bareness of the scene.

I explained the problem to Papp, and he gave me the key to his office, asking me to see if I could find a suitable background there. Just outside his office, I came upon some very large theatrical posters of the plays that Papp had produced in the past. Bare ceiling fluorescents glowed, about 20 feet above the posters. The lighting was not overly dramatic, but the background of the posters was far better than the bare stage I had already rejected as a possibility.

The only remaining problem was the deep shadows cast by the lights under Papp's eyes. A bare-bulb strobe light filled the dark shadows, and did not overpower the natural lighting condition.

TECHNICAL DATA

Camera and Lens:	Canon AE-1, with 35–70 mm Canon zoom lens.	**Development:**	Push-processed to ASA 800 in Kodak Versamat, with FR chemicals.
Lighting:	Fluorescent lights in ceiling, boosted with bare-bulb strobe light.	**Print:**	Kodak RC paper, 11″ × 14″; developed in Kodak Ektaflo Developer, Type 1; standard dilution, 13 oz. concentrate to 115 oz. water.
Film and Exposure:	Kodak Tri-X; 1/60 sec. at f/5.6.		

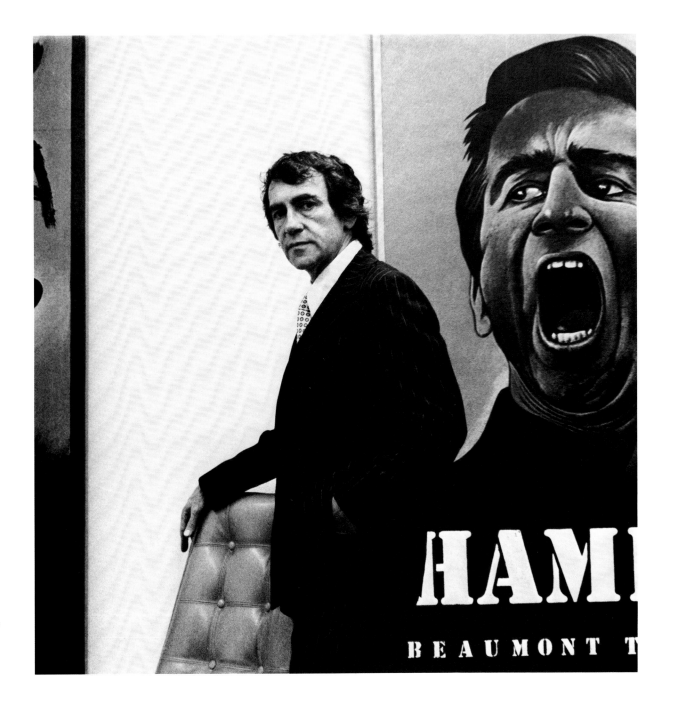

Japanese Diplomat

The United Nations delegate lounge is one of the most interesting hunting grounds in the world for faces. The mixture of exotic dress, the glottological sounds of many of the world's tongues, and the kaleidoscopic swirl of faces is like a fanciful movie set on a giant Hollywood sound stage. At any moment one expects to see a monocled director, chewing a fat cigar, a tiny round beret perched atop his bald head, to stroll into the crowd, raise his hand for silence, and shout, "Lights, action, camera, roll 'em!"

The audience of these diplomats is the world, and their actions affect every man, woman, and child living in it. Diplomats are usually amenable to having their picture taken. The limelight is a part of their natural habitat, and even when they are under intense personal pressure—in the crux of some world-shaking international crisis—their training keeps them poised, calm, and always ready to cope with any eventuality. They are well aware of the value of publicity, and they know that the speeches made before the United Nations will be recorded on film and disseminated to the far corners of the earth, and more importantly for them, to their own country as well.

This portrait was made as part of a series of faces at the United Nations. The Japanese subject was unaware of the camera. He was engaged in conversation with two of his compatriots, and I was situated many yards away from his table, shooting with a 300 mm lens with a tele-extender—the equivalent of a 600 mm lens.

TECHNICAL DATA

Camera and Lens:	Canon AE-1, with 85–300 mm Canon zoom lens fitted with 2× tele-extender.	**Development:**	Push-processed to ASA 800 in Kodak Versamat, with FR chemicals.
Lighting:	Natural window lighting.	**Print:**	Kodak RC paper, 11″ × 14″; developed in Kodak Ektaflo Developer, Type 1; standard dilution, 13 oz. concentrate to 115 oz. water.
Film and Exposure:	Kodak Tri-X; 1/30 sec. at f/2.8		

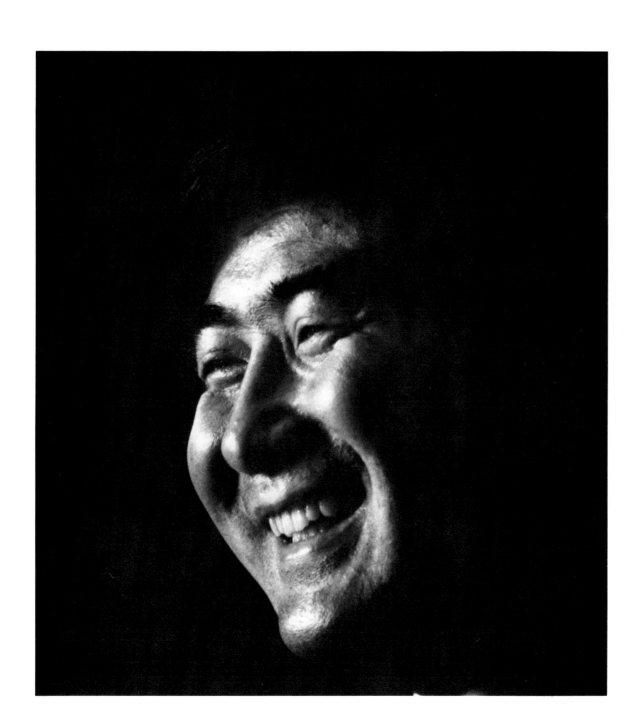

William Scharf, Painter

Take a room full of powerful, abstract paintings . . . combine them with a forceful, dynamic face . . . and what do you come up with? Trouble! Bill Scharf is a well-known abstract painter whose powerful images mix the basic human emotions—fear, love, desire, great outpourings of elation, sober awareness of death, and the soaring thrust of life's triumphant and joyful beginnings into a foreboding world. These images are made with such power and color that the viewer is drawn into the maelstrom of creation as it touches the basic chords of his own life.

If these paintings are so powerful, why weren't they used as background for the portrait? Although effective, the viewer's attention was completely drawn to the dynamic paintings; the subject was thus weakened, as well as any other outside element included in the composition. The face of the painter is by itself a powerful image and had to be handled separately.

This particular portrait was made while the artist was at work in his studio. The canvas in front of him was small in size, and the corner of the room did not allow for very elaborate lighting equipment. There was just enough room to insert a small flood lamp on a very short extension wire, without a reflector. This unit was clamped to the edge of the easel, below the level of Mr. Scharf's eyes. Exposure was made for the face values only, deliberately dropping all other tonalities to black.

TECHNICAL DATA

Camera and Lens:	Contarex, with 85 mm f/2 Zeiss Sonnar lens.	**Development:**	Normal development in Kodak D-76.
Lighting:	Bare-bulb floodlight.	**Print:**	Kodak RC paper, 11″ × 14″; developed in Kodak Ektaflo Developer, Type 1; standard dilution, 13 oz. concentrate to 115 oz. water.
Film and Exposure:	Kodak Tri-X; 1/125 sec. at f/5.6.		

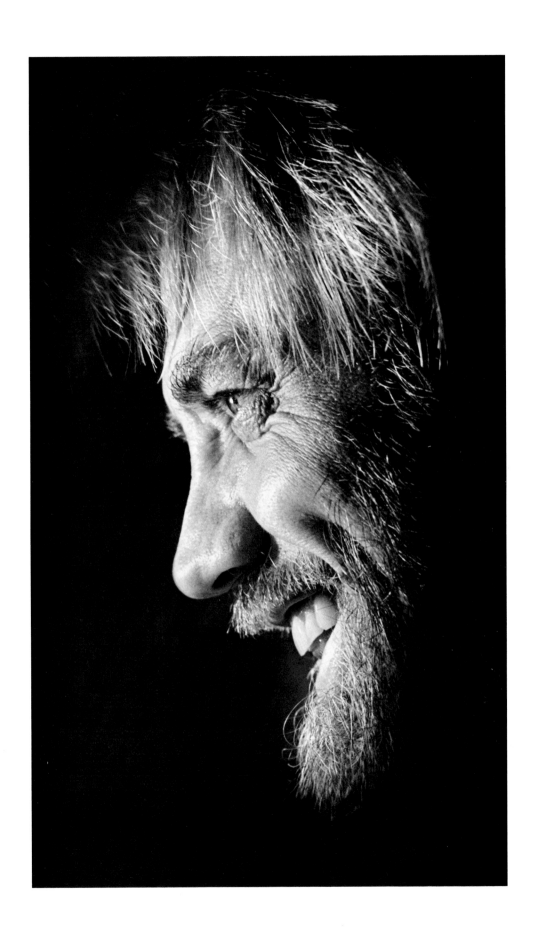

Haitian Primitive Painter

Haiti is a tiny, impoverished country ruled by a despotic, tyrannical dictator. It shares an island with the Dominican Republic, and although it is located in the lush tourist zone of the Caribbean and has much to offer the visitor by way of great scenic beauty, the political climate is so oppressive that Haiti's once flourishing tourist traffic has dwindled to a comparatively few curiosity seekers. The present ruler proclaimed himself "President for Life" in much the same manner as his father did. Roving bands of men armed with submachine guns, dressed in civilian clothes, and sporting dark sunglasses (more for concealment than protection from the sun) terrorize the native populace and visiting tourist alike.

The Haitian owes his language to France (actually it is a patois—a mixture of French and local dialects), and his cultural heritage to the black slaves that were imported in great numbers from the region of Africa known as Dahomey. The religion of the island is Catholic with a heavy intermixture of voodoo.

About 30 years ago, there was an artistic renaissance in Haiti. Almost spontaneously, magnificent canvases blossomed in many native huts. There was a tremendous boom in Haitian art. The canvases were richly colored, reflecting the people and countryside; in many of them were expressions of the occult and voodoo that dominate the lives of the people.

This portrait shows a typical Haitian primitive painter at the Centre d'Art in Port Au Prince, the capital of Haiti. The portrait was made at four o'clock in the afternoon, in the open courtyard of the center. The light was the blazing summer sun.

TECHNICAL DATA

Camera and Lens:	Leica, with 35 mm *f*/2 Summicron lens.	**Development:**	Normal development in Kodak Microdol-X, diluted 3:1.
Lighting:	Full summer sun.	**Print:**	Kodak RC paper, 11″ × 14″; developed in Kodak Ektaflo Developer, Type 1; standard dilution, 13 oz. concentrate to 115 oz. water.
Film and Exposure:	Kodak Plus-X; 1/500 sec. at *f*/11.		

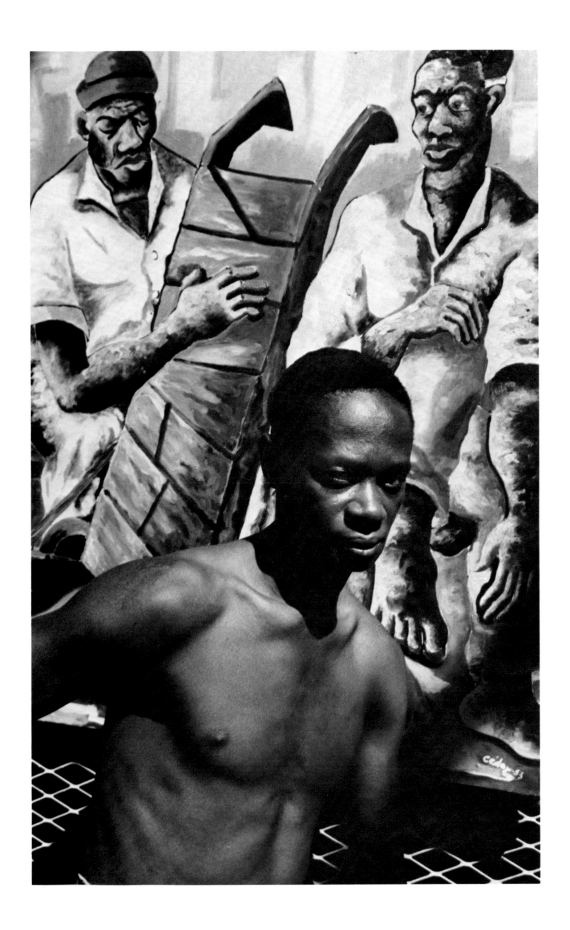

Jorge Amado, Brazilian Author

This gentle-looking man is Brazil's most widely known author. His novels depict sweeping panoramas of life in a land rich in contrasts. Amado's concern is for the common man and his struggle to secure the basic necessities of life for himself and his family. Although he has traveled extensively, his writings reflect what he has seen and experienced in his own country.

Brazil is a fascinating fusion of primitive life among the Indians of the Amazon, and sophisticated life-styles of the industrial tycoons of Sao Paolo. Amado's span of interest encompasses the mass of people between these two extremes.

The author is a man of simple tastes, whose way of life reflects his love for his country and his fellow man. In his home he has gathered about him works of art by contemporary artists, sculptors, and craftsmen, as well as beautiful pieces created centuries ago.

The initial portraits of Amado surrounded by some of these artistic works were not exactly what I wanted. The setting was colorful, and the pictures satisfactory; but there was something lacking that I couldn't quite fathom.

I was invited to have lunch with the Amados and was treated to a variety of typical Brazilian dishes, among them the national dish *feijoada*, and an alcoholic potion called *Cashasa*, not unlike Kentucky moonshine in potency and look. After lunch we walked to the back of the house to a beautiful patio. He settled himself on his favorite bench with his cat beside him. The setting, pose, and lighting (very bright, open shade) were ideal, and resulted in this picture.

TECHNICAL DATA

Camera and Lens:	Zeiss Contarex, with 85 mm *f*/2 Zeiss Sonnar lens.	**Development:**	Normal development in Kodak Microdol-X.
Lighting:	Daylight; open shade.	**Print:**	Kodak RC paper, 11″ × 14″; developed in Kodak Ektaflo Developer, Type 1; standard dilution, 13 oz. concentrate to 115 oz. water.
Film and Exposure:	Kodak Plus-X; 1/500 sec. at *f*/8.		

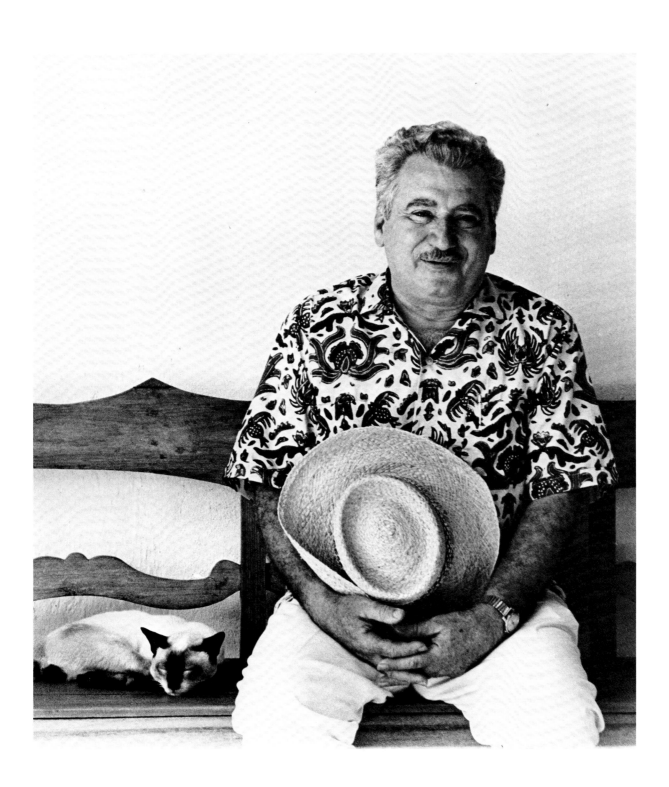

Chaim Gross, Sculptor

Mr. Gross is a craftsman whose work and person radiate power, and who becomes so intensely absorbed in his work that he is unaware of anything around him. It is rare that a photographer finds ideal lighting conditions for a portrait in an on-location site, and Mr. Gross's studio was no exception. The studio was marvelous for a sculptor who must have space to work; but the lighting, photographically speaking, was terrible.

My original concept for the portrait was to show the sculptor at work, playing off the handsome ruggedness of his face against the impressiveness of his work. I set up three strobe units and asked the artist to continue working. He was only too happy to oblige, and immediately busied himself with a mallet and chisel, hammering away at a massive block of wood.

As the chips began to fly, the strobe lights, set up at cross-angles from one another, proceeded to flash. I moved around, constantly changing position, look-ing for the ideal juxtaposition of his head and the shape he was working on, for the portrait I had in mind. After two rolls of film (72 exposures), I had a lot of technically good pictures, but felt that I had not yet captured the essence of Chaim Gross, the sculptor.

I decided to take a short walk, to try to clarify my own thinking processes. It was a beautiful fall day; the sky was bright blue and the weather was crisp and clear. Returning to the studio, I rang the bell and waited for the door to open.

The vestibule where I waited was flooded with soft, reflected light from a large white building across the street. Within the vestibule there was an ornate iron grill, silhouetted against a gray wall. When Mr. Gross answered the door, his face hung like a luminous object against the subdued brightness of the gate. The quality of the natural light was so beautiful, and so right for the subject that I held him there and made the portrait.

TECHNICAL DATA

Camera and Lens:	Canon F-1, with 85 mm f/1.8 Canon lens.	**Development:**	Push-processed to ASA 600 in Kodak D-76.
Lighting:	Indirect daylight.	**Print:**	Kodak RC paper, 11″ × 14″; developed in Kodak Ektaflo Developer, Type 1; standard dilution, 13 oz. concentrate to 115 oz. water.
Film and Exposure:	Kodak Tri-X; 1/125 sec. at f/2.8.		

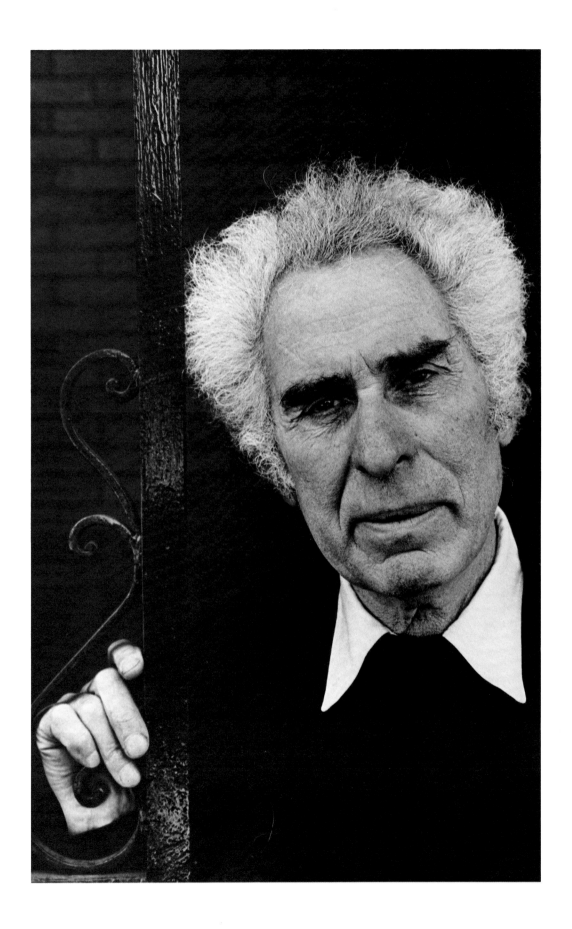

Chaim Grade, Poet

Mr. Grade is one of the gentlest of men. He exudes a warmth that seems to reach out and enfold you like a security blanket, and shield you from the world's ills. Upon entering Mr. Grade's small, crowded apartment in the Bronx, there was an instant metamorphosis. I was suddenly a member of the family; my visit had been anticipated, and the dining table was set with the family's best china, linen, and crystal. There were finely shaped, elaborately decorated little cookies and cakes spread out in profusion, the result of hours of preparation by Mrs. Grade. Russian-style tea was served, with thin slices of lemon, decoratively fanned out like a still-life painting. Exotic liqueurs in exquisitely shaped bottles were passed around the table.

We finally adjourned to the poet's study, a tiny room filled with floor-to-ceiling bookcases crammed with books in a number of languages and subjects. Mr. Grade was speaking, and suddenly I saw before me another side of this warm human being—the scholar. He is a philosopher, who looks kindly on life and mankind despite the grievous injustices that man has visited on his fellow man and the planet on which he lives. He has the rare gift of being able to scrutinize man through the eyes of the poet-philosopher.

The idea of doing this portrait as a double exposure was a natural one, since I was attempting to show the two personalities that exist side by side in this remarkable human being.

TECHNICAL DATA

Camera and Lens:	Canon AE-1, with 50 mm Canon macro lens.	**Development:**	Push-processed to ASA 600 in Kodak Versamat, with FR chemicals.
Lighting:	Strobe (one unit) on 20-foot extension cord.	**Print:**	Kodak RC paper, 11″ × 14″; developed in Kodak Ektaflo Developer, Type 1; standard dilution, 13 oz. concentrate to 115 oz. water.
Film and Exposure:	Kodak Tri-X; 1/60 sec. at f/11. Double exposure on same frame of film.		

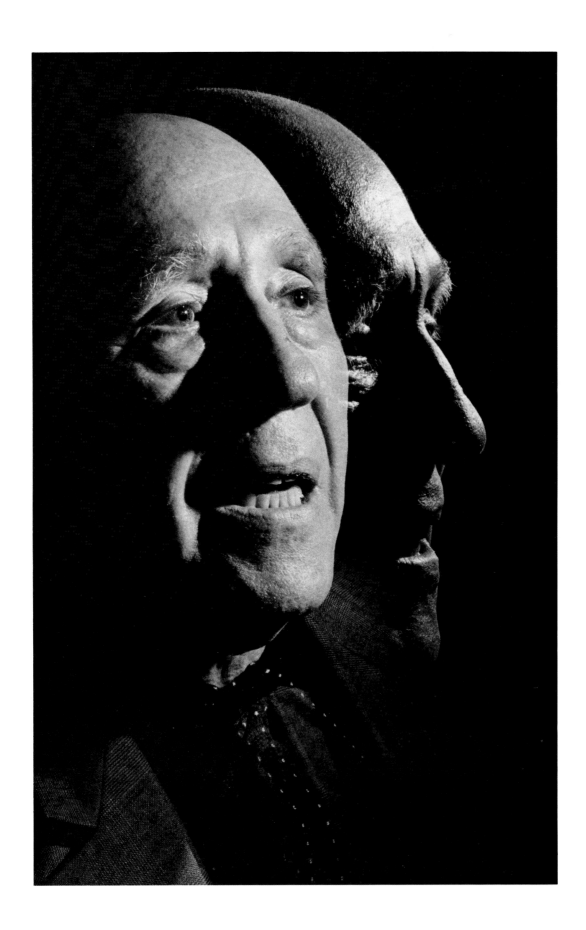

Coney Island Suntan Man

Coney Island has always been a great place for picture taking. I was there one day in the dead of winter. The skeletal structures of the Cyclone roller-coaster ride, the Wonder Wheel, and the ferris wheel loomed darkly against the bright blue sky. The white sandy beach was empty. A few seagulls floated lazily in the sky, swooping down occasionally over the water looking for food. The boardwalk, thronged with people on hot summer days, was now almost deserted. Here and there a few food vendors hawked their wares—brightly colored balloons, plastic toys, and french fried potatoes in grease-spattered paper bags. Most of the amusement rides were shut down for the winter. Several blocks away a lone merry-go-round tinkled mournfully.

I photographed a few water patterns as the waves came rushing up to the beach, swirled around, and rapidly receded. At a distance I saw a man sunning himself on a boardwalk bench. His face was dramatically darkened by the sun; a shock of white hair and silver spectacles shone brightly against his tanned features. I approached and asked permission to take his picture. He was flattered by the request and readily assented.

I deliberately used a dark green filter to heighten the impact of dark skin against white hair. The filter darkened the sky behind the subject, giving excellent separation to the light-colored hair. Slight underexposure and additional development further increased the contrast.

TECHNICAL DATA

Camera and Lens:	Zeiss Contarex, with 50 mm *f*/2 Zeiss Planar lens.	**Development:**	Push-processed, with 25 percent additional development in Kodak Microdol-X.
Lighting:	Bright sunlight, with dark green filter.	**Print:**	Kodak RC paper, 11″ × 14″; developed in Kodak Ektaflo Developer, Type 1; standard dilution, 13 oz. concentrate to 115 oz. water.
Film and Exposure:	Kodak Plus-X; 1/500 sec. at *f*/11.		

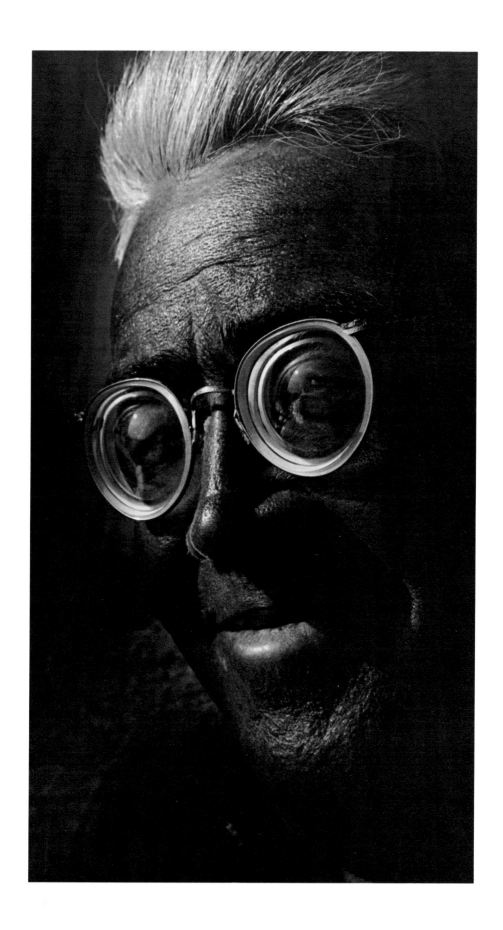

Nelson Rockefeller

Nelson Rockefeller has been in the public eye for so long a time that he is a master of the art of facing a camera. While Governor of New York (the time when this portrait was made), he would hold frequent press conferences at his New York headquarters. The setting was specifically designed for television and still-photography coverage. Broad, powerful spotlights were permanently recessed into the ceiling of the room where the press sessions were held. There were about a dozen lights, some directed on the dais itself, some on the background, and some set up to fill shadows. Almost any kind of lighting effect could be achieved by simply flicking one of the switches set into the wall as you entered the room.

The advantage of this setup for the still photographer was flexibility. Television camera crews prefer rather flat lighting for best color reproduction on the home TV screen. Black-and-white coverage is better with more contrasty lighting; and with the number of lights available, and ease of changeability, elaborate lighting effects could be attained without effort.

But there is another way to increase the contrast of lighting. This portrait was made during a press conference, with the lights set for the TV cameras. Due to time limitations I had to work with the flat lighting that was in use. By simply changing my position—moving 90 degrees to the angle of the lights—a good, contrasty cross-light was attained.

There is a lesson to be learned from this: When faced with a bad lighting situation, a good portrait can often be salvaged by changing camera position to achieve better lighting contrast.

TECHNICAL DATA

Camera and Lens:	Canon F-1, with 85 mm $f/1.8$ Canon lens.	**Development:**	Normal development in Kodak D-76.
Lighting:	Six spotlights.	**Print:**	Kodak RC paper, 11″ × 14″; developed in Kodak Ektaflo Developer, Type 1; standard dilution, 13 oz. concentrate to 115 oz. water.
Film and Exposure:	Kodak Tri-X; 1/250 sec. at $f/2.8$.		

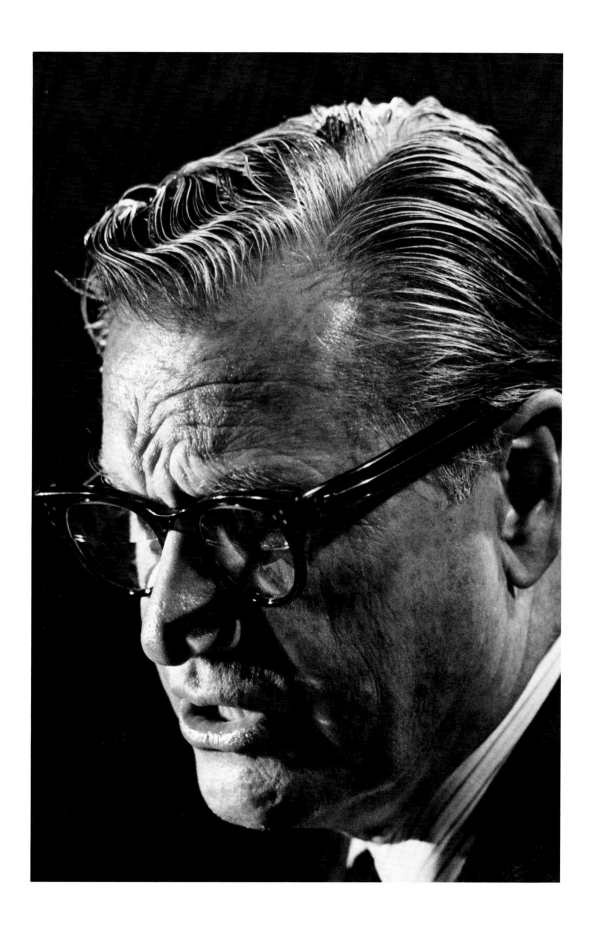

Street Portrait

The street portrait is every bit as exciting as the studio portrait, but there are different sets of factors involved. In the studio the photographer exercises precise control over such external factors as lighting, background, and props.

There are unlimited lighting combinations to be used, as well as different light sources. While it is true that the choice of backgrounds is relatively small, placement and lighting are flexible. Subject, background, lighting, and props can be altered in many ways to suit the photographer. For particularly important subjects, the photographer can determine in a few minutes whether he has achieved what he has set out to do, by developing the film and examining the wet negatives. A second alternative used by many professionals today is to first shoot a Polaroid picture to determine whether the lighting and background are desirable.

The street portrait, on the other hand, presents a series of complex situations. Lighting, background, and subject must be dealt with in split seconds. The photographer has no control over direction of the light, placement of the subject, or type of background. But there are methods of circumventing problem situations. Disturbing backgrounds may be blurred out of focus by selecting a longer lens and using a larger aperture. Harsh sunlight, with its attendant deep shadows, may be tamed with supplementary flash fill or portable reflectors. Proper exposure and development of the film are also very effective in controlling excessively hard lighting or unavoidably flat contrast.

When doing the street portrait, composition must be given careful attention, and a trigger finger must be poised on the shutter-release button, ready to fire as soon as the necessary elements of the portrait merge into harmony—when the lighting, background, subject placement, and expression come into unity. The photographer must be ready for that ephemeral moment; its duration will be fleeting.

TECHNICAL DATA

Camera and Lens:	Canon AE-1, with 80–200 mm Canon zoom lens.	**Development:**	Push-processed to ASA 600 in Kodak D-76.
Lighting:	Daylight.	**Print:**	Kodak RC paper, 11″ × 14″; developed in Kodak Ektaflo Developer, Type 1; standard dilution, 13 oz. concentrate to 115 oz. water.
Film and Exposure:	Kodak Tri-X; 1/500 sec. at *f*/4.		

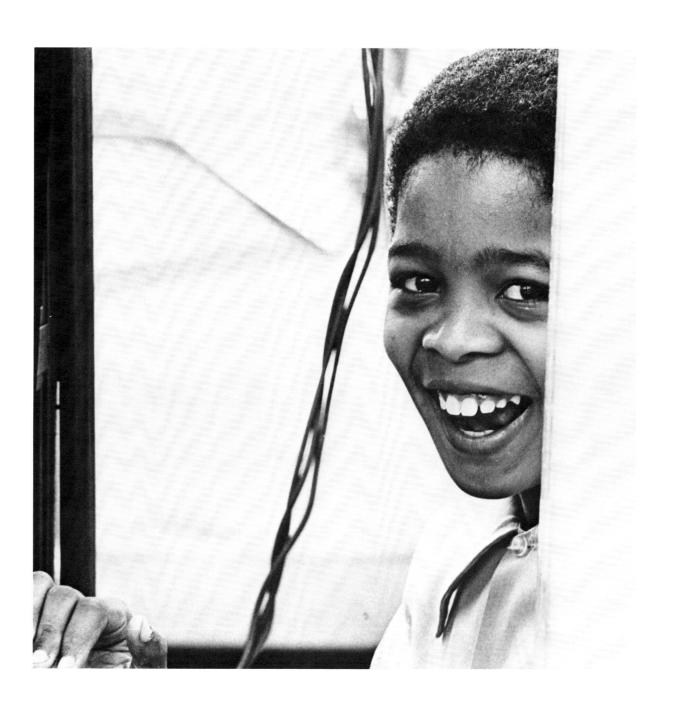

Dave Marash, Newscaster

Many television news commentators are selected by the networks for their acting abilities rather than their reportorial talents. One of the notable exceptions to this system is newsman Dave Marash. A hardworking reporter of considerable talent and attractive screen presence, he manages to sum up an event being covered in deceptively easy fashion. Professionals in the field know the thorough research and reporting abilities that go into capturing the essence of a major story in a few concise paragraphs, and a minute or two of striking news clips.

A large group of reporters, photographers, and TV teams were waiting to interview the controversial head of the New York-New Jersey Port Authority. The wait was long and drawn out, and I decided to fill the time by doing this portrait. It had to reflect the personality of the subject in a simple, straightforward, visual statement. I wanted the lighting to be a little on the theatrical side; and, psychologically, the subject to be unaware that the portrait was being made. Since he was so used to facing cameras, Marash might assume a professional stance that would reduce the feeling of spontaneity in his expression.

This portrait proved to be a long waiting game. The subject had to be in the right position for the picture and the lights of the camera crews. His pose and position had to work well within the compositional frame. It took two hours of waiting, but I finally managed to bring all the elements together.

TECHNICAL DATA

Camera and Lens:	Canon AE-1, with 35–70 mm Canon zoom lens.	**Development:**	Push-processed to ASA 600 in Kodak Versamat, with FR chemicals.
Lighting:	Three quartz floodlights: two at opposite sides of the head; the third filling the shadows.	**Print:**	Kodak RC paper, 11″ × 14″; developed in Kodak Ektaflo Developer, Type 1; standard dilution, 13 oz. concentrate to 115 oz. water.
Film and Exposure:	Kodak Tri-X; 1/125 sec. at f/4.		

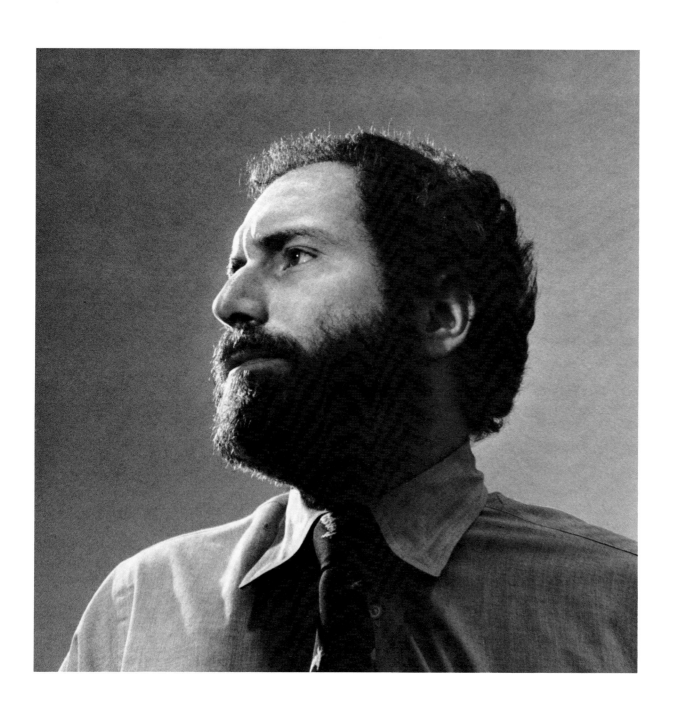

Two Sisters

The art of the double, or multiple, portrait introduces a host of problems. There are many possible variations on this theme: husband and wife, mother and daughter, father and son, uncle and niece, two sisters (as in this example); the list is endless. Composition becomes more difficult than that of the single portrait; lighting problems multiply; and the background has to be watched more carefully. The photographer is dealing with two people of different temperaments and dissimilar personalities at the same time.

The sisters in this portrait are relatively close to one another in age, and similar in personality. They are both photogenic; thus it was easy to photograph them from any angle.

The posing problem was simplified by keeping the background very plain. Many combinations of head positions were tried: one head higher than the other; both heads at the same level; double profiles with the girls looking at each other; double profiles with the girls looking away from each other; and finally, one sister full face to the camera, the other in profile.

An important consideration in the making of this portrait was that both models were rested. We made a game out of the posing, and the girls suggested ideas of their own. We even tried some of their impractical suggestions. This gave both girls a feeling of direct participation in the sitting, and the whole thing became a fun project for them, and much simpler for me.

Elaborate lighting would have introduced elaborate problems. Lighting the heads individually would have meant changing the lighting setup every time the position of the heads was shifted.

A single umbrella strobe setup was used. This resulted in even lighting without harsh shadows, and allowed for effortless reposing.

Most of the portraits that resulted from the sitting were good, but this was the best of the lot.

TECHNICAL DATA

Camera and Lens:	Canon AE-1, with 35–70 mm Canon zoom lens.	**Development:**	Normal development in Kodak D-76.
Lighting:	Single strobe, with umbrella reflector.	**Print:**	Kodak RC paper, 11″ × 14″; developed in Kodak Ektaflo Developer, Type 1; standard dilution, 13 oz. concentrate to 115 oz. water.
Film and Exposure:	Kodak Tri-X; 1/60 sec. at f/16.		

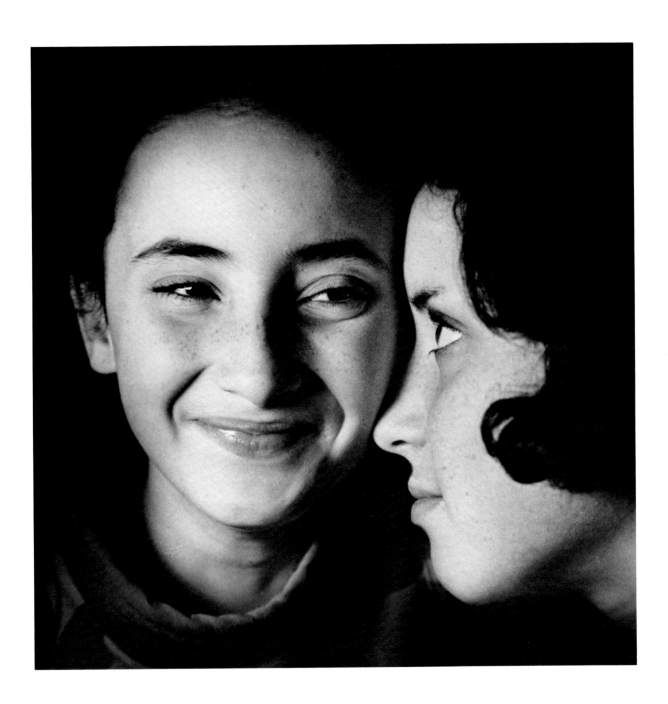

Chimaltenango Indian Father and Son

Photographing people of different lands and dissimilar cultures is one of the most fascinating aspects of portraiture. Perhaps the most difficult challenge in this type of picture situation is the language barrier. Some communication between photographer and subject is usually essential to a successful portrait; and without the aid of language, such communication becomes formidable, but not impossible.

I was on assignment in Guatemala, working on a project that called for many components: the land and its people; the cultural mix of Hispanic, Indian, and American; as well as the representation of ancient and modern Guatemala together in one essay.

One day a government agricultural engineer offered to take me to his native village, where the Chimaltenango Indians have lived for centuries. It was an exciting 4½-hour trip by jeep over some pretty rough terrain; and the car bucked like a bronco going over gullies, through shallow streams, and over steep hills. Immediately upon arrival at the village, I checked my cameras, and my ability to walk, in that order. Fortunately, both were still functioning.

Although they lack most modern conveniences, such as telephones, electricity, and automobiles, the Chimaltenangos somehow live a full, satisfying life. The image of this Indian father and son proved to be the most interesting, and at the same time the most difficult to make of the many pictures taken that day.

The picture was made in the interior of the subjects' home. Some daylight filtered through an opening in the side of the house. The father was quite calm about the sitting; the son, a little frightened. He couldn't quite fathom what was going on. He kept expecting something to happen. English and Spanish were both incomprehensible to the Indian, so I fell back on that age-old, universal form of communication—sign language.

The light was very poor, and I had no tripod. The exposure with an 85 mm $f/1.8$ lens was 1/2 sec. at $f/1.8$. The house was constructed of an adobe-like material; and by slightly pressing the corner of the camera into the side of the house, the material yielded somewhat, and gave the camera solid support, although the position was awkward. There are times when luck is with you. This was one of those days.

TECHNICAL DATA

Camera and Lens:	Canon F-1, with 85 mm $f/1.8$ Canon lens.
Lighting:	Filtered daylight.
Film and Exposure:	Kodak Plus-X; 1/2 sec. at $f/1.8$.
Development:	Push-processed, with 50 percent additional developing in Kodak D-76.
Print:	Kodak RC paper, 11″ × 14″; developed in Kodak Ektaflo Developer, Type 1; standard dilution, 13 oz. concentrate to 115 oz. water.

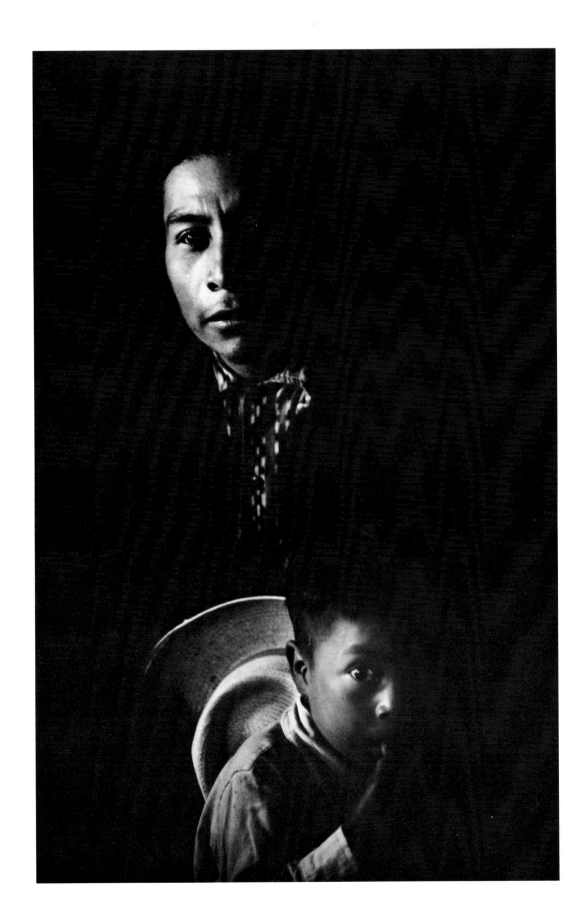

Hal Prince

Think of a Broadway show that you have seen and enjoyed within the past 20 years, and chances are that you will come up with the name of a hit show produced by Harold Prince. *West Side Story, Damn Yankees, New Girl In Town, Fiddler on the Roof,* and *A Little Night Music* are just a few of the plays that have had the "Prince" stamp, which, at the curtain's close, sends the audience off into the night humming the tunes and remembering the complexities of the story line.

Mr. Prince produces and directs with the sure instinct of a talent born to the theater. His temperament, like the actors he deals with, is mercurial; his actions, like those of the public he caters to, are unpredictable; but the end product, whether it be a big brassy musical, or drama built around the framework of a topical theme, usually becomes a crowd-pleaser.

Since producing a show for Broadway is a gamble, it is fitting that Hal Prince should have a large wheel of fortune behind his desk. The wheel is imprinted with some of the successful shows he has produced through the years, and is in keeping with the rest of his office, which is furnished in theatrical fashion.

The setting was excellent for the concept of the portrait. Many people have difficulty facing a camera; not Mr. Prince. As befits a man who has spent years of his life in the limelight, he is quite relaxed, and takes photographic direction as well as any of the top actors he has worked with. Lighting conditions were ideal; bright daylight poured through the window on the subject's right, making it unnecessary to use supplementary lighting.

TECHNICAL DATA

Camera and Lens:	Canon F-1, with 50 mm *f*/1.4 Canon lens.	**Development:**	Push-processed to ASA 600 in Kodak D-76.
Lighting:	Bright daylight from window.	**Print:**	Kodak RC paper, 11" × 14"; developed in Kodak Ektaflo Developer, Type 1; standard dilution, 13 oz. concentrate to 115 oz. water.
Film and Exposure:	Kodak Tri-X; 1/250 sec. at *f*/5.6.		

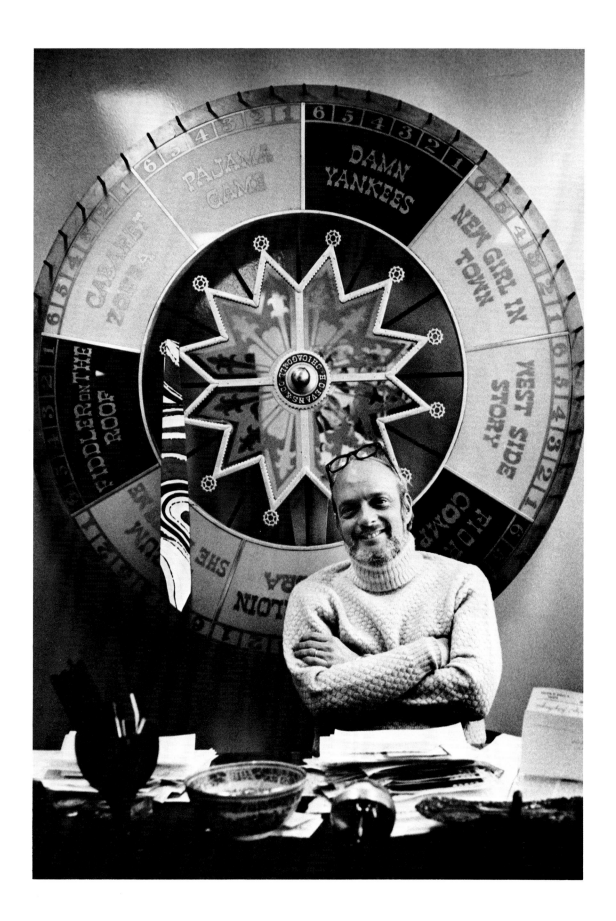

Mrs. Aristotle Onassis

For a woman who loves privacy as much as she does, Jackie has appeared on the front pages of more newspapers and magazines than any other woman making the same claim. As the wife of one of the most popular presidents in American history, her every movement was recorded by the media of every country that possessed a television station or newspaper. Her personal taste in clothing triggered instant fads in fashion for women around the world. Following the assassination of President Kennedy, she withdrew almost completely from the public eye, but there was constant public speculation as to her movements and whereabouts.

When she married Greek shipping magnate Aristotle Onassis, the media was driven to such excesses as chartering helicopters and yachts; and hiring special teams of reporter/photographers that pursued her underwater, on land, and from the sky in their attempts to supply the demands of editors responding to public craving for any kind of coverage about the couple. It was an international hide-and-seek game with Jackie continually striving to hide, and the world press constantly seeking her out. The death of her second husband set off a renewed frenzy of press coverage that has finally begun to slacken.

This portrait was made on one of the rare occasions when Jackie sought press coverage. She belongs to a civic-minded group in New York City that is trying to save Grand Central Station from the wrecker's ball. A press conference was called at a restaurant in the station; and when it was announced that Jackie would be present, the conference became a media event, with as much coverage as would be accorded to a president or a visiting monarch.

A 200 mm lens was selected to isolate Jackie from the members of the committee that surrounded her, and the reporters crowding close with microphones and pads. The profusion of television lights provided more than adequate illumination, and choosing the right pose was merely a matter of waiting, and shooting at the propitious moment.

TECHNICAL DATA

Camera and Lens:	Canon EF, with 200 mm f/4 Canon lens.	**Development:**	Push-processed to ASA 600 in Kodak Versamat, with FR chemicals.
Lighting:	Multiple television quartz lights.	**Print:**	Kodak RC paper, 11″ × 14″; developed in Kodak Ektaflo Developer, Type 1; standard dilution, 13 oz. concentrate to 115 oz. water.
Film and Exposure:	Kodak Tri-X; 1/125 sec. at f/4.		

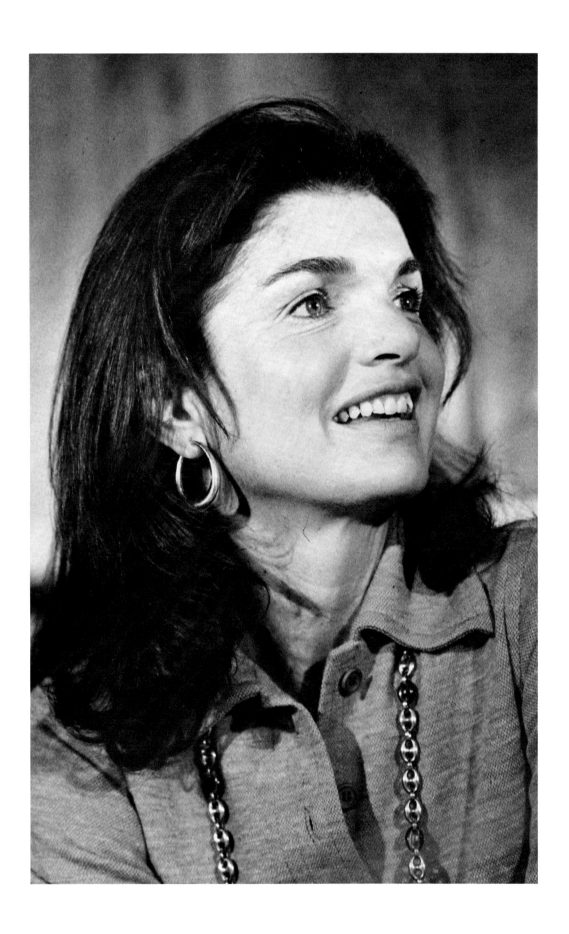

Linda Past

The assignment was a challenging one. Photographs were needed to illustrate an article dealing with the many states of mental depression. The editor suggested hiring a professional model. There is nothing wrong with the use of models for fashion illustration, but the problem in an assignment like this one was credibility. The subject had to appear as though she were one of the case histories being discussed in the piece; and most professional models look like they have just stepped out of the pages of a fashion magazine. There were additional problems—the pictures had to be on the editor's desk the next morning, and very few people were available since it was the Memorial Day weekend.

I decided to try to find an actress rather than a model for this role, feeling that she would be better equipped to handle the as-signment. There is a residence in New York for young actresses who occasionally take modeling jobs between acting roles. The person in charge of the residence had a young woman in mind for the part, and as luck would have it, she was available.

Her name is Linda Past, and she turned out to be perfect for the job. Linda had the intelligence to instantly grasp the subtleties of the part she was to play, and the ability to convey the feeling and put it across. We worked at the illustration for hours, shooting in many different locations in different sections of the city, and finally winding up in a studio location. The picture that seemed to tell the story best was this one. It was made within the confines of a telephone booth on a street corner. A macro lens enabled close-up shooting and cropping.

TECHNICAL DATA

Camera and Lens:	Canon AE-1, with 50 mm Canon macro lens.	**Development:**	Normal development in Kodak D-76.
Lighting:	Bright sunlight.	**Print:**	Kodak RC paper, 11″ × 14″; developed in Kodak Ektaflo Developer, Type 1; standard dilution, 13 oz. concentrate to 115 oz. water.
Film and Exposure:	Kodak Tri-X; 1/500 sec. at $f/16$.		

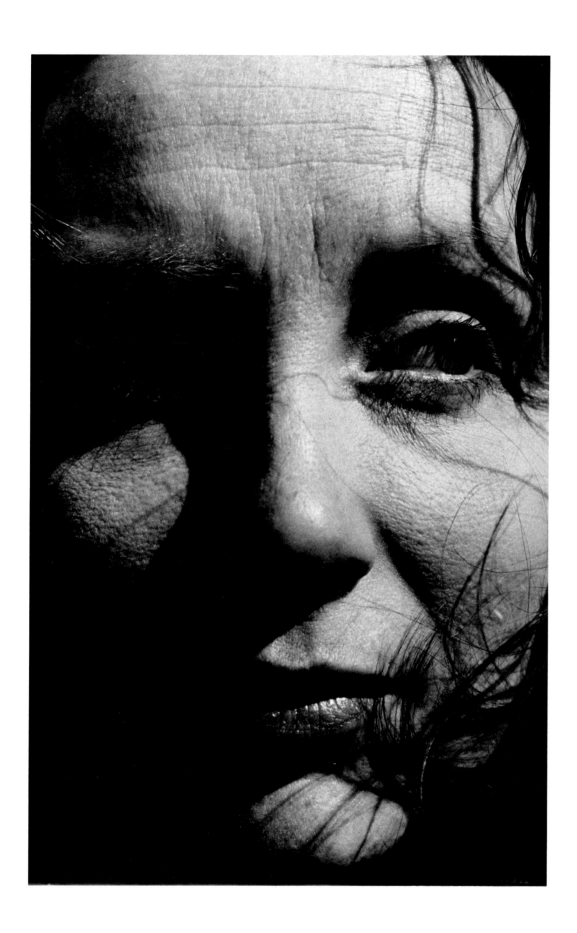

Shelley Duvall

Movie stars have changed considerably since the golden days of Hollywood when the film factories churned out miles of technicolored unreality. Gone are the over-dressed, over-made-up glamour queens and the false-front sets they acted in. Fantasy and reality were so intermixed in that Kafka-like world that neither the actors nor the public could distinguish one from the other.

This brings us right to Shelley Duvall. A working model of the new style "star," she bears as much resemblance to the movie queens of the past as does the Masarati to the Stutz Bearcat. Shelley was discovered at a party in Houston, Texas. Her dress, like her manner, is simple and faintly conservative. She is shy, a little diffident, and very serious about her career. When she is speaking to you, her entire attention, and indeed all of her senses seem to focus intensely on your person.

The setting for the portrait was a popular East Side cafe, Elaine's. It was one of those afternoon public relations bashes where members of the cast of the movie *California Split* were gathered to meet the press for interviews and pictures. Visually, the cafe was in almost total darkness. Every now and then a strobe light winked brightly in some corner of the room, or 3000 watts of television lights shone for a few seconds so that a camera crew could record a few feet of film for the nightly newscast. There were nearly 300 people jammed into a room designed to hold less than half that number comfortably. Space was at such a premium that I had to borrow two seats from a couple so that the picture could be made.

The only positive element about the situation was the background. It was a scenic wallpaper that looked like a backdrop for a movie being shot in southern Italy. A single strobe unit was used, covered with two thicknesses of handkerchief. There were two reasons for this technique. I was seated only 2 feet from the subject and the light would have been too bright for the distance; and a larger aperture enabled me to blur the background a little so the eye would concentrate on the subject.

TECHNICAL DATA

Camera and Lens:	Canon AE-1, with 35–70 mm Canon zoom lens.	**Development:**	Push-processed to ASA 600 in Kodak Versamat, with FR chemicals.
Lighting:	One small strobe unit covered with two thicknesses of white handkerchief.	**Print:**	Kodak RC paper, 11″ × 14″; developed in Kodak Ektaflo Developer, Type 1; standard dilution, 13 oz. concentrate to 115 oz. water.
Film and Exposure:	Kodak Tri-X; 1/60 sec. at f/5.6.		

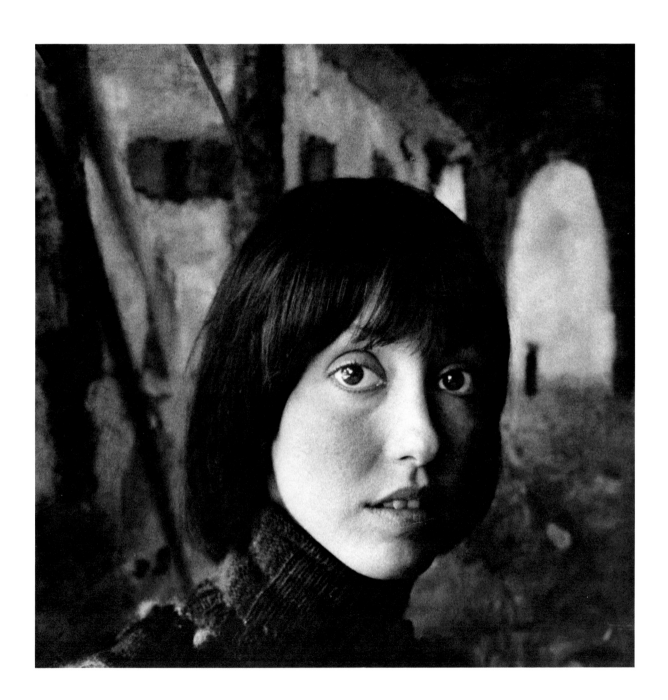

Federico Fellini

Fellini's name always conjures up images of strange-looking acrobats gyrating dizzily across the screen, followed by a parade of bizarre beings—clowns, dwarfs, freaks—walking off the screen and into the reality of our minds. Fellini is a kind of magician who manages to transpose ephemeral make-believe into chilling reality. His stage is set in the theater of the mind, and he has few equals in the milieu where fantasy and reality overlap, and the two become one.

The thought of another hotel room as a setting bothered me a little; but all that changed when I was ushered into a room that looked like a set for a Fellini film. The room was crowded with people of all shapes and sizes. They were not clowns or acrobats, but jugglers—jugglers of words. There were French words, Italian words, and English words. They leaped from person to person, hung in midair, and tumbled from mouth to mouth.

As I started setting up lights and clamping strobes to door frames, book shelves, and the backs of chairs, Fellini's eyes darted from one light to another, checking their placement, evaluating their potential effect, and at the same time losing not a word of conversation with his friends.

Although the lighting was mine, the pose, in a sense, was his. I kept shooting as he continued talking, and when his hands assumed this pose, I shot frame after frame to capture what I hoped would be the quintessential Fellini. Each element of this portrait is there by design. The light, shadow, and substance are waiting to be molded into some kind of Felliniesque reality.

TECHNICAL DATA

Camera and Lens:	Canon AE-1, with 85 mm f/1.8 Canon lens.
Lighting:	Three strobe lights off camera: two cross-lighting the subject; and one on the background.
Film and Exposure:	Kodak Tri-X; 1/60 sec. at f/8.
Development:	Normal development in Kodak D-76.
Print:	Kodak RC paper, 11″ × 14″; developed in Kodak Ektaflo Developer, Type 1; standard dilution, 13 oz. concentrate to 115 oz. water.

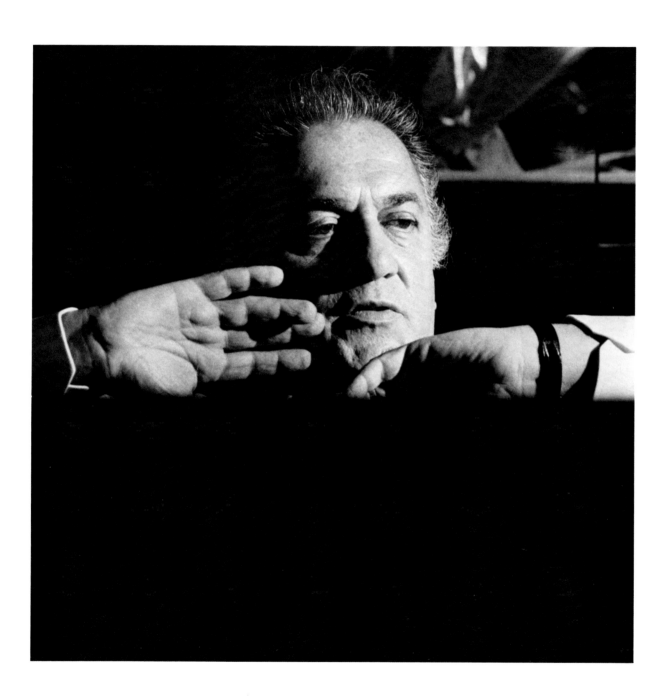

Two from La Perla

There are two Puerto Ricos. The first, and best known is the chain of luxury hotels that winds around the island like a diamond necklace, glittering with be-jeweled tourists who crowd the gaming tables at night, and sun themselves on hundred-dollar-a-day stretches of beach during the day. They spend more money in a week than many islanders make in a year.

Just down the road from the din-filled discos and palaces of haute cuisine live the native Puerto Ricans. The skies there are also filled with twinkling stars, and they have the same white sandy beaches, but that is where the similarity comes to a screeching, agonizing halt.

La Perla (a beautiful name; translated from the Spanish, it means "the Pearl") is one of those horrendous slums that have no right to exist anywhere. But they do exist everywhere. Ramshackle, tumbledown huts are propped up on stilts over the water. Inside, there are none of the amenities of life we take for granted. There is no running water, no electricity, no protection from disease-carrying creatures and vermin; and worst of all, not enough food to sustain life in a decent, humane fashion.

This portrait was taken from an essay on the "other" Puerto Rico. The two youngsters in this portrait show that the human spirit, in its mysterious way, can and does smile in the face of adversity; and that humanity, whether in the person of young or old, deserves more than an inhuman, marginal subsistence.

The setting was outdoors in the brilliant, tropical summer sun.

TECHNICAL DATA

Camera and Lens:	Leica, with 90 mm $f/2.8$ Elmarit lens.	**Development:**	Twenty percent less development in Kodak D-76 to soften the harshness of the light.
Lighting:	Direct summer sun.	**Print:**	Kodak RC paper, 11" × 14"; developed in Kodak Ektaflo Developer, Type 1; standard dilution, 13 oz. concentrate to 115 oz. water.
Film and Exposure:	Kodak Plus-X; 1/500 sec. at $f/8$.		

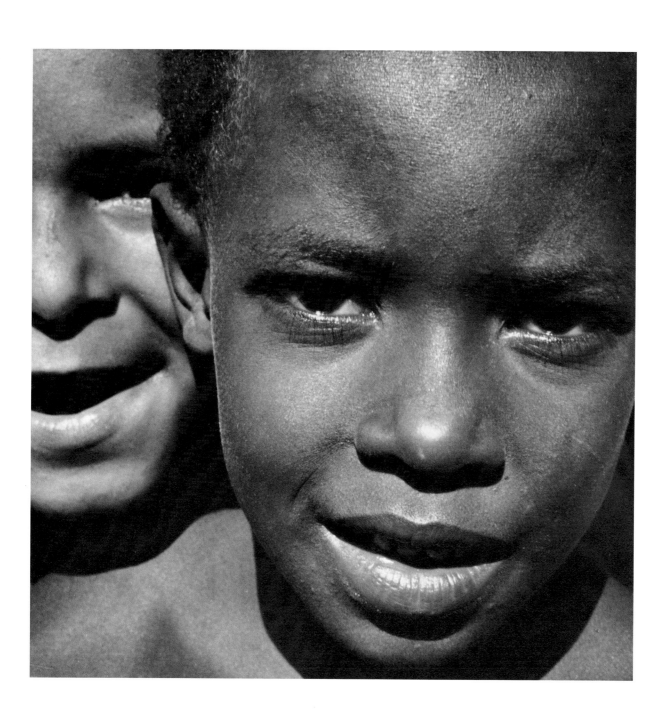

Margaret Mead

It is something of a paradox to find a giant housed in a diminutive frame, but Margaret Mead (at five feet) towers over most of her peers. She achieved instant fame at the beginning of her career in 1928, upon publication of her book *Coming of Age In Samoa*. Since that time she has had a long list of books that have been popular with the general public as well as the scientific community.

Her thesis that the sophisticated, highly civilized American family community could learn a great deal about raising their children from the supposedly primitive Samoan culture raised eyebrows among fellow anthropologists as well as the public at large, but in time became accepted scientific fact. That the diverse cultures of the world better understand themselves and one another is one of her great contributions to world harmony. Mead believes that mankind is a single family unit, whose members—although they live in diverse geographic locations, and speak many different languages—are of the same family.

This portrait was made on the occasion of her 75th birthday. The dramatic background for the picture is the Hall of the Peoples of the Pacific, at the Metropolitan Museum of Natural History. The model behind her, a primitive religious figure from the Pacific Island group, was a perfect symbolic background for the picture. The level of light in the museum was low, but a flash would have introduced a feeling of artificiality to the setting. I opted instead for a semi-time exposure (1/8 sec. at f/2.8), hand-holding the camera, and push-processing the film to ASA 800.

TECHNICAL DATA

Camera and Lens:	Canon AE-1, with 35–70 mm Canon zoom lens.	**Development:**	Push-processed to ASA 800 in Kodak Versamat, with FR chemicals.
Lighting:	Fluorescent, mixed with weak daylight.	**Printing:**	Kodak RC paper, 11″ × 14″; developed in Kodak Ektaflo Developer, Type 1; standard dilution, 13 oz. concentrate to 115 oz. water.
Film and Exposure:	Kodak Tri-X; 1/8 sec. at f/2.8.		

Croix Rouge

The occasion for this portrait was the return of a group of Croix Rouge (Red Cross) volunteers from France. It was Memorial Day, and the group came over from Europe to thank the American people for their contribution to France during two world wars. The members of the group joined the traditional Memorial Day parade down Fifth Avenue, but continued on down the Avenue until they arrived at a small park in lower Manhattan where there is a memorial to the fallen soldiers of both countries.

The ceremonies were simple. Taps were sounded by a lone bugle; there was a multi-gun salute fired into the air; and finally, a wreath was layed at the base of the monument. There were many fine faces in the group, but the face of this proud woman, her tunic ablaze with ribbons given her by this country and her own for her meritorious acts during wartime to both nations, seemed to epitomize the entire day. The stirring martial music made her hold her head a little higher; as she thrust back her shoulders, her eyes misted with tears, and her face softened with memories.

The photographic problems that confronted me were space and time. Police barriers, officials, and people stood between me and the subject. If I had waited for the end of the ceremony, the magic moment would have passed, and I might have lost my subject in the breaking crowds. Fortunately, I had a 300 mm telephoto lens in my case. This long-focal-length lens enabled me to reach across the distance to capture the moment and the image. The 300 mm is normally not a portrait lens, but on that occasion it saved the day.

TECHNICAL DATA

Camera and Lens:	Canon AE-1, with 300 mm Canon lens.	**Development:**	Push-processed to ASA 800 in Kodak Versamat, with FR chemicals.
Lighting:	Daylight; cloudy, bright.	**Printing:**	Kodak RC paper, 11" × 14"; developed in Kodak Ektaflo Developer, Type 1; standard dilution, 13 oz. concentrate to 115 oz. water.
Film and Exposure:	Kodak Tri-X; 1/250 sec. at f/5.6.		

Brassai

Brassai is one of the universally acknowledged contemporary masters of photography. His pictures are of the night world of Paris in the 1930s. Peopled by prostitutes and pimps, homosexuals, gangsters, and show people, it is a world that has disappeared, except for the nostalgic, evocative images that Brassai has preserved for us. His photographs are the only remaining artifacts of an era that many speak of with sentimentality, but few have ever seen.

Brassai was scheduled to come to New York for the opening of a show of his photographs at the Marlboro Gallery, and for the publication of his book, *Brassai's Secret Paris of the Thirties*. I called him at his hotel, and when he learned that I could speak French, he opened up, and was delighted to make arrangements for the portrait.

My concept was to photograph him outdoors at night, working with a camera as he normally does. He responded warmly to my suggestion that we do the picture in the Times Square area. While Times Square is hardly Montmartre, it is an area he was interested in seeing at night, and we made arrangements to meet the following evening.

It turned out to be windy, and it was pouring rain. I was more than a little worried that the session would be called on account of the weather. Brassai was not at all deterred by the rain, and we set out in a taxi for Broadway. Working with flash would have resulted in a completely black background, since the theater lights would not register. An alternative was to move him close to the marquee of a movie house that was ablaze with light. There was enough light for the portrait, and he was delighted with it.

TECHNICAL DATA

Camera and Lens:	Canon AE-1, with 24 mm f/2.8 Canon lens.	**Development:**	Push-processed to ASA 800 in Kodak D-76.
Lighting:	Outdoors at night near theater marquee.	**Printing:**	Kodak RC paper, 11″ × 14″; developed in Kodak Ektaflo Developer, Type 1; standard dilution, 13 oz. concentrate to 115 oz. water.
Film and Exposure:	Kodak Tri-X; 1/8 sec. at f/2.8.		

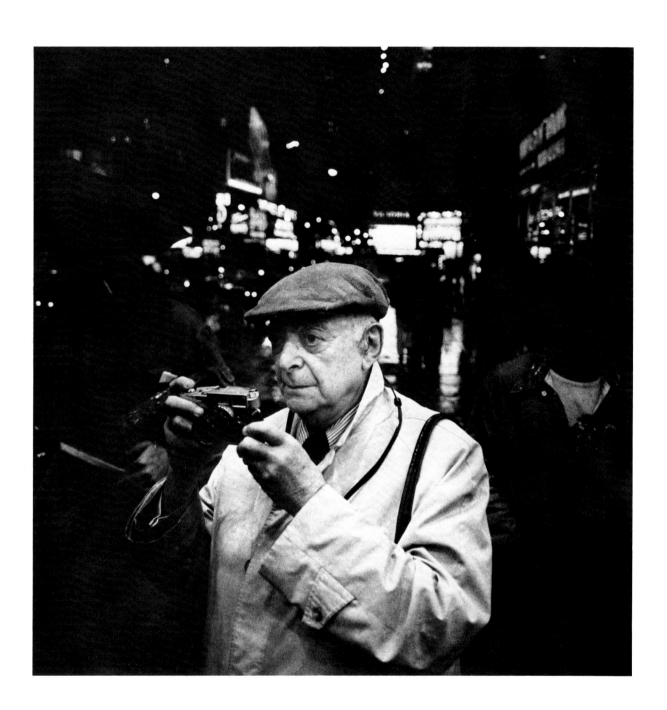

Margaux Hemingway

Several years ago an explosive force made an impact on the "beautiful people" scene in New York. With a degree of intensity that would have registered at the top of the Richter scale, Margaux Hemingway established herself almost instantaneously as the brightest star in the night skies of New York, and the most charming beauty among the many that bloom here. Any hostess who could snare her for a party had, at once, the most talked about party in the city.

Margaux does things with great flare, and makes headlines at the drop of a hat. A perfect example of this is the party where she is pictured. She was coming from Washington, and her plane arrived late at the airport. Because she had promised that she would be present at this party, she chartered a helicopter at the airport, and had it land in Central Park, close enough to the street she was going so that she could make it on foot from the park.

At the party, everyone thought that she was not going to make an appearance; and many were downing their last drinks, and donning their coats, when suddenly Margaux came bursting through the door. In 3 minutes she must have kissed 30 cheeks. Like live fuel thrown on a flagging fire, the party suddenly came alive again. Coats were put away, new bottles of spirits were brought to the bar, and drinks were replenished.

The lens on my camera was a 24 mm wide-angle, which is not ideal for portraits, but Margaux's initial spontaneity and freshness came through in the initial photographs made with this lens.

TECHNICAL DATA

Camera and Lens:	Canon F-1, with 24 mm f/2.8 Canon lens.	**Development:**	Push-processed to ASA 1200 in Kodak Versamat, with FR chemicals.
Lighting:	Available light.	**Print:**	Kodak RC paper, 11″ × 14″; developed in Kodak Ektaflo Developer, Type 1; standard dilution, 13 oz. concentrate to 115 oz. water.
Film and Exposure:	Kodak Tri-X; 1/30 sec. at f/2.8.		

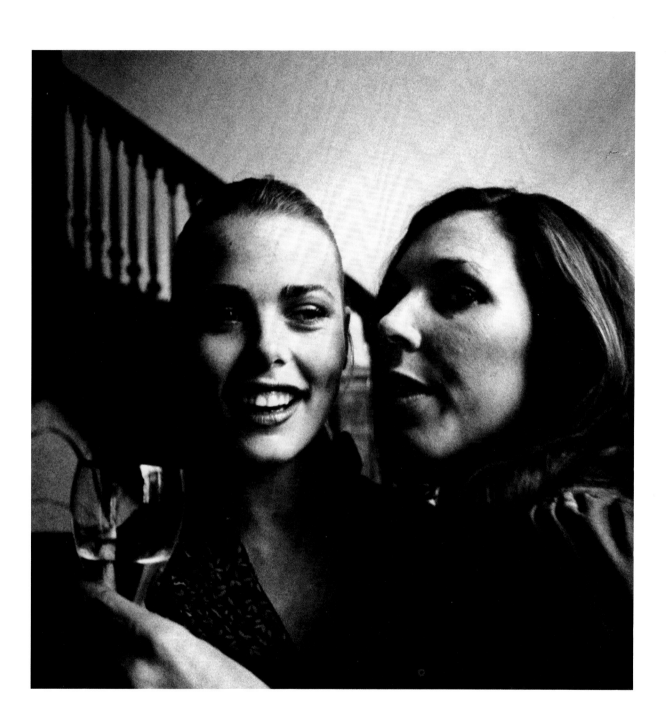

Olivia Newton-John

How can you miss in a situation like this? Start with one of the loveliest, freshest faces in show business, add a handsome, doleful-looking puppy, and the result is a public relations portrait that would charm the ears off the harshest critic. The setting was anything but ideal—a dark, crowded bank lobby. Dozens of people were milling around—bank officials, the general public, half a dozen P. R. reps, and an assortment of photographers and reporters.

The Society for the Prevention of Cruelty to Animals was running a double-barreled media event; they were trying to get passersby to adopt some of the animals that had been brought into the bank, and placed strategically near the front windows so that they could be seen from outside. To further attract attention, several show people, Olivia Newton-John among them, had been asked to lend their presence to the event. There was, in addition, a soft sell attempt to raise funds for the organization.

Outside, it was dark; rain and clouds obscured what little daylight there was. Inside, lunchtime crowds were trying to get closer to the animals and the show people. The pushing, shoving, and elbowing resembled a subway rush hour at its worst.

Somehow I had to separate Olivia and the puppy from the crowds. The answer to the problem was light. I turned Olivia toward the bank window, so that the available light would illuminate her and the puppy, and melt the crowds in the background into darkness. As soon as I asked her to smile, those incandescent eyes of hers lit up, and her face broke into a broad grin that seemed to trigger the motor drive of the camera. A dozen good images resulted.

TECHNICAL DATA

Camera and Lens:	Canon AE-1, with 35–70 mm Canon zoom lens.	**Development:**	Push-processed to ASA 1200 in Kodak Versamat, with FR chemicals.
Lighting:	Very dim daylight.	**Print:**	Kodak RC paper, 11″ × 14″; developed in Kodak Ektaflo Developer, Type 1; standard dilution, 13 oz. concentrate to 115 oz. water.
Film and Exposure:	Kodak Tri-X; 1/15 sec. at f/3.5.		

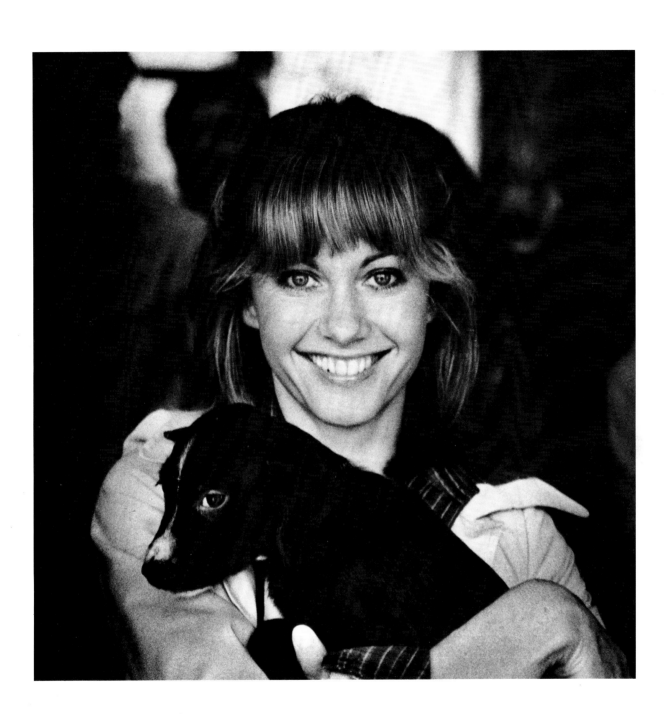

Mexican Mother and Baby

It is always exciting to photograph in foreign countries. Different cultures and customs hold a fascination for the traveler with a camera that enhances his enjoyment of the trip because he can relive it through the photographs he makes. Put a camera into the hands of any traveler and he becomes imbued with a sense of adventure as he embarks on a voyage of discovery. The camera becomes a magnifying glass that enables the photographer to see, close-up and in greater detail, the facets of a country that make it different from his own.

Mexico is a marvelous country for picture taking. The sky is perpetually blue, the weather is a combination of spring and summer, and the sun shines most of the time.

When traveling, most people have a tendency to stick to the standard sights of the country—the well-known landmarks, monuments, and churches. The traveler with a camera will do better wandering off the beaten path in search of situations that yield more interesting photographs than the picture postcard views on display at every newsstand.

This portrait of a Mexican mother and her baby waiting at a bus stop in Mexico City was the result of just that kind of rambling around. The area was in the worker's quarters on a narrow side street. The child was dressed in a beautiful outfit.

The unyielding expression on the face of the mother was probably caused by my sudden appearance in front of her, waving a camera and a long lens, which she may have taken as a threat to her baby. She reacted as any mother would, and shielded her child. After I had taken my pictures, I explained to her that I was an *extranjero* (foreigner), which was probably obvious to her; and all fences were mended when I took her name and address, and promised to send her a photograph.

This is the kind of photograph never found on the well-traveled streets of any city. Street shooting of this kind also requires hair-trigger responses to situations—focus has to be quick and accurate. Semi-automatic and automatic cameras that set diaphragm openings or shutter speeds are of great help.

TECHNICAL DATA

Camera and Lens:	Canon EF, with 200 mm *f*/2.8 Canon lens.	**Development:**	Push-processed to ASA 600 in Kodak D-76.
Lighting:	Daylight; open shade.	**Print:**	Kodak RC paper, 11″ × 14″; developed in Kodak Ektaflo Developer, Type 1; standard dilution, 13 oz. concentrate to 115 oz. water.
Film and Exposure:	Kodak Plus-X; 1/500 sec. at *f*/5.6.		

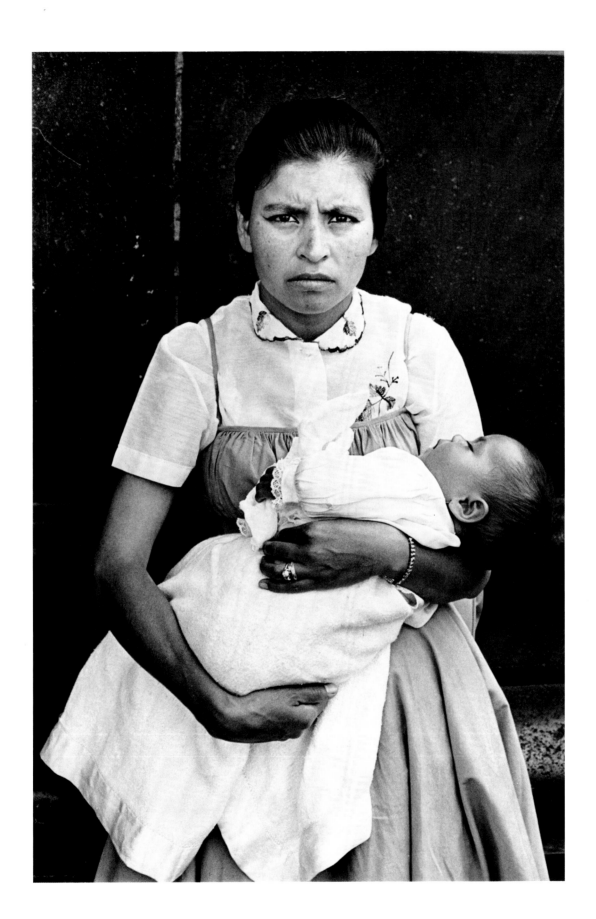

LSD Trip

The hippie culture blossomed in the 1960s. Marijuana, LSD, amphetamines of all kinds, and uppers and downers were very much in vogue in certain areas of New York and San Francisco. I covered a great many assignments during that time, and at the outset decided against conventional treatment of an unconventional subject. This led to many fascinating experiments: kaleidoscopes were constructed for their ability to fragment images; and inexpensive, uncorrected magnifying glasses were used as camera lenses in place of highly corrected, expensive lenses.

These magnifiers, mounted in cardboard tubes, produced some very interesting photographs, particularly when backlighting was the source of illumination. Another method was shattering a UV filter; the remaining glass fragments were smeared with vaseline, dusted with talcum powder, and sprayed with oil to achieve images that looked like they might be seen through the eyes of a person "high" on a mind-altering drug. Using fiberglass dotted with sequins, or poking a lens part way through wads of white cotton resulted in similar, surrealistic images. Many of these pictures were, in the popular vernacular of the day, "mind blowing."

This "LSD" portrait was part of a photographic essay showing the life-style of a large group of hippies sharing a communal pad in the East Village. From a description given to me by one of the group, I was trying to show what happens to the vision of a person under the influence of LSD. A prism was held in front of the lens, and the fragmentation effect was achieved by rotating the prism until the desired image appeared.

For this kind of experimental photography, a single-lens reflex camera is an absolute necessity. Only by experimenting with ground glass can this effect be controlled. Another point to remember is to use these effects sparingly. To use them indiscriminately is to vitiate them, and destroy their value as special effects.

TECHNICAL DATA

Camera and Lens:	Canon F-1, with 35 mm $f/2$ Canon lens.	**Development:**	Push-processed to ASA 600 in Kodak D-76.
Lighting:	Bright sunlight.	**Print:**	Kodak RC paper, 11″ × 14″; developed in Kodak Ektaflo Developer, Type 1; standard dilution, 13 oz. concentrate to 115 oz. water.
Film and Exposure:	Kodak Tri-X; 1/500 sec. at $f/16$.		

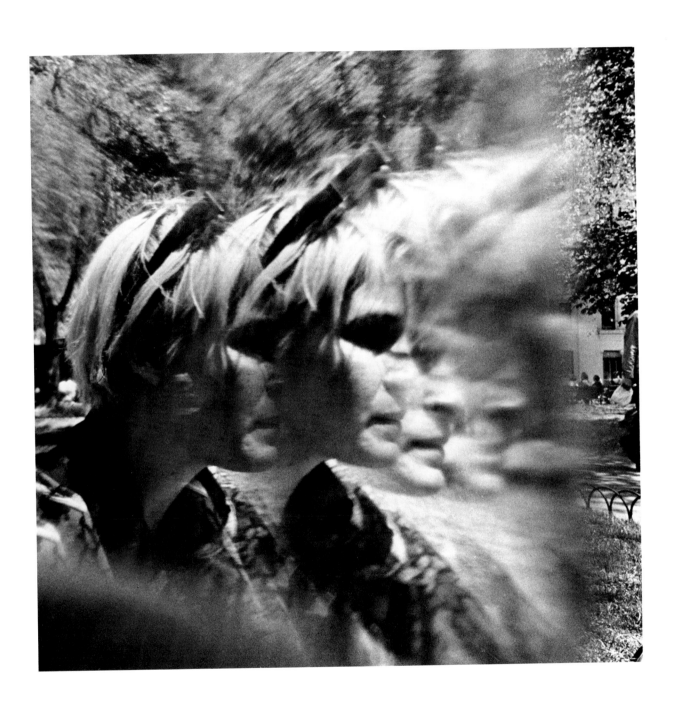

Judge Rothwax

How do you photograph a judge? Most of the portraits I have seen show judges dressed in their traditional black robes, seated in high-backed chairs, and staring somberly into the camera lens. There is nothing wrong with this concept, but I wanted to do it differently.

When I arrived at the judge's chambers, he was standing behind his desk making himself a cup of instant coffee. I thought this would make a nice humanistic picture, and with the judge's permission, I photographed him that way. Even as I worked, I knew this was not the portrait I was seeking.

My next attempt was the previously mentioned "typical" picture of the judge. This wasn't it either. I tried various pictures of the judge reading the morning newspaper; looking at some large, impressive law books; chatting informally with a visitor; and working with his secretary. But the little critic we all carry around inside ourselves kept nudging me and saying, "No, that's not it."

After exhausting all possibilities inside his office, I asked the judge if I could photograph him seated on the bench in court. The law states that picture taking inside a courtroom during a trial is not permissible, but it doesn't say anything about photographing in an empty courtroom. The judge finally agreed, and as luck would have it, the magnificent mural behind the bench served as a backdrop. Although the courtroom was empty, I had Judge Rothwax go through some of the motions of conducting a trial as I photographed him.

TECHNICAL DATA

Camera and Lens:	Canon AE-1, with 35–70 mm Canon zoom lens.	**Development:**	Push-processed to ASA 800 in Kodak Versamat, with FR chemicals.
Lighting:	Tungsten (available).	**Print:**	Kodak RC paper, 11″ × 14″; developed in Kodak Ektaflo Developer, Type 1; standard dilution, 13 oz. concentrate to 115 oz. water.
Film and Exposure:	Kodak Tri-X; 1/15 sec. at f/3.5.		

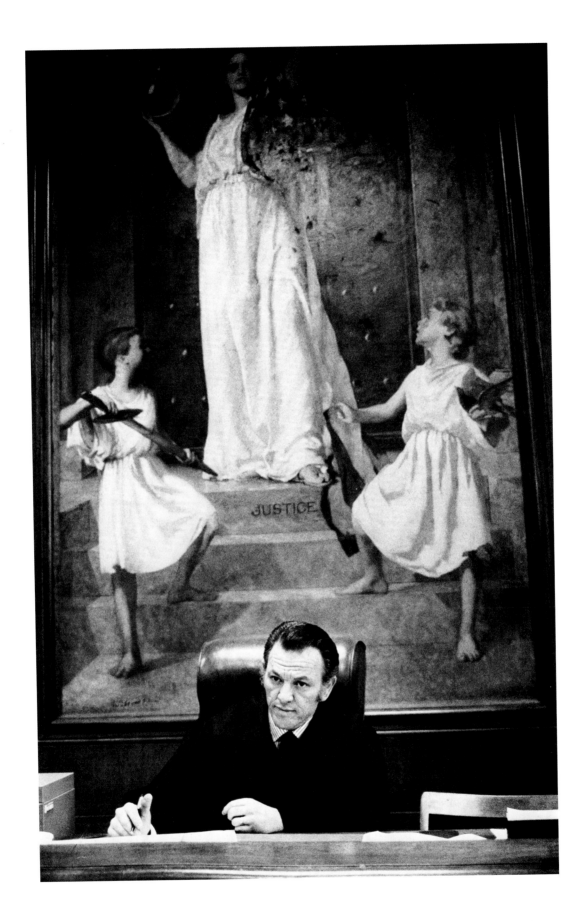

Chinese Tourist

This was one of the big events at Lincoln Center, and it wasn't even listed on any of their programs. A large group of Chinese tourists from the People's Republic of China was touring New York. The high point of their tour was a visit to Lincoln Center. The Center, a handsome architectural complex, sits astride the bright lights and crowded theater district below, and the melting pot of the Upper West Side above.

The Chinese tourists arrived in several buses in front of the Metropolitan Opera House, and spilled out, rapidly covering the area between the New York State Theater, the Met, and Avery Fisher Hall. There were young and old, tall and small, children and adults alike; heads swiveled to look at the different sights as their tour leaders urged them inside. Most of the men wore "Mao" style gray jackets; the women and children were dressed in neat blue quilted tunics.

Carrying a camera fitted with a short zoom lens around my neck, I joined one of the groups and followed them around. Most of the people did not seem to mind having their picture taken. The women and children were a little more shy than the men, but all stood their ground, peered curiously at the camera for awhile, and then continued on their way.

Although there were many interesting faces around me, the portrait I was seeking still eluded me. Suddenly, across the great hall from where I was standing, I spotted a young man with a camera to his eye, photographing through the window. The sun poured through the great glass walls, lighting his face perfectly.

TECHNICAL DATA

Camera and Lens:	Canon F-1, with 35–70 mm Canon zoom lens.	**Development:**	Push-processed to ASA 600 in Kodak Versamat, with FR chemicals.
Lighting:	Bright sunlight.	**Print:**	Kodak RC paper, 11″ × 14″; developed in Kodak Ektaflo Developer, Type 1; standard dilution, 13 oz. concentrate to 115 oz. water.
Film and Exposure:	Kodak Tri-X; 1/250 sec. at f/11.		

Luis Bunuel

The eternal problems of the location photographer are poor lighting and distracting backgrounds; and both usually come together in the standardized hotel room. Mr. Bunuel's room was no exception. The sole illumination in the room was from two small table lamps on either side of a long sofa. The walls of the room were bare; the furnishings, nondescript.

In such dismal surroundings, how could I suggest in a photograph something of the worldwide fame that Mr. Bunuel has achieved for his great films? How, with these meager props, could I convey something of the modesty and personal warmth of the man?

I was traveling light. My previous assignment had been a riotous demonstration; and in order to achieve the necessary mobility, I carried a small case with one camera, two lenses, and a few rolls of Tri-X film. Simple equipment is sometimes a virtue. More time can be devoted to thinking and photographing.

Bunuel instantly recognized my problem; he gazed around the bare walls as I did, and spoke knowingly of the problems of time restraints and the need for improvisation on the part of the photographer. Time was running out. Mr. Bunuel had many more appointments to meet, and was leaving the country the next morning. The portrait had to be made within the next 15 minutes, or not at all.

There was a small window in the corner of the room through which some daylight filtered. We moved an armchair over to the window, but my first attempt with the chair facing the window didn't look right. For one thing, the lighting was too flat. Finally, I turned the chair at a 45-degree angle to the window for this shot.

TECHNICAL DATA

Camera and Lens:	Canon AE-1, with 35–70 mm Canon zoom lens.	**Development:**	Push-processed to ASA 1000 in Kodak Versamat, with FR chemicals.
Lighting:	Tungsten and daylight.	**Print:**	Kodak RC paper, 11″ × 14″; developed in Kodak Ektaflo Developer, Type 1; standard dilution, 13 oz. concentrate to 115 oz. water.
Film and Exposure:	Kodak Tri-X; 1/15 sec. at f/2.8.		

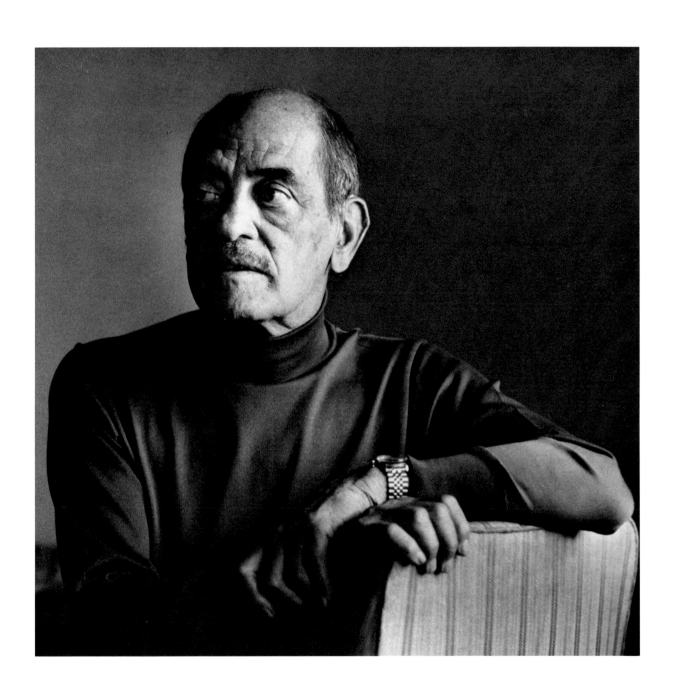

Alfred Hitchcock

In 1935, a suspense film, *The 39 Steps,* pushed Alfred Hitchcock to the top of the directorial ladder, and he has remained there ever since. He has continued to turn out superior films at the rate of one a year, each different from the previous one, but all carrying the unmistakable Hitchcock touch. His monogram on a film is like the hallmark on a piece of fine sterling—a guarantee that the product is of superior quality.

Our appointment was scheduled for 4 P. M. in a hotel room. The room, better than most New York hotels, was European in style. A profusion of deep-pile velvet pillows sat on beautifully carved mahogany frames, which rested against ivory-colored walls. Mr. Hitchcock looked as though he had just stepped out of one of his own films. His immaculate attire, and soft, deeply pitched voice emphasized the courtly, old-world charm that he possesses.

The noted director takes direction beautifully. Fully aware of what I was trying to do, his movements often preceded my requests. Because of time limitations, lighting and equipment were simplified. The camera was fitted with a medium telephoto lens, and a single, small strobe unit with a long extension cord and a small clamp. The subject was seated on a chair turned backwards so that he could rest his arms on the back support. The strobe light was clamped to the door of the hotel room (which was opened slightly to allow for the clamp), at a distance of 12 feet from the camera.

The continuous action of the motor drive enabled me to accomplish a series of 72 portraits in 15 minutes.

TECHNICAL DATA

Camera and Lens:	Canon AE-1, with 85 mm *f*/1.8 Canon lens.	**Development:**	Push-processed to ASA 600 in Kodak Versamat, with FR chemicals.
Lighting:	Small strobe light on 24-foot extension cord.	**Print:**	Kodak RC paper, 11″ × 14″; developed in Kodak Ektaflo Developer, Type 1; standard dilution, 13 oz. concentrate to 115 oz. water.
Film and Exposure:	Kodak Tri-X; 1/60 sec. at *f*/5.6.		

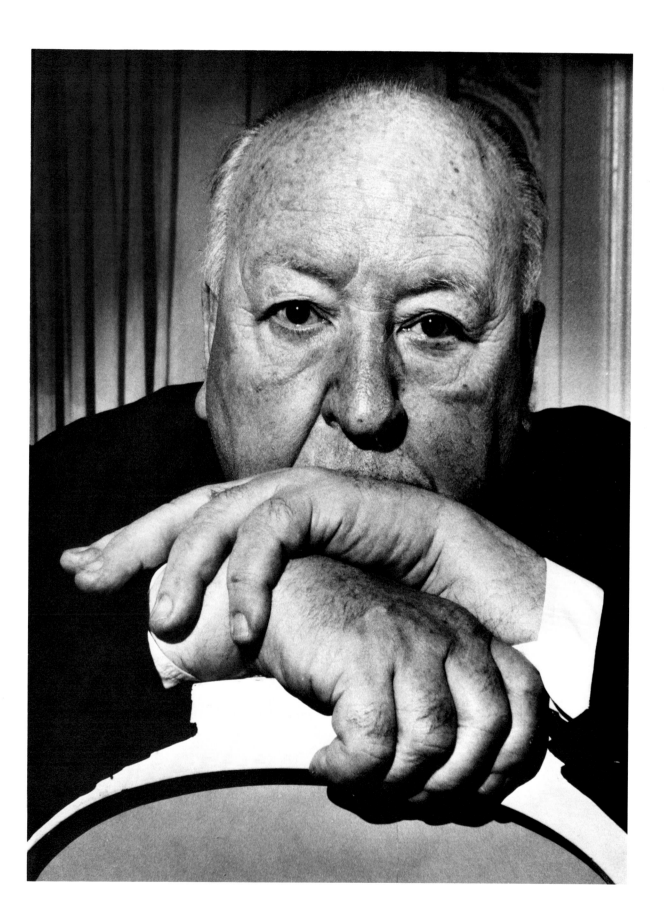

Prince Saud Al-Faisal

The "Thousand and One Nights" tales are filled with stories of powerful and wealthy sultans, whose jeweled coffers are filled with diamonds, rubies, and emeralds, and whose every wish is fulfilled by genies and slaves. This is the tale of a royal prince, Prince Saud Al-Faisal of Saudi Arabia, who—"High though his titles, proud his name, boundless his wealth as wish can claim"—couldn't get the apartment he wanted in New York.

The object of his desire was a cozy cooperative on Park Avenue with 18 rooms, valued at a mere half million dollars (about 50,000 barrels of oil, or six days production of the Saudi Arabian output). Cooperative apartments sometimes require the approval of the other owners of the building, and since royal tenants are as scarce as flying carpets, they are usually accepted without difficulty. Surprisingly, the tenants voted down the Prince's application, fearing that his presence would cause disturbances in the form of picket lines, police barriers, and possible bomb scares.

The portrait was made in the usual hotel room. It would have been a much more dramatic photograph had the Prince chosen to wear his flowing Arabic costume and headdress.

The light used was a single quartz lamp throwing out 1000 watts of brilliance. It was set high and to the right of the subject to emphasize skin texture, and to avoid unsightly shadows on the wall.

TECHNICAL DATA

Camera and Lens:	Canon AE-1, with 35–70 mm Canon zoom lens.	**Development:**	Push-processed to ASA 600 in Kodak Versamat, with FR chemicals.
Lighting:	Single 1000-watt quartz lamp on light stand.	**Print:**	Kodak RC paper, 11" × 14"; developed in Kodak Ektaflo Developer, Type 1; standard dilution, 13 oz. concentrate to 115 oz. water.
Film and Exposure:	Kodak Tri-X; 1/125 sec. at f/4.		

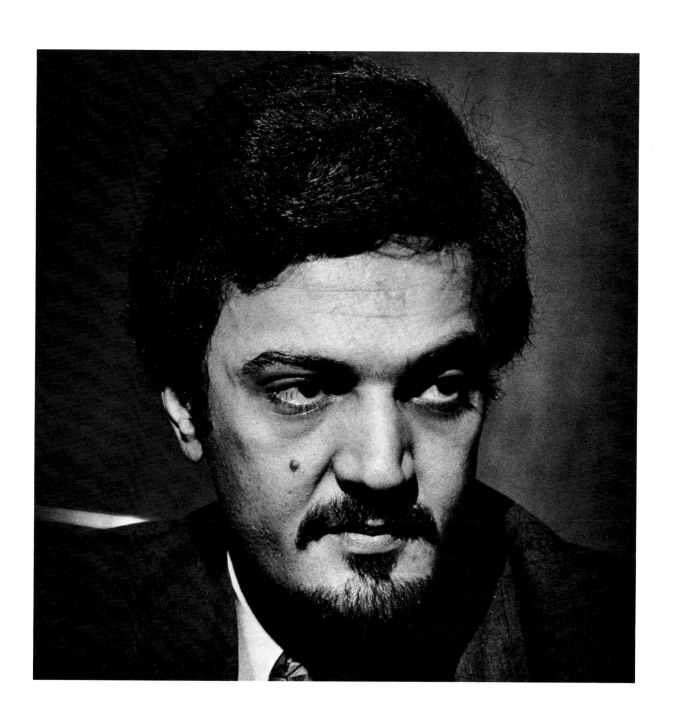

Bella Akhmadulina, Russian Poet

Who ever heard of Bella Akhmadulina? Millions of Russians, and thousands of people in world literary circles. Russian theaters sell out when it is announced that she is giving a reading of her latest works. Her books disappear from the shops as soon as they are placed there.

She was in New York on the first leg of a journey through America, a land that has fascinated her for a long time. Poets must touch, taste, and savor the bouquet of experiences that make up their lives, and this was a marvelous opportunity to perceive at first hand the sights and sensations of a country known to her only through other people's impressions.

The day was beautiful. It was early spring, and the sun's warmth was edged with a breeze that still held the chill of winter. She was staying at the apartment of a friend in New York, and was seated out-doors in an open patio area surrounded by friends, her husband, a translator, a *Times* reporter, and myself.

Most people, except perhaps those in the performing arts, feel constrained about posing for pictures when they are in the midst of a group of people. Her face brightened perceptibly when the translator told her that I would like to do the portrait away from the people that surrounded her.

Beyond the patio in a large garden area, I photographed Ms. Akhmadulina in front of an enormous tree facing the East River. Although she seemed relaxed, the poetess had an air of intensity that dominated her shyness. Despite the camera and alien surroundings, or perhaps because of them, her expression and manner were that of a person totally immersed in a world of her own creation.

TECHNICAL DATA

Camera and Lens:	Canon AE-1, with 35–70 mm Canon zoom lens.	**Development:**	Normal development in Kodak Versamat, with FR chemicals.
Lighting:	Outdoors, under a tree.	**Print:**	Kodak RC paper, 11″ × 14″; developed in Kodak Ektaflo Developer, Type 1; standard dilution, 13 oz. concentrate to 115 oz. water.
Film and Exposure:	Kodak Tri-X; 1/500 sec. at f/8.		

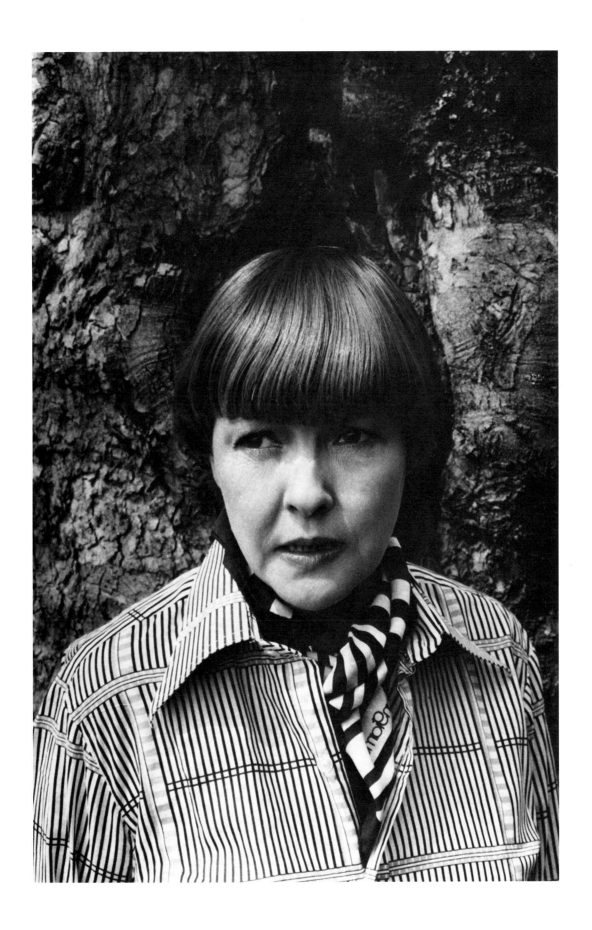

W. Eugene Smith

A legendary figure in the field of photo-journalism, Gene successfully brought the role of the documentary photographer into the magazine field. Outwardly, he is quiet, soft-spoken, and almost diffident in manner. His photographs speak for him. They are awesome, powerful images that tear at the fabric of complacency, injustice, and brutality of man to his fellow man, and to his environment.

Gene's World War II photographs are as powerful an indictment against the insanity of the battlefield as were Goya's images of the "Disasters of War." As a result of wartime incidents, he has undergone numerous operations, and painful, shattering experiences.

His "Schweitzer" and "Nurse Midwife" photographic essays for *Life* magazine show the other side of man's nature—the capacity for sacrifice and devotion to the needs of the innocent and oppressed.

Gene's book, *Minimata,* shows the horrifying results of man destroying his own environment, and maiming and crippling his fellow man. His gallant crusade has nearly cost him his life on a number of occasions. In the course of the Mimimata story, he was seized by Japanese company guards, hurled bodily against a concrete wall, and finally thrown to the ground unconscious. This episode nearly cost him his eyesight as well as his life.

Ironically, one of his most powerful series, "Madness," has never been published. These searing, powerful photographs constitute an unforgettable document of the insanity of the sane.

This portrait was made at a time when Gene was in this country to undergo surgery to save his eyesight. He was in continual pain, which his face and the position of his hand show. Although the interview being conducted was to be a story about Gene Smith the photographer, he continually turned the course of the interview to the plight of the poor Japanese people of the small fishing village of Minimata, some of whom had been crippled and maimed for life. In his usual modest fashion, he was not interested in publicizing himself, but in the villagers who were brutalized in the name of "progress."

TECHNICAL DATA

Camera and Lens:	Leica CL, with 90 mm *f*/2.8 Tele-Elmarit lens.	**Development:**	Normal development in Kodak Versamat, with FR chemicals.
Lighting:	Small strobe light, handheld off camera.	**Print:**	Kodak RC paper, 11″ × 14″; developed in Kodak Ektaflo Developer, Type 1; standard dilution, 13 oz. concentrate to 115 oz. water.
Film and Exposure:	Kodak Tri-X; 1/60 sec. at *f*/11.		

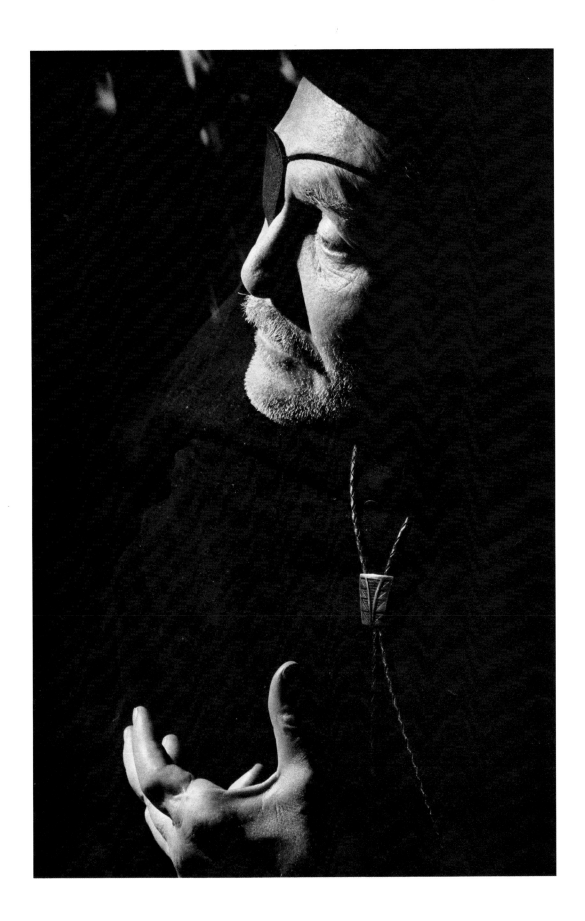

Fidel Castro

One of the most difficult-to-catch subjects in my portrait quest was the leader of the Cuban people, Fidel Castro. Getting into Cuba, a difficult task for *Norteamericanos,* was simpler than getting Fidel within portrait range of my cameras. He had no regular office, nor office hours. My contact was the Cuban Minister for Foreign Affairs, who kept telling me that the session would be arranged "shortly."

I had originally planned to spend two weeks in Cuba, but as the weeks passed I was about ready to give up, when I learned that Fidel was scheduled to appear at a party in the Canadian Embassy. I was there promptly at 7 P.M., drifting from room to room, looking for the elusive Fidel.

For security reasons, the embassy officials would not confirm whether or not he would be there. I decided to wait until the party's end. By midnight the number of people present had thinned out considerably, and at 15 minutes past the hour, Fidel strode into the room accompanied by six bodyguards and several officials.

He closeted himself with the Canadian Ambassador for an hour; and when he emerged, decided to hold an informal press conference with the various correspondents that remained. No pictures were permitted, and at the end of the conference he asked whether everybody was happy. I stood up, and told him that I was not. He seemed to be taken aback at first; but when I explained that I had been trying for six weeks to catch up with him, and needed some portraits of him to make my visit to Cuba complete, he laughed, motioned to his Minister of the Interior, and arranged several days of meetings that were specifically aimed at helping me secure the coverage that I still needed for the assignment.

For the next two days, he personally escorted me around Havana and many of its suburbs, giving me countless opportunities to photograph him alone, and with the people. He also allowed close-up views of many of the projects he was most interested in showing.

TECHNICAL DATA

Camera and Lens:	Pentax, with 180 mm *f*/2.8 Zeiss Sonnar lens.	**Development:**	Normal development in Kodak D-76.
Lighting:	Bright sunlight.	**Print:**	Kodak RC paper, 11″ × 14″; developed in Kodak Ektaflo Developer, Type 1; standard dilution, 13 oz. concentrate to 115 oz. water.
Film and Exposure:	Kodak Tri-X; 1/1000 sec. at *f*/8.		

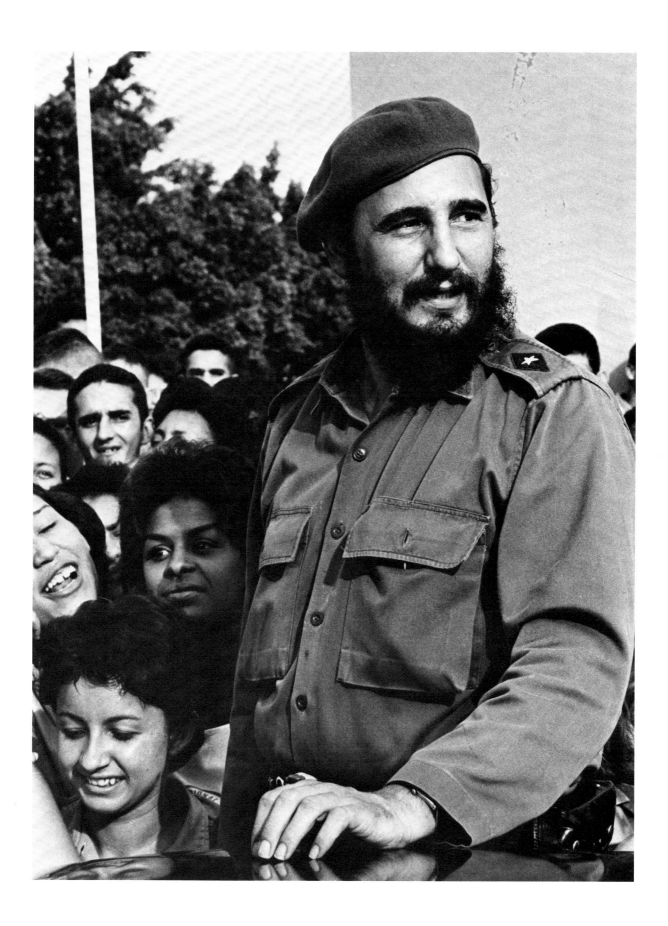

Kermit Love, Puppeteer

Kermit has a face that people love, and children adore. This is not surprising. He looks exactly like everyone's image of Santa Claus. His eyes are bright blue, and shine like ice crystals. His face is round and jolly, and his mouth, creased into a permanent smile, promises to break into hearty laughter at any moment. He is used to dealing with people, all kinds of people: little ones, big ones, sad ones, and happy ones; but most of all, with little wooden ones.

These wooden personalities are faithfully dressed in authentic costumes and their faces are instantly recognizable. Bill Robeson in his Emperor Jones costume, the Mad Hatter from *Alice in Wonderland*, Howdy Doody, Fudini, Fred Astaire, and Helen Hayes are some of the many personalities with whom Kermit works.

Unfortunately, when I arrived to photograph Kermit, the puppets were all packed in the wooden crates they call home. Photographing the puppeteer without his puppets would have been as unthinkable as separating Romeo from Juliet.

For the next hour, working with the assistance of some of his young aides, Kermit unpacked some of the characters from the trunk, and set them inside the shelves that surrounded the hall. We then spent another hour arranging and rearranging the puppets to attain the best possible background.

Every time the position of several figures was changed, half a dozen spotlights had to be shifted and repositioned for the best effect. The background was lit separately so that the figures would stand out in relief against it.

TECHNICAL DATA

Camera and Lens:	Canon AE-1, with 35–70 mm Canon zoom lens.	**Development:**	Push-processed to ASA 600 in Kodak Versamat, with FR chemicals.
Lighting:	Six mini-spotlights arranged to light figures, face, and background.	**Print:**	Kodak RC paper, 11″ × 14″; developed in Kodak Ektaflo Developer, Type 1; standard dilution, 13 oz. concentrate to 115 oz. water.
Film and Exposure:	Kodak Tri-X; 1/30 sec. at f/5.6.		

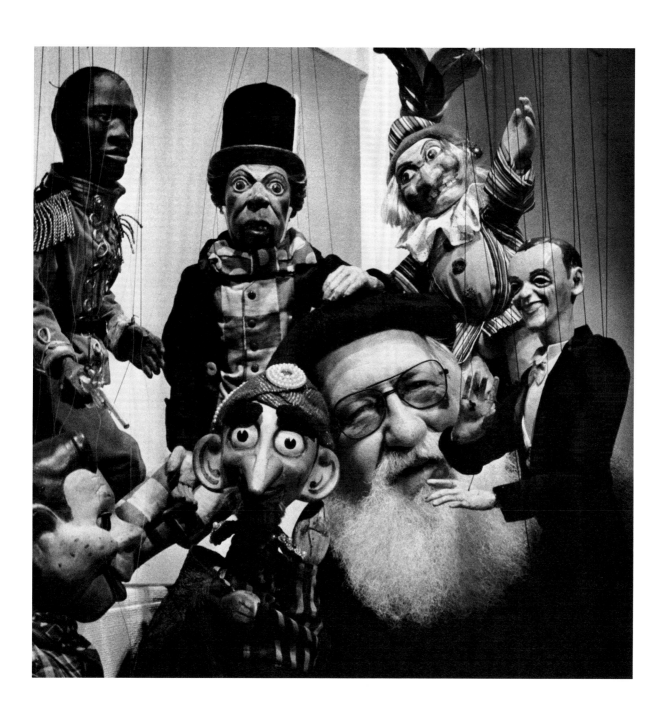

Norma Donaldson

From whatever angle you look at her, Norma Donaldson is a knockout. When she appears on stage in the Broadway production *Guys and Dolls,* her warmth and presence reach right out across the footlights and instantly charm the audience. Her perceptive and superb characterization of Miss Adelaide catapulted her to the top of Broadway musical stardom.

Up close in her dressing room, other dimensions of her multifaceted personality reveal her to be a sensitive, warm human being with a great deal of concern for people.

She was beautifully attired for the sitting, in a simple, classic white dress that lent its own dignity to her already commanding presence. My original idea was to use the existing light in the room, but the bare bulbs that ringed her dressing room mirror threw disconcerting shadows on her face and gown. There was little time to fuss with elaborate setups as Miss Donaldson was due on stage in 30 minutes; so, out came two Lowell "Tote-A-Lights"—1000-watt quartz lamps with built-in barn doors.

The main light was clamped to a shelf, 3 feet above her head; the fill light was attached to the dressing room door, 8 feet away from the main light. With a 35–70 mm zoom lens on the camera, and a two-frame-per-second power-winder, it was possible for me to produce a variety of portraits, ranging from closely cropped head shots to semiwide-angle torso pictures, in the 15 minutes that remained.

This superb actress intuitively grasped what I was trying to capture on film; and with her help, I was able to accomplish a difficult task in minutes.

TECHNICAL DATA

Camera and Lens:	Canon AE-1, with power-winder and 35–70 mm Canon zoom lens.	**Development:**	Push-processed to ASA 600 in Kodak Versamat, with FR chemicals.
Lighting:	Two quartz, Lowell "Tote-A-Lights" (1000 watts each).	**Print:**	Kodak RC paper, 11″ × 14″; developed in Kodak Ektaflo Developer, Type 1; standard dilution, 13 oz. concentrate to 115 oz. water.
Film and Exposure:	Kodak Tri-X; 1/125 sec. at *f*/2.8.		

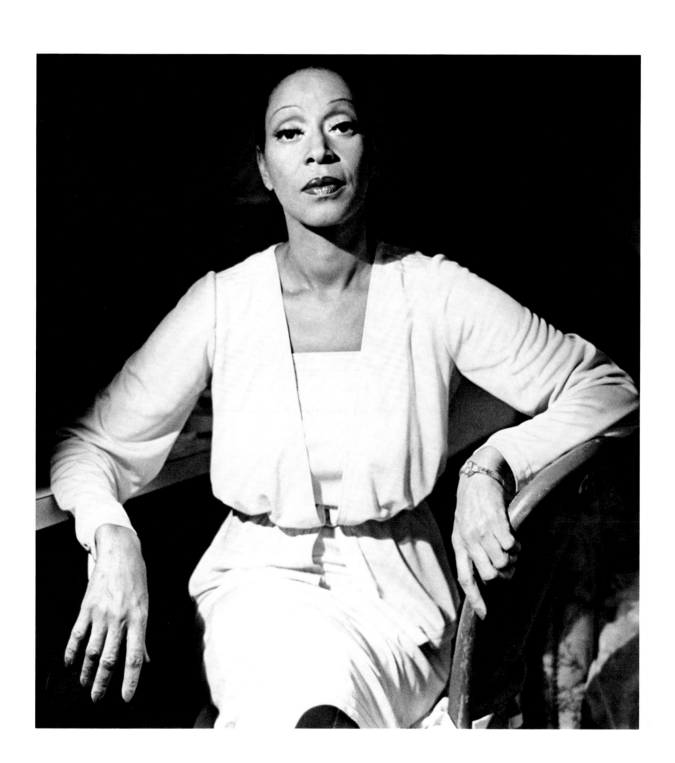

Spanish Soldier

This portrait, from a Spanish travel book, *Portrait of Spain,* was part of a series I did, showing how Franco used troops, police, secret service, and troopers to maintain his power in a regimented police state. An entire country marched in goose step to the orders of a despotic tyrant.

When Franco won the terrible civil war in Spain, it was a joyless victory. When father battles son, brother slays brother, and cities and towns that have withstood the ravages of time for centuries are wantonly destroyed in a few days of pitched battle, there can be no victors—only survivors. Many years after the war drew to a close, another war took its place. It was always a battle for survival. The battlefield was the home and the heart of the populace.

Franco ruled Spain with an iron hand, surrounding himself with sycophants, living a life of luxury in a marble palace, and rewriting the history books of his nation. Many of his people lived bleak lives; hunger and fear were their constant companions; hope was their opiate.

This portrait, part of a photographic documentary made in Spain over a period of 12 years, shows a portion of a parade during a holiday; but captures the power of the military, a visible reminder to the people of the eternal vigilance of a dictator who feared possible reprisals, and covert resistance to his rule.

Security barriers kept me at some distance from the marching troops, so it was necessary for me to work with a 300 mm lens to bring the face selected up close.

TECHNICAL DATA

Camera and Lens:	Pentax, with 300 mm $f/4$ Zeiss Sonnar lens.	**Development:**	Push-processed to ASA 800 in Kodak D-76.
Lighting:	Daylight; overcast and cloudy.	**Print:**	Kodak RC paper, 11″ × 14″; developed in Kodak Ektaflo Developer, Type 1; standard dilution, 13 oz. concentrate to 115 oz. water.
Film and Exposure:	Kodak Tri-X; 1/125 sec. at $f/4$.		

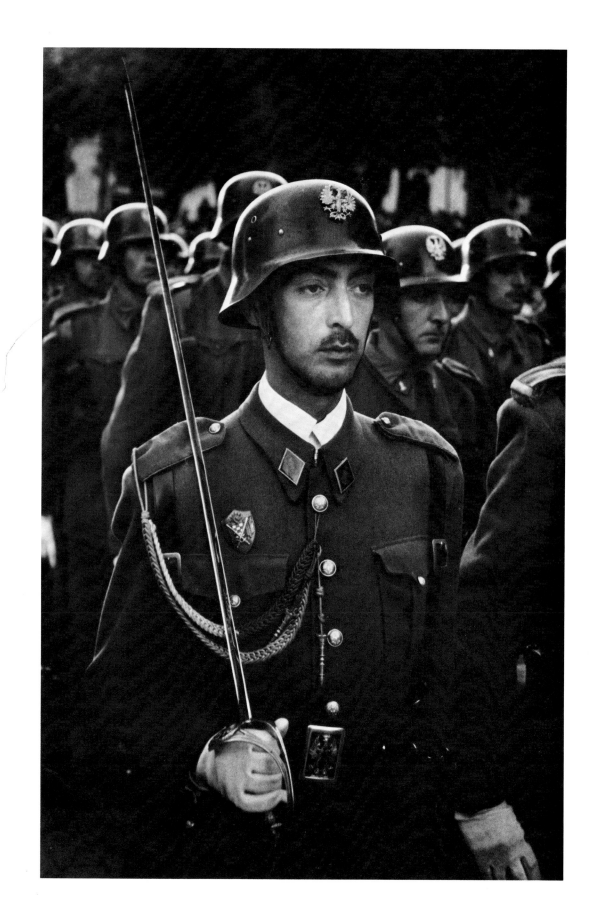

Mstislav Rostropovich

Russian-born cellist Mstislav Rostropovich was a child prodigy. At the age of four, he began playing the piano and composing music, and is considered the world's greatest cellist. Although he is a Russian citizen, he has been living like a man without a country, traveling most of the time, and giving concerts in Paris, Tokyo, London, New York, and other great cities of the world.

For him, his music has always been a passport into the hearts and minds of people everywhere—a kind of magical key that takes him past the barriers of language, custom, and ethnic differences. He resembles a kind of character that Disney would create—a person overflowing with joy, laughter, and love for his fellow man.

When this portrait was made, he was staying at the home of a friend in New York; and as I entered the apartment, he was just finishing an anecdote in Russian. Although I have no knowledge of the Russian language, his laughter was so infectious that it brought forth a smile from me.

I decided to light the subject with a strobe, relying on the action-freezing capabilities of the electronic light to capture the continuous, fleeting expressions that played so quickly across the maestro's face. The power-winder was an additional convenience enabling me to concentrate fully on the man and his expressions, rather than the petty logistics of manually winding the film, and shifting the eye away from the camera and then back again. The light was positioned to one side to avoid reflection from the painting in back of the subject; and the small aperture allowed me to disregard his forward and backward movements, which at larger apertures, would have resulted in some out-of-focus images.

TECHNICAL DATA

Camera and Lens:	Canon AE-1, with power-winder and 35–70 mm Canon zoom lens.	**Development:**	Normal development in Kodak D-76.
Lighting:	Single, small strobe light, clamped to table-lamp stand with 25-foot extension cord.	**Print:**	Kodak RC paper, 11″ × 14″; developed in Kodak Ektaflo Developer, Type 1; standard dilution, 13 oz. concentrate to 115 oz. water.
Film and Exposure:	Kodak Tri-X; 1/60 sec. at f/5.6.		

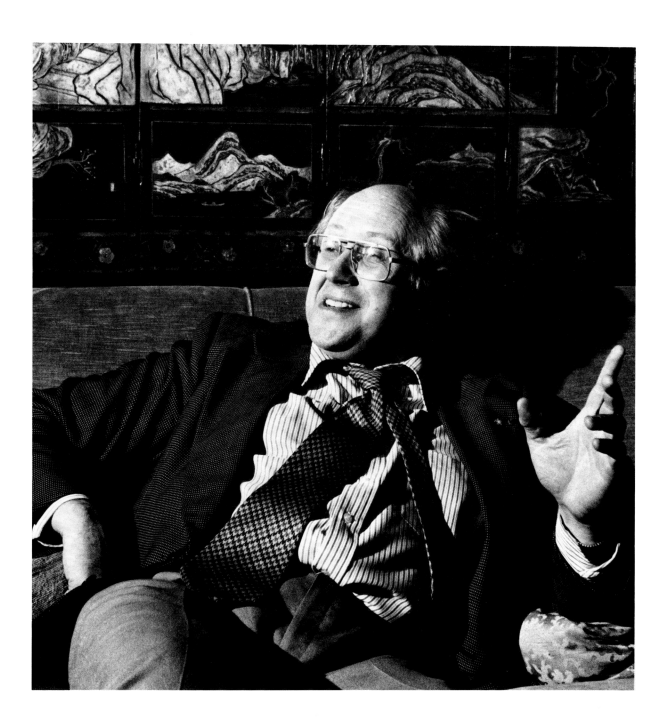

Afro-American

The casual, street portrait can offer as powerful a study of humanity as the formal studio portrait; and photographers from the very beginning have produced great street portraits. Paul Strand's classic photograph of the blind woman in the street, Anton Bruhel's lyrical portraits of Mexican people outdoors, and Lewis Hine's unforgettable documentaries of the poor all offer evidence that there is a great tradition in street portraiture.

The technical challenges to be overcome are formidable. The photographer has little or no control over background, lighting, or subject. However, this is on the minus side of the ledger. On the plus side, the very nature of the technique induces spontaneous realism; and accidental juxtapositions often result in exciting compositions that are often not even noticed by the photographer at the instant he takes the picture.

I have asked a number of people to guess where this picture was made, and the answers ranged from Kenya, to Nairobi, to Senegal. The actual location was a crowded side street in Coney Island. It was a hot, humid day, and there must have been over half a million people jamming the streets and beaches. Sideshow barkers were shouting there spiels, and roller coasters were clattering away in the background when I spotted this handsome woman proudly garbed in the style and artifacts of her cultural heritage.

My reaction was instantaneous, and part instinctive. I shifted my camera so that she would be placed against the dark background behind her. I had time to fire off only three exposures, and she was lost in the crowd. Despite the "firing from the hip" technique, there is a quiet dignity and serenity to the scene that belies the frenzied activity that pervaded it.

TECHNICAL DATA

Camera and Lens:	Canon F-1, with bellows and enlarging lens used as a camera lens (from an article in the journal *35 mm Photography* on using enlarging lenses as camera lenses).	**Film and Exposure:**	Kodak Tri-X; 1/500 sec. at f/8.
		Development:	Normal development in Kodak D-76.
Lighting:	Summer sunlight.	**Print:**	Kodak RC paper, 11" × 14"; developed in Kodak Ektaflo Developer, Type 1; standard dilution, 13 oz. concentrate to 115 oz. water.

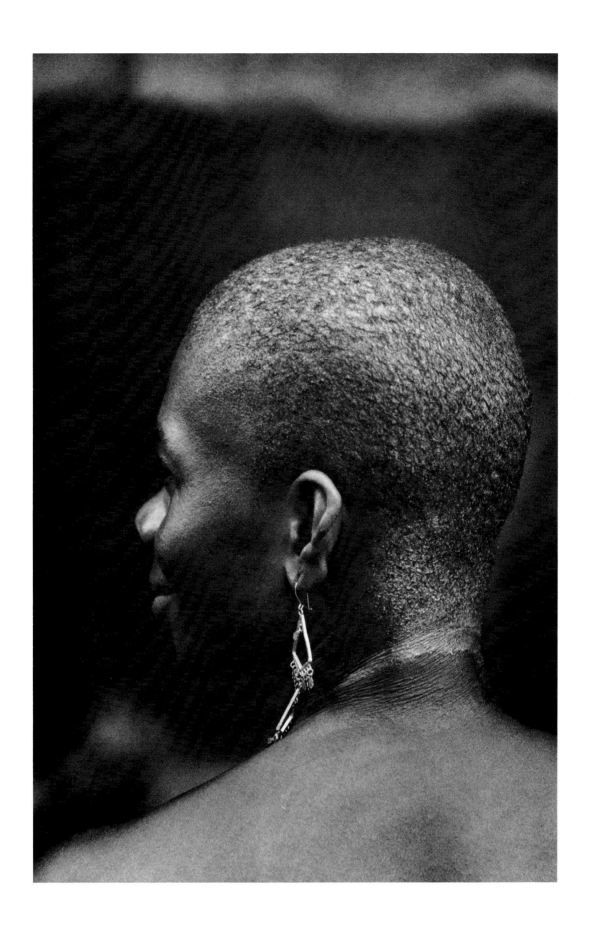

Dolly Parton

She resembles every little girl's fantasy image of a real live movie star. A bright, platinum blonde wig adds inches to her petite frame. Her large, baby-blue eyes twinkle merrily in an incongruous setting of larger-than-life false eyelashes. The warmth and charm that she radiates draw people to her like a flower laden with pollen draws bees. Underneath all this glamorous camouflage lies a very talented composer, performer, and businesswoman. Her talents are so varied that they cut across many musical lines and have made her a cult figure to country and western music fans, as well as to rock, pop, and college audiences. Her performances are often giant stage spectacles, with elaborate settings and myriads of colored spotlights.

Well, there I was again in the usual small, drab hotel room. The setting was unattractive; the light filtering through the window was fair; but the subject was ebullient, and delighted at the idea of having her picture taken. Her easy, affable manner made photographing her a snap. I had no choice but to set her near the window in order to have enough light to expose the film properly. Somehow I felt that a single strobe light would have been too harsh, and the directness of natural light somehow fit her face and personality better than any other lighting setup. A very low camera angle emphasized her facial characteristics in the most complementary manner.

Although the quality of daylight was good, it was rather low in actinic value. This necessitated pushing the film to achieve better contrast in the negative, and to brighten the sparkle in her beautiful eyes. The background was burned in during printing to emphasize the brightness of her hair, and the twinkle in her eyes. She seemed to enjoy every minute of the picture-taking session.

TECHNICAL DATA

Camera and Lens:	Canon AE-1, with 50 mm f/1.4 Canon lens.	**Development:**	Push-processed to ASA 800 in Kodak D-76.
Lighting:	Natural filtered daylight.	**Print:**	Kodak RC paper, 11″ × 14″; developed in Kodak Ektaflo Developer, Type 1; standard dilution, 13 oz. concentrate to 115 oz. water.
Film and Exposure:	Kodak Tri-X; 1/250 sec. at f/2.8.		

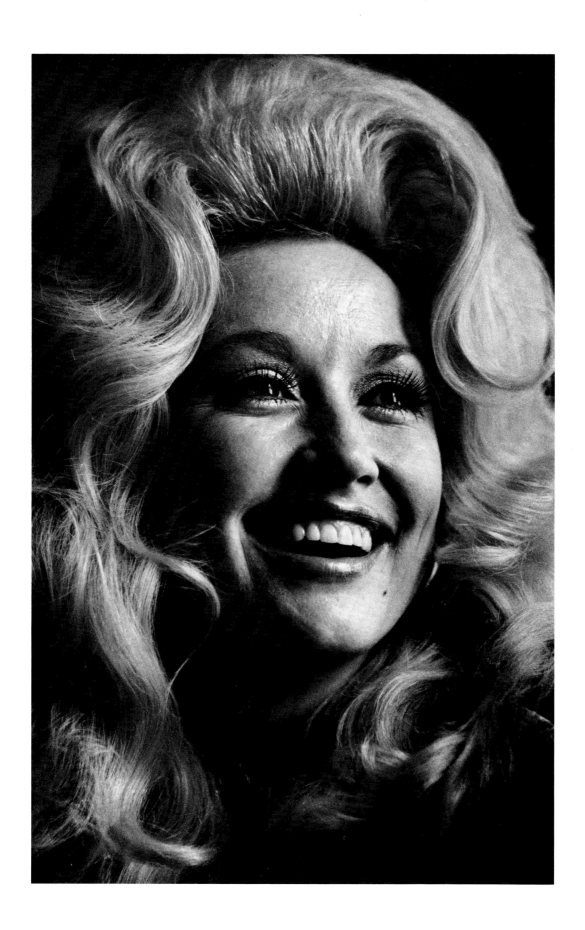

Lillian Hellman

In her long, distinguished career as a writer and playwright, Miss Hellman has been in the eye of many political storms. An innovator of great talent and a keen delineator of world-power politics, she has maintained her position in the forefront of the field of American letters for decades.

Her face radiates power and self-confidence, and is one of the most impressive that I have encountered in many years of photographing personalities. In fact, the rugged handsomeness of her face dictated the lighting conditions that I used. I treated those beautifully carved features as though they were a handsome piece of sculpture; the face was cross-lighted for texture, and a large aperture was used to throw out of focus a distracting background that might have competed for the viewer's attention.

The subject faced the camera squarely, as she does every difficult situation she has encountered. The camera lens was on a direct line with her eyes. No matter how you look at this portrait, the eyes follow you, holding you in an almost hypnotic grip.

Three umbrella strobes were used; one was placed at each side of the head, equidistant from the ears and level with them; and the third umbrella unit was placed in front of the subject as a main light, directed into the eyes.

TECHNICAL DATA

Camera and Lens:	Canon AE-1, with Canon 35–70 mm zoom lens.	Development:	Push-processed to ASA 600 in Kodak Versamat, with FR chemicals.
Lighting:	Three umbrella strobes.	Print:	Kodak RC paper, 11″ × 14″; developed in Kodak Ektaflo Developer, Type 1; standard dilution, 13 oz. concentrate to 115 oz. water.
Film and Exposure:	Kodak Tri-X; 1/60 sec. at f/5.6.		

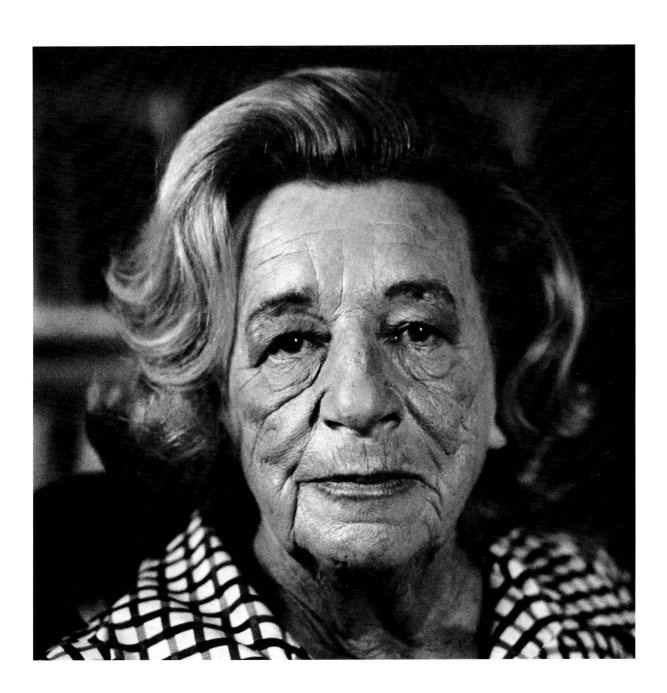

South Bronx Politician

Ramon Velez is a very controversial political figure in the South Bronx. Forty percent of the youths who reside there are on the unemployment rolls.

The deserted, decayed tenements behind Mr. Velez, which look as though they have been the target of a sustained aerial bombardment, are but a part of the many problems facing the residents of the borough, and the people that represent them. Even the natural lighting of this setting was a help; the grim, gray day seemed to emphasize the drabness and scope of the problem. The fact that a segment of our population must scratch out an existence and raise families in such an atmosphere of blight and despair had to figure in as background in the portrait.

The composition was deliberately planned so that the tenements, as well as the subject, vie for your attention. The sharply angled viewpoint is meant to give the onlooker a feeling of unsteadiness and lack of orientation as though the world he is viewing is teetering on the edge of collapse, as it is.

As people are shaped by their surroundings, so too are portraits shaped by their composition. When you are able to introduce a meaningful interplay between subject and content, the portrait takes on added scope that brings to it fuller meaning.

TECHNICAL DATA

Camera and Lens:	Canon AE-1, with 20 mm f/2.8 Canon lens.	**Development:**	Push-processed to ASA 800 in Kodak D-76.
Lighting:	Daylight; overcast and cloudy.	**Print:**	Kodak RC paper, 11″ × 14″; developed in Kodak Ektaflo Developer, Type 1; standard dilution, 13 oz. concentrate to 115 oz. water.
Film and Exposure:	Kodak Tri-X; 1/250 sec. at f/5.6.		

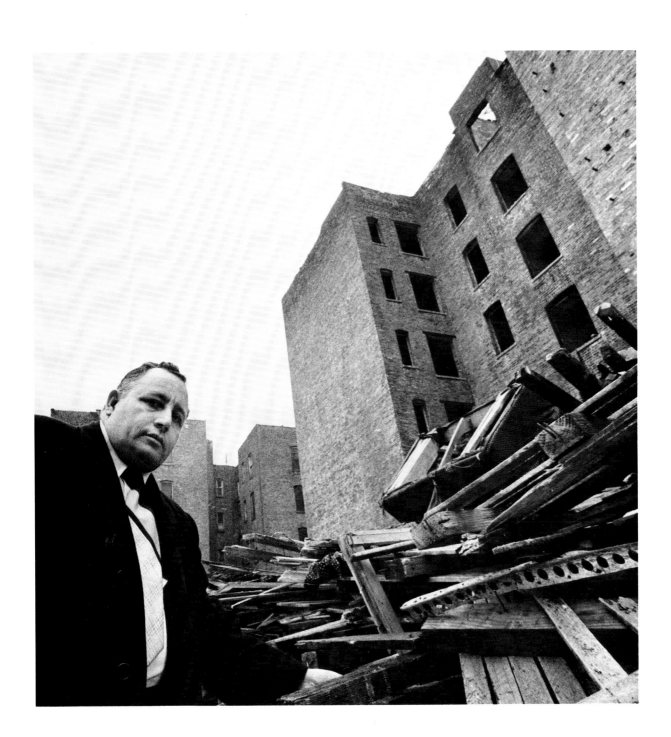

Irish Lad

Children in their natural habitat—in the street, and in the company of their friends—are among the easiest of all portrait subjects. Their natural exuberance, lack of artificiality, poise, and, as this subject shows, total charm, are a pleasure to portray.

This portrait was made on a street in Dublin, for a book about the children of Ireland. The aim of the book was to show American children how their counterparts in other countries live, play, and look.

Photographing a subject of this type in a studio setting would have been a disaster! The inhibiting atmosphere of an enclosed room, and the artificial lighting and painted backdrops would have negated the feeling of informality. Of course, when working in the street, the photographer is subjected to the vagaries of transient light; and there is the need to search for a suitable background. However, the advantages far outweigh the disadvantages.

As winsome and appealing as children are, their attention span is limited, and it is most important that the photographer work quickly and unobtrusively. Happily, there is no language barrier in Ireland, and soon the questions were flying thick and fast about America, the camera, and myself.

There are few adults who could face a camera as naturally and confidently as this youngster did. After we were through, several of his friends "sat" for me and enjoyed the experience as much as he did.

TECHNICAL DATA

Camera and Lens:	Pentax, with 85 mm f/1.8 Takumar lens.	**Development:**	Normal development in Kodak D-76.
Lighting:	Daylight; cloudy bright.	**Print:**	Kodak RC paper, 11″ × 14″; developed in Kodak Ektaflo Developer, Type 1; standard dilution, 13 oz. concentrate to 115 oz. water.
Film and Exposure:	Kodak Tri-X; 1/250 sec. at f/4.		

TECHNICAL INFORMATION ON COLOR PORTRAITS

Plate No. 1: Balinese Dancer

Camera and Lens: Canon AE-1, with 85 mm f1.2 Canon aspherical lens.

Lighting: Full-stage lighting— spotlights and floodlights.

Film and Exposure: Kodak High Speed Ektachrome (tungsten); 1/125 sec. at f/2.8.

Development: Normal development by Eastman Kodak.

Comments: The combination of high-speed lenses and high-speed color film gives the photographer shooting possibilities that were not possible a short time ago. Exotic costumes and unusual makeup gain impact in color portraits.

Plate No. 2: Medieval Costume

Camera and Lens: Canon AE-1, with 85 mm f/1.2 Canon aspherical lens.

Lighting: Open shade; small strobe light used to fill shadow side of the face.

Film and Exposure: Kodachrome 64; 1/60 sec. at f/4.

Development: Normal development by Eastman Kodak.

Comments: The small strobe light, which takes up very little room in a gadget bag, is an invaluable lighting tool for fill light and for emergency lighting where the existing illumination is too weak, or unsuitable for color. Although the costume is very simple, the colorful background strengthens the composition.

Plate No. 3: Sally Urang

Camera and Lens: Canon AE-1, with 85 mm f/1.2 Canon aspherical lens.

Lighting: Deep shade; late afternoon.

Film and Exposure: Kodak Ektachrome 200; 1/30 sec. at f/2.

Development: Normal development by Eastman Kodak.

Comments: Formal clothing for portraits, particularly for the freshness and youth of a girl like Sally, would rob the portrait of much of its charm. Although this portrait was made in deep shade, a large building across the street from our location threw a great deal of reflected light on the subject. A 1B skylight filter (slightly pink in color) was sufficient to counteract the normally blue tones encountered when photographing in the shade.

Plate No. 4: Boy in a Red Costume

Camera and Lens: Canon AE-1, with 85 mm f/1.2 Canon aspherical lens.

Lighting: Bright sun.

Film and Exposure: Kodachrome 64; 1/250 sec. at f/8.

Development: Normal development by Eastman Kodak.

Comments: When photographing people with dark skin, it is very important to give at least one stop larger opening than indicated by the exposure meter. In automatic cameras, set the exposure compensating dial for two times the indicated exposure; with manually operated cameras, use one f-stop more exposure than indicated by the exposure meter.

Continued on Page 137

Plate No. 1

Plate No. 2

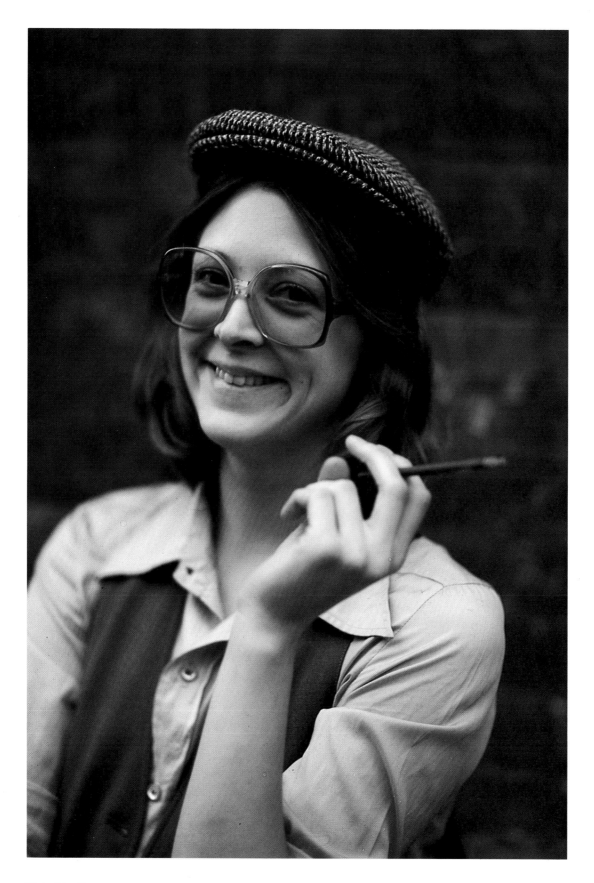

Plate No. 3

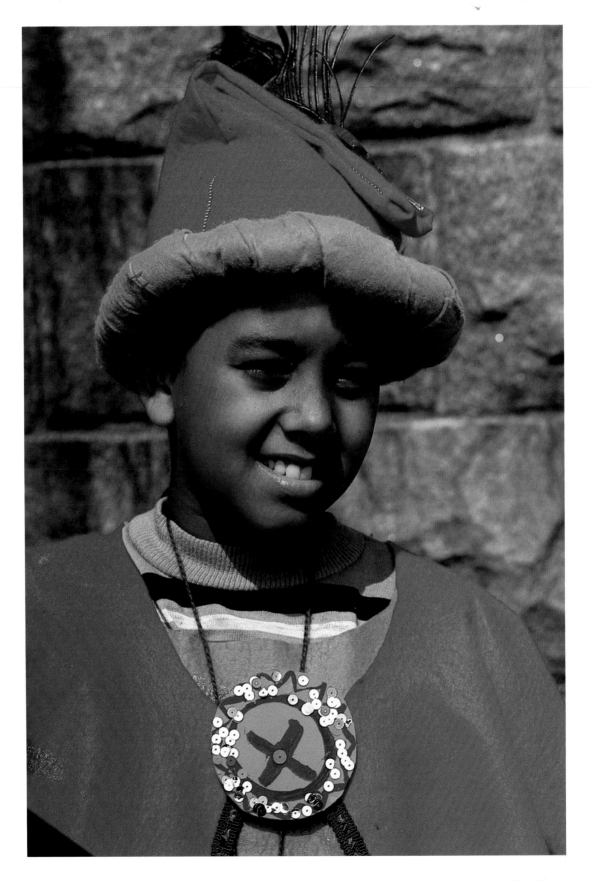

Plate No. 4

Plate No. 5

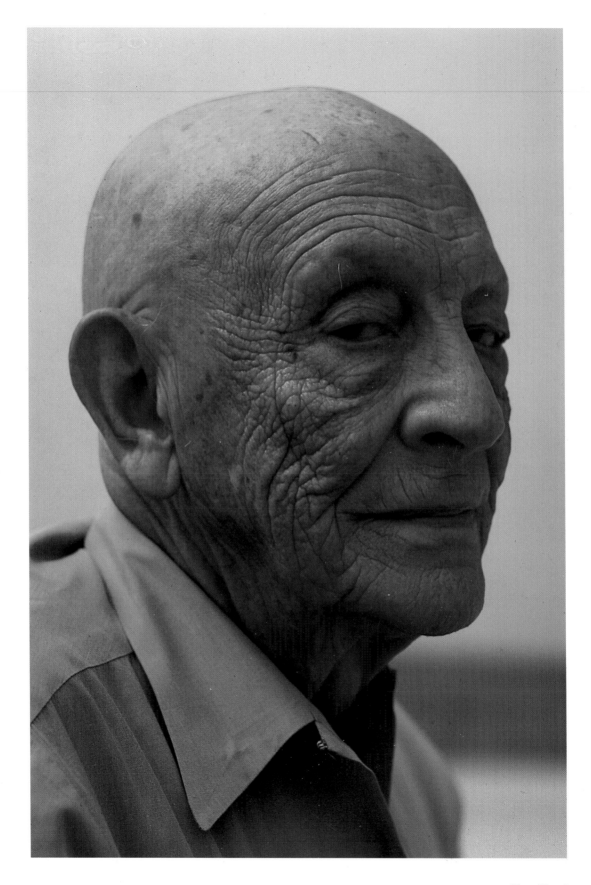

Plate No. 6

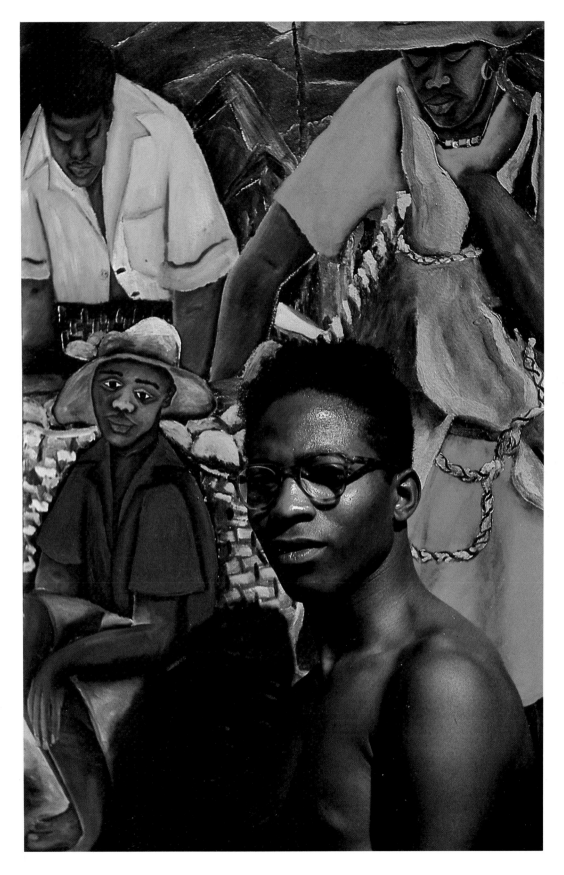

Plate No. 7

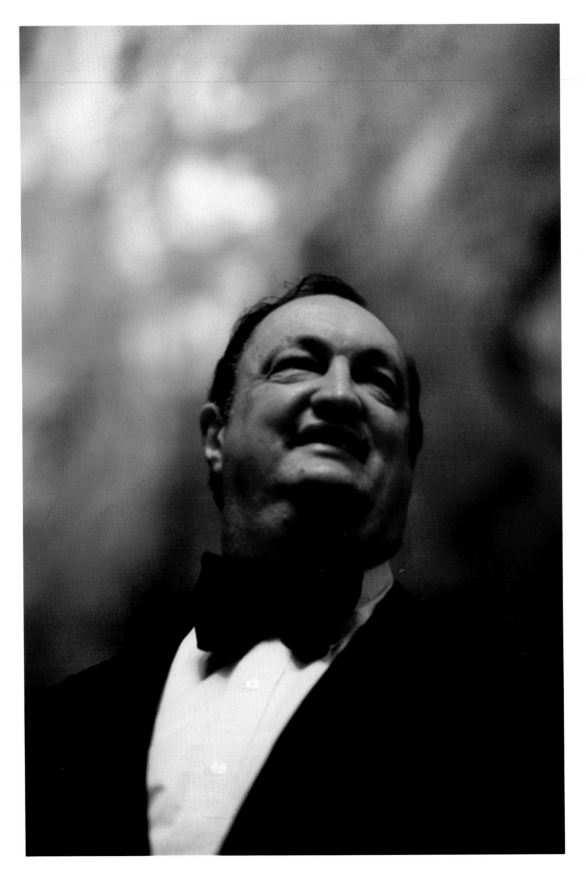

Plate No. 8

Plate No. 5: Costumed Figure

Camera and Lens: Canon AE-1, with 85 mm f/1.2 Canon aspherical lens.

Lighting: Sun and shade.

Film and Exposure: Kodak Ektachrome 64; 1/125 sec. at f/4.

Development: Normal development by Eastman Kodak.

Comments: This kind of exposure requires an exact balance between highlight areas and shadow areas. Bracketing exposure in half stops enabled me to reach that exact exposure.

Plate No. 6: Harry W. Baehr

Camera and Lens: Canon AE-1, with 85 mm f/1.2 Canon aspherical lens.

Lighting: Hazy sunlight.

Film and Exposure: Kodachrome 25; 1/125 sec. at f/5.6.

Development: Normal development by Eastman Kodak.

Comments: Mr. Baehr, a renowned journalist, has such strong features that background and handling of the portrait were kept to an absolute minimum. This portrait was photographed at a beach in Westhampton against a clear blue summer sky, with exposure for the dark side of the face.

Plate No. 7: Haitian Painter

Camera and Lens: Leica 3F, with 35 mm Zeiss Biogon lens (adapted for Leica).

Lighting: Summer sun.

Film and Exposure: Kodachrome 25; 1/125 sec. at f/5.6.

Development: Normal development by Eastman Kodak.

Comments: This portrait of a Haitian primitive painter, photographed in Port Au Prince, Haiti, needed color to do it full justice. A flashbulb was used to soften and lighten the harsh shadows of the tropical Haitian sun.

Plate No. 8: John Mazzola

Camera and Lens: Canon AE-1, with 85 mm f/1.2 Canon aspherical lens.

Lighting: Natural (tungsten lighting).

Film and Exposure: Kodak High Speed Ektachrome (tungsten); 1/15 sec. at f/1.2.

Development: Push-processed to ASA 320 by Eastman Kodak.

Comments: John Mazzola, the genial, dynamic President of Lincoln Center for the Performing Arts, was photographed in his natural habitat. How do you introduce a touch of color in a background of marble and crystal? A large painting provided exactly what was needed. A Gitzo tripod, with the legs pitched very low to the ground, was a necessity for the slow shutter speed.

PART II

EQUIPMENT & TECHNIQUES

1. Camera and Lens

For most of the 140 years that photography has been in existence, the large (4" × 5"–8" × 10" camera has been the standard size for the professional photographer. There are valid reasons for this choice. Most portraits were made in studios, and portability of the equipment was not necessary.

Retouching the negative was considered to be as important as lighting and composition; and the larger the negative, the easier it was to retouch. After a while retouching became an end in itself; and some photographers went at it with such a heavy hand that the subject's face resembled a characterless mask, and the finished print contained more paint than picture.

In the late 1920s, Oscar Barnack introduced the Leica camera—a camera so small, it fit the palm of the hand. It was capable of taking 36 pictures on a roll of motion picture film. This great photographic tool made it possible for the photographer to move out of the studio and into the field; it completely revolutionized the art of photography.

A new kind of candid portraiture came into being as people were photographed informally in their own surroundings. The results were charming, natural, and so popular that photography quickly gained aficionados by the thousands.

The paradox that emerged from this innovation was the role of the portrait photographer. He continued to take portraits with a large, unwieldy view camera mounted on a massive tripod; and laboriously retouched negatives in much the same manner as the earliest practitioners of the art. To this very day such photographers can be found in many parts of the world. They continue

**Early
Portrait
Photography**

to exist because there are people who are willing to pay for what amounts to photographic plastic surgery. A skilled retoucher can remove the wrinkles of age as well as the facial blemishes of youth; and can make the skin look as smooth as white formica, with all traces of personality and character obliterated.

The 35 mm Camera

In the late 1930s, *Life* magazine came into being, and a new kind of portraiture was born. Scientists, artists, industrialists, and people from all walks of life were photographed informally and candidly in their natural surroundings. Backgrounds and foregrounds assumed a new importance in portraiture as they linked the subject with his life-style, and broadened the scope of photography with a new type of interpretive portrait.

In the beginning, many of the magazine photographers turned to the larger format (4" × 5") cameras when photographing important people; but gradually, as lens quality improved and films upgraded, there was a move toward the 35 mm format.

The picture magazines with their large circulations educated the eye of both the photographer and the public. Exciting covers and full-page pictures of world-famous personalities, made with 35 mm cameras, showed the way to a new kind of portraiture. The advent of television added still more sophistication to the eye of public and photographer alike, and photography became one of the most popular hobbies in the world. There is hardly a household in this country that doesn't contain several TV sets, and more than one camera.

Computer technology has transformed the 35 mm camera into an electronic marvel; photoelectric eyes scan the subject and instantly program lens and shutter for the correct exposure. New ways of manufacturing optical glass, coupled with revolutionary design changes, have resulted in almost complete elimination of flare, and improvements in lenses never before attained. Film speeds have kept pace with quality and tonal range, and a large variety of enlarging papers is now available. Using the 35 mm camera with its complement of fine, precision lenses; processing the negatives for optimum quality; and using the right enlarging paper to get the best results from your negatives will result in final prints that will rival in quality those taken with larger format cameras.

Although many fine photographs have been made with the 35 mm rangefinder camera, the 35 mm single-lens reflex camera is, in my opinion, the best tool for portraiture; and this text will concern itself with the SLR. Most techniques discussed will work as well with the rangefinder model, but the advantages of the ground-glass screen, with its brilliant image, large image size, and ease of visualizing depth of field, have made the SLR the most popular camera in use today. New advances in technology have brought down the price, size, and weight of these cameras; and my own professional experience with them over a period of years, averaging thousands of pictures per year, has proved to me that their performance, reliability, and quality have been, and continue to be, outstanding.

Choosing a Camera

How do you choose a camera for yourself? Start with a reliable dealer. He will be happy to show you a variety of models, and explain the advantages and disadvantages of each. Narrow your choice down to two. Operate the controls; focus the lens; see how the camera handles, how it feels, and how it responds to your own personal touch. Buying a camera on the basis of advertising claims alone is a gamble that might not pay off. You will find yourself "fighting" the camera if it is the wrong one for you. The controls will never feel right, and the perpetual discomfort will continually intrude on you and on your creative thinking processes. The ground-glass image should be bright and easy to focus. If your camera offers a variety of ground-glass screens, try them all until you find the one that works best for your needs.

Choosing a Lens

There is no "ideal" lens for portraiture. Different situations require different lenses. For example, for the environmental portrait where foreground, background, or a combination of both is vital to the interpretation of your subject, a wide-angle lens (these come in focal lengths from 15–35 mm) will serve better than the traditional medium telephoto (85–105 mm). On the other hand, if a close-up head is what you are after, the better perspective and "drawing power" of the medium-telephoto lens is ideal. Trying to use the normal, 50 mm lens that comes with most cameras for a close-up that will fill the frame of your picture will surely result in discernible distortion of the face. Moving in close with a wide-angle lens will result in even more distortion; that is why the

wide-angle lens should only be used when there is important peripheral material to be included, and when the face becomes a part of a larger, overall design.

For location portraits of personalities or important political figures, you may have to keep your distance for security purposes: A lens from 200 mm to as much as 1000 mm will be required if you are trying to pull out a portrait head at a great distance. The following chart will help you visualize different situations, and the lenses required:

Lenses

TYPE (mm)	USE
Wide-angle 24, 28, 35	Environmental portraits where the background and/or foreground material is important to the portrait.
Short telephoto 85, 90, 100, 105	Close-up heads, and in small rooms where it is possible to approach the subject closely.
Telephoto 135, 180, 200	Close-up heads, where it is not possible to approach the subject too closely.
Fisheye, Wide-angle 15, 21	Satirical portraits, or caricatures. Heightened dramatic effects; foreground, background emphasis.
Telephoto 300–1000 **Zoom** 35–105, 80–200, 200–500	Long-distance portraits, where a subject, such as a president, royalty, etc., is at a great distance from the camera.

A word of warning about using wide-angle lenses for portraits: Keep the subject's head in the center of the frame; it will help minimize distortion.

When using the fisheye lens for caricatures or satirical effects, the closer you get to the subject, the more effective the distortion becomes. Another special situation that calls for the use of a wide-angle lens for portraits is the group portrait, where two or more people are in the picture. For this situation it is wise to use a wide-angle lens with a long focal length; start with the 35 mm and continue on down from there. The group portrait will also require more depth of field than the single head; this means pouring on as much light as possible so the lens may be stopped down for adequate depth of field.

The zoom lens is marvelous for portraiture. It enables the photographer to vary his composition from a fixed position. A good solid support for the lens—tripod, monopod, or clamp—is important at long (135–200 mm) focal lengths.

Motor drives (3½–5 frames per second) or power-winders (2–3 frames per second) are very useful for modern portraiture. The logistics of removing the camera from shooting position to manually wind to the next frame, and then refocusing the camera are largely obviated by the motor drives. Fleeting expressions, momentary changes of position, and shifts of body or head are instantly and effortlessly captured by this useful accessory. A small, "soft" release, available for most cameras, which threads into the shutter-speed release, enables quicker triggering of the shutter for faster response.

Another great accessory is the right-angle finder. There are times when the camera position should be at a lower level than the face of the subject; this device screws into the eyepiece of the

camera and enables the photographer to look down into the finder, and hold the camera at a lower position with ease. Some of the newer ones have a 2× magnifier built into the finder that aids in more accurate focus. They are designed so that they may be shifted 90 degrees. This makes shooting verticals as easy as shooting horizontals.

When shooting illustrative portraits where only a portion of the head is being shown, the macro lens should be considered. This is a special-purpose lens that is much more highly corrected for close-up work than any of the other lenses. Most macro lenses will focus as close as 4 inches in their normal mode, and 2 inches by adding the extension ring that usually comes with them. It is possible to secure very striking visual effects with this type of lens because of its extreme sharpness at close range.

Lens Accessories

A useful lens accessory is the tele-extender. A 2× tele-extender will double the focal length of any lens to which it is coupled, and the 3× will triple the focal length. However, there is a considerable loss of light when using the extenders. For example, with the 2× extender, there is a loss of two f-stops; i.e., an f/2.8 lens wide open becomes an f/5.6. With the 3× extender, there is a loss of three f-stops; an f/2.8 lens becomes an effective f/8. The image brightness falls off considerably, and the higher magnification makes it very difficult to focus these lens attachments accurately. There is also a considerable loss of quality, but there are times when they can be very useful. And the tele-extenders are considerably less expensive than the cost of another lens.

Lens Attachments

Finally, there are lens attachments, costing a few dollars, that entirely change the character and style of the lens to which they are attached. For example, diffusion or soft-focus attachments will neutralize and reverse the inherent sharpness of a fine lens. The image produced with this type of supplementary lens will have a soft, ephemeral quality. You might want to try this effect when photographing a woman, particularly with backlighting. The skin will glow softly, in a most appealing manner, and the highlights on the hair will have an attractive incandescent luster. This attachment is particularly good when lighting conditions are very contrasty; the contrast will be softened considerably.

For dramatic, theatrical effects, the "star" filter attachment is very good. All point sources of light in the picture, as well as reflections from shiny surfaces, will be converted into brilliant 4-, 6-, or 8-pointed stars, depending on the type of star filter used.

To make your own special effects attachment, try smearing a little vaseline on a skylight filter, leaving the center section of the filter clear. When using this attachment, keep the subject's face in the center of the filter; the rest of the image will fade into a pleasing, misty, out-of-focus vignette. There is only one way to determine if you like this type of effect . . . try it and see. Photography offers many learning experiences. If you accept the challenges instead of bypassing them, your work will inevitably improve from the learning experience.

2. Black and White

Black-and-white film falls into three general types for portraiture: fast film (ASA 400), medium-speed film (ASA 125), and slow film (ASA 16–32). In the past the fast films were very grainy and their resolving power ranged from fair to poor; but the advances in improved film-manufacturing technology in the past 5 or 6 years have been tremendous, and today's fast films approach the medium-speed variety so closely in grain and resolving power that, for all practical purposes, they yield nearly the same results in the moderate range of enlargement ($8'' \times 10''$–$11'' \times 14''$).

The advantages offered by the ASA 400 films (faster shutter speeds and smaller apertures) override the minimal disadvantages. Most of the portraits in this book were made with Kodak Tri-X film (ASA 400), which on some occasions was pushed to as much as ASA 1600. In these extreme cases, the increased granularity and contrast and decreased resolving power were less important in the final print than the blurred images and out-of-focus photographs that would have resulted from the use of slower, fine-grain films. Paradoxically, the slower films with their inherently high contrast are not as good outdoors under conditions of high contrast as the faster films, which are softer and have great latitude.

For example, when doing an outdoor portrait in bright sunlight, the sun often causes the forehead, cheeks, and chin of the subject to reflect highlights with such intensity that the slower films with their narrow spectrum of latitude have a tendency to block up brighter skin values. Unless development and exposure are rigidly controlled, these areas of the skin become so dense on

Film

the negative that they come up white, or have harsh, chalky tones. The faster films under the same conditions have a much softer range of tonal values. They have more latitude, do not block up as easily, and have the advantage of allowing the photographer to move from bright sunlight, to deep shade, to night shooting, all with the same film. When you do a lot of location shooting, this factor becomes a very important one.

Filters

Filters are often used for dramatic emphasis. One of the more useful ones in outdoor portraiture is the green filter, which gives good textural rendition of skin tones. For maximum effect, a filter such as the Kodak Wratten 58 (medium green) has a factor of 6. This means the lens diaphragm must be opened $2\frac{2}{3}$ f-stops. In bright sunlight, a film like Kodak Panatomic-X would result in an exposure of 1/125 sec. at $f/2$. With a film in the medium-speed range, such as Kodak Plus-X, the exposure would be 1/125 sec., between $f/5.6$ and $f/4$. But with Kodak Tri-X, there would be a more convenient exposure of 1/125 sec. at $f/11$–8. As you can see from this comparison, the Tri-X film gives you a number of additional options not available with the slower films.

Stopping the diaphragm down would pose no problems, but stopping down with the slow films would necessitate slower shutter speeds that might result in camera shake, or subject blur. On the other hand if you wanted to use high shutter speeds for spontaneous expressions, or with actively moving subjects (children or street portraits), there would be no difficulty. With medium-speed films, a wide aperture would be required, and

there would be very little depth of field. With the slow films it would be impossible; remember, these exposures are for bright sunlight!

The popular, small, thyristor strobe units are another argument in favor of the fast film. The average lens opening with the more powerful small units and ASA 400 film is f/5.6 for medium distances (8–15 feet). With ASA 125 film, proper exposure is close to f/2.8; and with ASA 16–32 film, forget it! Another factor that will decrease film speed with strobe units is the background or subject brightness. Dark backgrounds with little or no reflecting surfaces will require opening the lens an additional one to two f/stops. Once again, the *only* film with sufficient speed to handle most situations is the ASA 400 film.

Although most of the photographs in this book were made with Tri-X film ASA 400, and it is the film that I recommend highly for natural, spontaneous portraits, most of the technical details that follow will be applicable to the other black-and-white films. Developing times will be different, but most film manufacturers pack detailed information as to proper processing times with all their films. In any case, I always recommend using the information as a starting point, and establishing your own developing times according to the procedures with which you have been working. Keep in mind that there are many other variables; thermometers have variances of 1–3 degrees; shutter speeds vary as much as 25–35 percent from their markings; and exposure meters, whether built into the camera or of the external variety,

Strobe Units

may be off by as much as two *f*-stops. It's easy to see that a combination of these factors may cause inexplicable underexposure or overexposure, underdevelopment or overdevelopment, or both.

A good camera repairman, such as Marty Forscher at Professional Camera Repair Service in New York, has been checking the shutters of professionals for many years, and giving them a chart with every camera, detailing the exact shutter speeds of their individual cameras. A process thermometer, accurate to a fraction of a degree, is a worthwhile investment, and will insure proper temperature control in the darkroom for the all-important task of developing the film. A bad print can always be made over; a badly processed roll of film is a catastrophe.

The key to consistent results—a necessity for fine 35 mm portraits—is the elimination of all unknown variables. In the long run this will not only represent a saving of time and money, but it will insure repeatability of results under all conditions. The ASA 400 figure that a film manufacturer puts on his film is really more of a guide or suggestion; this applies equally to the medium- and slow-speed films. Settling on one type of film and establishing your own parameters will insure best results.

Exposure

The relationship between shutter speeds and *f*-stops seems to confuse many photographers. Since the factors involved are unchanging mathematical ratios, they should be a little easier to understand. Both shutter speeds and *f*-stops perform the same

function; each allows an accurate measure of light to reach the film. For example, most shutters are calibrated as follows, in fractions of a second: 1/1000, 1/500, 1/250, 1/125, 1/60, 1/30, 1/15, 1/8, 1/4, 1/2, and 1 second. Most *f*-stops on lenses have the following calibrations: *f*/1.4, *f*/2, *f*/2.8, *f*/4, *f*/5.6, *f*/8, *f*/11, *f*/16, *f*/22, and *f*/32. A look at the shutter speeds will show that the progression is regular; 1/125 sec. is twice the number on its right, and half the speed of the number on its left. Looking at the *f*-stops, the same ratio applies: From the left, *f*/2.8 is approximately twice the speed (will allow about two times as much light to reach the film) as *f*/4; and *f*/5.6 will allow half as much light to reach the film as *f*/4.

To further clarify the relationship, let's take an arbitrary exposure reading of 1/125 sec. at *f*/11. Here is how that would look on your camera in tabular form:

f/4	*f*/5.6	*f*/8	*f*/11	*f*/16	*f*/22
1/1000	1/500	1/250	1/125	1/60	1/30

The top line represents *f*-stops, and
the bottom line represents shutter speeds.

Assuming that 1/125 sec. at *f*/11 is the correct exposure, you can progress up or down the scale in either direction and get the same exposure: 1/1000 sec. at *f*/4 will be the same as 1/500 sec. at *f*/5.6, 1/250 sec. at *f*/8, 1/125 sec. at *f*/11, 1/60 sec. at *f*/16, or 1/30 sec. at *f*/22. This mathematical relationship will always hold true; if the exposure is changed to 1/30 sec. at *f*/4, we know that 1/60 sec. at *f*/2.8 will yield the same exposure, and so will 1/15 sec. at *f*/5.6. The reason for the flexibility of different shutter speeds and larger or smaller apertures will be examined next.

Choosing Correct Shutter Speeds

One of the main functions of high shutter speeds is their ability to stop action. If you were to photograph a child playing, in order to "stop" the action of his movements, and secure a good portrait, a relatively fast shutter speed must be chosen. A slow shutter speed would result in an unsatisfactory, blurred image. How does this work in practice? Suppose the exposure meter indicates a reading of 1/125 sec. at $f/11$. Consulting the accompanying tabular material, 1/1000 sec. at $f/4$, or 1/500 sec. at $f/5.6$, will provide the same exposure as 1/125 sec. at $f/11$. Either of these high shutter speeds will give satisfactory results. If you were to use 1/60 sec. at $f/16$, or 1/30 sec. at $f/22$, the amount of light reaching the film would also be the same, but the resulting image would be blurred and unsatisfactory.

Suppose the child is not moving; in back of him is a mural that you would like to show in detail in the finished photograph, and in front of him is an interesting collection of seashells. In order to show good detail in both background and foreground, you must resort to a smaller aperture. Selecting an f-stop of $f/16$ shows an indicated shutter speed of 1/60 sec.; or if the lens were stopped down to $f/22$, the indicated shutter speed would be 1/30 sec. The foreground and background are now in focus, but there is another problem to overcome—steadying the camera for the slow shutter speed. Unless the camera is held with rock-like stability, camera movement can spoil the photograph.

Keep in mind that when shutter speeds slower than 1/30 sec. are selected, we are into time exposures (1/15, 1/8, 1/4, 1/2, and 1 full second or longer). To achieve best results, a sturdy tripod

must be used. Even if a conventional tripod is not used, there are a number of satisfactory tabletop tripods. When used with a sturdy tilt-top, these tripods can be utilized on tables, desks, or even the sides of walls, thus enabling the photographer to achieve the same steadiness as he would with a conventional floor model.

Development

Books have been written about the science of film development. There are more developers to choose from than there are films. Developers come in all kinds of formulations; there are high-contrast, fine-grain, and general-purpose developers; developers that will process a roll of film in 30 seconds, or half an hour. Which developer should you use? A developer that will best serve your particular needs, and one that will yield reasonably fine grain coupled with good film speed is ideal. This developer should also be clean working, have good keeping properties, deliver a long range of tonal values and good shadow detail, and keep highlight areas from blocking up.

Does such an ideal developer exist? It does indeed. In fact it was introduced by Eastman Kodak more than 40 years ago under the name D-76, and it is still very much in demand by amateur and professional photographers alike. The developer has excellent characteristics, delivers full ASA speed, renders good shadow detail, works well at high and low temperatures, can be used for push-processing to ASA 1600, is not expensive, has superb keeping qualities, is forgiving of photographer error, and can

be found almost anywhere. In fact, you can make it yourself from the following simple formula:

Film Developer

INGREDIENT	SPECIFICATION
Water	125 F (52 C)
Elon	29 grains (2 grams)
Sodium sulfite (dessicated)	3 oz., 145 grains (100 grams)
Hydroquinone	73 grains (5 grams)
Borax, granular	29 grains (2 grams)
Cold water to make	32 oz. (1 liter)

Standard developing time at 68 F (20 C) is 8 minutes. Capacity of 1 gallon is supposed to develop 10 rolls of 35 mm, 36-exposure film; but in actual practice you can go to 15 rolls. Most professionals use the developer in 1:1 dilution, and throw the solution away after one use; the increased developing time for 1:1

use is 11 minutes at 68 F (20 C). This classic developer has always been popular and remains so to this day.

Film Processing

After all the time and trouble you have experienced taking your picture, think of the time you would waste and the frustration you would feel if a good take were ruined by poor processing. The importance of careful handling of the film at this juncture cannot be stressed enough. To begin with, your working area must be scrupulously clean. Never develop film in the same room where you have just mixed chemicals. Chemical dust hanging in the air may settle on the film while it is wet, and ruin it. Diluting stock solutions of the developing agent should be done very carefully. Too much or too little water added to the developer will adversely affect the solution. When developing by time and temperature, temperature must be rigidly controlled, and accurately measured with a good thermometer. Solutions containing floating particles, whether they be impurities in the water or undissolved chemicals, should be filtered before use. In a pinch, sterile cotton will do, or one of the photographic funnels made for this purpose that has a fine-mesh screen built into it.

The darkroom *must* be dark. Stray light leaking in through doors or windows may spoil your film. Kodak recommends agitating the film in a small tank for 5 seconds at intervals of 30 seconds. Long experience indicates that 10 seconds every minute works as well and is more convenient. This is for film development. In the fixing solution, there should be 30 seconds of con-

tinuous agitation the first minute, followed by 10 seconds per minute after that. Washing the film should be done in water controlled to about the same temperature as the developer, stop bath, and fixer; wash for 15 minutes in rapidly running water (or 2–4 minutes if a chemical hypo eliminator is used; it saves water and does a better job). Place the film in a wetting agent (such as Kodak Photo-Flo) for 30 seconds, and then wipe off the excess water marks marring the film. Hang the film in a dust-free area to dry, and store in Mylar or Kodapak, or acid-free white paper for maximum protection.

3. Lighting

In the beginning there was the sun. Early photography studios were constructed to take full advantage of its brilliance. Slow lenses and slower films demanded it. As films and lenses improved in speed, the concept of the north light was utilized, and the sun was entirely blocked out. Finally, with the introduction of powerful studio flood lamps and brilliant spotlights, all daylight was blocked out and artificial light was the only source used. When the camera moved out of the studio and into the street for the candid portrait, the sun and the muted beauty of soft daylight illumination were rediscovered. Today, the photographer uses light as one of his most important accessories, and chooses the kind of light according to the interpretive style of the portrait he is doing.

An Important Accessory

The problem with the sun as a direct light source is the inability of most subjects to keep their eyes open or their features relaxed in direct sunlight. There are times when you will find it necessary to shoot anyway. One of the most useful accessories to have around at such times is the small electronic strobe unit. It is balanced for daylight color; and its size allows it to be tucked into the smallest of camera cases for accessibility. Finally, it can be used as a fill-in light to lighten shadow areas in the face, or as a main light source if the subject's head is turned away from the sun. This combination will give you a lighting effect similar to that used in a studio with a strong backlight and normal main light. If you do not have a strobe with you and must take a portrait with backlighting, the

Direct Sunlight

157

subject can be moved near a wall that is reflecting the sun. This works well in emergency situations.

A less convenient way to fill shadow areas is with a foil reflector. The reflector is usually 18″ × 36″ in size, with one side covered with aluminum foil, and the other with a white matte surface. Foil reflectors are usually made by the photographer.

Open Shade, Outdoors

The soft, even lighting of open shade gives the photographer one of the best lighting situations for outdoor portraits. Light seems to emanate from every corner of the sky, bathing the features in a glowing luminosity that is quite unlike the hard brilliance of direct sunlight. Eyes remain wide open, features are relaxed, and the subject is very much at ease. Even the negatives have a transparency that makes them a joy to print. By adding 25 percent developing time to negatives made under these conditions, the white values will have a little more sparkle, and the blacks will be emphasized for better contrast. No additional illumination is required unless you wish to add a lighting effect of your own choosing.

Single Light Source

One of the greatest boons to modern portrait photography was the invention of the tiny, thyristor strobe unit. In situations where speed of operation is essential, its almost instant recycling capabil-

(Right) Outdoors in bright sunlight, using a nearby wall as a reflecting surface. This is one way to get two variations from one light source. However, it will not work if the wall is not white.

(Right) Subject is backlit by bright sun. A foil or matte-white reflector throws enough additional light on the face; but since it is weaker actinically than the sun, if you expose for the face, the sun will give the head and hair a nice highlight effect.

ity is a great time-saver. Some of these units will even recycle fast enough to keep pace with the two-frame-per-second power-winders. With this little package of "sunlight" in your case, virtually any situation that you are apt to encounter can be adequately lighted.

I always make one modification when I acquire a new unit. I have the cord changed, and the socket altered so that the unit will take a standard, detachable P. C. cord. The other end of the cord has a standard socket plug, making it a simple matter to add a 20- or 30-foot extension cord.

The quality of light obtained from a shoe-mounted strobe is abominable. On the other hand, taking the strobe unit off the camera, and mounting it at a distance from the subject adds a whole spectrum of lighting effects and flexibility to the little unit. A simple C-clamp with a quarter-twenty thread, and small tilt-top enables the strobe to be mounted on bookshelves, door frames, and lighting fixtures; the possibilities are endless.

There is a basic lighting setup for a single light source, which is also applicable to a single floodlight, or a single umbrella light. Placing the light 5–8 feet from the subject, and 2–4 feet above the level of the subject's face at a 45-degree angle, helps to eliminate unsightly shadows in the background. The height of the light above the level of the subject's face eliminates reflections on eye-glasses; gives good modeling contour to the face; spills some light on the background for better effect; bounces light off the surrounding walls for more even light; and gives better skin texture, sharpness, and contrast.

(Left) Single light source. The light is at a 45-degree angle, 5–8 feet from the subject, and 2–4 feet above the subject's face.

Two Lights

There is a noticeable improvement in lighting effects when two lights are used instead of one. The first light is used as a main light, and the second can be used in a variety of ways. For example, it can be placed behind the subject's head, and aimed at the main light. If it is placed at the same elevation as the main light but closer to the subject, this second light will help pick up detail in dark hair, and add highlights to the head. Light hair will take on a sparkling, halo-like effect that is particularly effective with women and children. (When using this mode, turn off the electric eye, and switch to manual.) Another possibility is to use the second light as background illumination by turning it and pointing it toward the background. The beauty of the thyristor design in this situation is that no matter where you place the second unit, exposure will be correct, because of the automatic eye. Speaking of automatic eyes, the second unit can be touched off by adding a simple, inexpensive photoelectric triggering device that plugs right into the socket of the P. C. cord.

Replacing strobes with floods in the aforementioned situations will result in exactly the same effects. When using strobe units on extension wires, or floods that plug into the wall, check the picture area before shooting to make sure that none of the wires is showing in your photograph.

Three Lights

With three units at your command, there are many more possibilities open to you. The main light is relatively constant in all of these situations. The second light can be used in back of the

(Right) Two lights. The main light is at a 45-degree angle, 5–8 feet from the subject, 2–4 feet above the subject's head. The second light is aimed at the background and angled so there is no light spill on the subject.

(Right) Three-light setup. The first light (main light) is at a 45-degree angle, 5–8 feet from the subject, and 2–4 feet above the subject's head. Fill light is in front of the subject at a 45-degree angle on the other side of the main light at the same elevation as the head, but 12–14 feet away. The third light is on the background, angled to avoid spill on the subject's head.

subject to highlight the head or lighten the hair, and separate it from the background. The third light can be used to light the background, giving the entire setup modeling, depth, and separation. Or, the second light can be used to highlight the hair, and the third light can be bounced off the ceiling to fill all shadow areas of the picture.

Another interesting lighting effect is to place two strobes, equidistant from each other, at a distance of approximately 5 feet, lighting the side of the subject's head. The third light, with its automatic sensor switched off, directly faces the subject at a distance of 8 feet, and fills in the shadows caused by the other lights.

Bounce Light

There are several applications of the bounce light. The first, and most universally used is the ceiling bounce. The best way to utilize this effect is to angle the strobe 45 degrees toward the ceiling, making sure that the light is high enough above the subject's head so that no direct light spills on the subject's face. The unit should be at least 5 feet from the subject, with the automatic sensor switched to manual.

A second method is wall bounce. There may be times when the ceiling is too far away from the subject to work effectively. Or, you might want to try this interesting method for a variation in lighting. The effect will be quite dramatic.

A third method is to bounce the light off the front of your chest. This too produces a lighting effect quite different from the first two, and worth trying.

(Left) Single bounce light. The light source is angled toward the ceiling at a 45-degree angle. Care is exercised not to spill direct light rays on the subject's face. The light may also be handheld at the camera, instead of being placed on a light stand. Exposure increase is about two f-stops (for a white ceiling).

161

Bare Bulb

Some of the small, professional strobe units have removable reflectors. With this kind of unit you might wish to try one of the most remarkable bounce techniques in the book. The bare-bulb bounce is a way of achieving soft, even light with open, detailed shadow areas. The strobe bulb, without its reflector, is placed in the middle of the room, at a height of about 6 feet, with the subject about 3 or 4 feet in back of the bulb. When the strobe is fired, a very interesting effect takes place. The entire room becomes a giant reflector. The walls, ceiling, and floor reflect the light rays in hundreds of criss-cross patterns, bouncing off of every exposed reflective surface, and lighting all the shadow and highlight areas with a uniformity that is akin to outdoor lighting in open shade. The rays of light will bathe the subject in luminosity from all angles, like an enveloping stream of water.

(Above) Side-wall bounce, single light. This is a useful variation from the ceiling bounce, and lighting on the face is more interesting. Exposure increase lessens as the subject is placed closer to the wall. It is not advisable to use this technique if you are shooting in color and the wall is not white. (Above Right) Single bounce light off the photographers' chest. This technique is particularly useful when the ceiling is too high and the walls are not close to the subject. It may also be used effectively at night. (Right) Bare-bulb setup. The entire room becomes a giant reflector as light is bounced off walls, ceiling, and floor; shadows are filled with reflected light. The light source is about 5–8 feet from the subject and slightly higher than the subject's head.

Umbrella bounce is a technique that brings a mobility and flexibility to bounce lighting that is in many ways superior to merely bouncing a light off of a ceiling or wall. Special umbrellas are made specifically for photographic lighting. They are usually white, come in a choice of shiny or matte surfaces, and range in size from 18 inches, for easy portability, to 60 inches, for fixed studio use. Bouncing light off of a wall or ceiling gives the photographer a very limited choice of lighting. The umbrella, on the other hand, may be positioned in dozens of different positions for many subtle lighting effects.

The quality of light emanating from an umbrella delineates fine texture, yields excellent skin tonalities, and avoids the contrasty effects of direct light. The easy portability of the 18-inch umbrella makes it ideal for the location portrait; and its broad

Umbrella Light

(Above Left) Single umbrella light. This technique is similar to single direct light, but the final effect is much softer; shadow areas are more open and overall effect is more pleasing. (Above Right) Twin umbrella lights diametrically opposed at 45-degree angles from the subject. For umbrella lighting, this effect is more dramatic than the single source. Both umbrellas are 4–8 feet from the subject's head and 2–4 feet above it. (Left) Three umbrella lights. The subject is lit with three umbrella lights, which literally bathe the face in light from all angles. The face lighting is quite dramatic with strong sidelights and open shadows. The two side umbrellas are equidistant from the subject's ears, on a level with the head; the front light is farther away from the subject and acts only as a fill for the shadows.

coverage (akin to using an 18-inch reflector) avoids hot spots and over-bright highlights that are associated with concentrating reflectors.

Small Strobe

Although it was originally designed for amateurs, the small strobe has long since been adopted by professionals. Slim Aarons, a good friend and well-known photojournalist, travels around the world several times a year on assignment, shooting full-page color ads, and major magazine color essays. His principal light sources are three $20 strobe units.

In my own work as a staff photographer for *The New York Times*, I photograph as many as 200 well-known personalities in the course of a year. My lighting kit contains two small strobes, occasionally augmented by a third if a large background is an important element in the portrait to be made. In emergency situations I have sometimes used table or floor lamps. Any source of light can be used if it is properly handled.

The small thyristor strobe is very efficient and does its job well. A light source that is used by professionals is often termed a professional light source . . . these tiny units certainly qualify.

4. The Print

The culmination of all your efforts shows itself in the final print. The creative intensity poured into making a fine portrait, and the rigidly controlled labors of processing the negatives will come to fruition in the print. One of the great thrills in photography is immersing a sheet of enlarging paper in the developing tray and watching the gradual emerging of the image on paper as it builds in tone and intensity. The yellowish tinge of the safelight is reflected in the shiny, wet paper; the acidic smell of fresh hypo hangs in the air; and the tiny droplets of chemical solution trickle back into the tray as you examine the fruits of your labor.

The good print is not measurable by scientific formulae or rigid mathematical tables. It is an esthetic experience arrived at by a combination of science and art, and a continuation of your creative interpretive efforts. The mechanical logistics of enlarging can be taught in weeks . . . producing the fine print may take years.

There are some photographers who never print their own work. Two that come to mind are Cecil Beaton and Henri Cartier-Bresson. Compare a print made by Bresson's printer, and one of W. Eugene Smith's own prints, and the difference will immediately become apparent. Only the photographer is aware of the nuances of the photograph he has made; he put them there. Only he knows exactly what he is trying to say . . . photographically. Only he can produce the best print from his negative. His vision may require that the print be dodged, burned in, darkened, lightened, or cropped in a certain way; only he knows what kind of manipulation will produce on paper what he created when the photograph was made.

The Art of Printing

Over the years many professionals have asked me, plaintively, if I know a good printer. No matter how good a printer is, he cannot create on paper what was in the photographer's mind when the photograph was made. Printing is a curious science of art and intuition. Only the photographer who has taken the picture knows the exact combination of ingredients, and it may take him many sheets of paper to arrive at what he sees in his mind's eye.

Proof of the value of the photographer making his own print can be found in the photographs obtained by museums, galleries, and collectors. The photographic print made by the photographer himself is much more highly prized than similar prints made by others from the same negatives. A good example of this is the Weston photographs. Prints made by Edward Weston sell for upwards of $1000. The same prints, made from the same negatives by one of his sons, can be purchased for as little as $400.

The Contact Print

Printing, like any craft, must be studied and practiced. Before the photographer can exercise his creative interpretations, he must learn the ABC's of the process. The first step in the printing process is making the contact sheet. The printing frame is specially designed to hold the strips of film flat during the printing process. It is not necessary to get top quality on the contact print. Remember, there are 20 or 36 exposures being printed at once, some of them varying in density from others. You are looking for tiny prints with enough information and detail to evaluate expression,

composition, and any disturbing elements that may have been overlooked when the picture was made.

A good magnifier is essential to enable correct "reading" of the tiny contact. I have been using an excellent 4× wide-angle magnifier made by Schneider that shows the entire contact print, corner to corner, and makes evaluation quick and certain. It can be focused for your own vision, and is an invaluable tool.

Another worthwhile accessory is the negative notcher. It looks like a hole-punching device, but there is a stop plate built in that notches a half-moon area and does not protrude into the picture area. This enables you to find the negative you are looking for in the dark by touch. If you should go back to a roll of film after a period of years, the notch will tell you instantly which negative was originally printed. Good stationery stores carry this item.

Enlarging the Negative

Enlarger. The most important piece of equipment in your darkroom is the enlarger. There are three types of enlargers: (1) condenser, (2) diffusion, and (3) a combination of both.

There is no doubt that the most widely used type is the condenser. The enlarger head consists of a light-bulb holder (the enlarger bulb is a white, translucent, 150-watt lamp), and a set of condenser lenses situated directly below the lamp housing. The condensers focus the rays of light on the negative, and spread the illumination evenly across the negative surface. This type of enlarger gives sharper, more contrasty prints than the other types, and is more likely to show dust and scratches on the negative.

The diffusion enlarger also has a lamp housing with a 150-watt, white, translucent bulb; but instead of a set of condensers, it has a piece of flashed opal glass, or a ground glass, graduated in density so that it is more opaque in the center where the brightest rays of light fall, and less opaque at the corners to even out the intensity of light across the negative plane. The diffusion enlarger prints more slowly, and with less contrast, but is more effective in masking dust, scratches, and other negative defects.

The third type of enlarger, a combination of condenser and ground glass, or opal, lies somewhere between the other types in contrast and intensity, and is much less commonly used.

Better enlargers offer a choice of enlarger heads, and can be switched from one type to another at any time by purchasing an additional accessory head.

The most important mechanical factor to look for in an enlarger is rigidity. There will be times when exposures may run as long as a minute or more; and if the enlarger is not steady, your prints will lack the quality of the negative from which they were made. The focusing mechanism must be well designed so that it doesn't shift during exposure and destroy the clarity of the photograph. The enlarger should be properly grounded to help keep dust problems at a minimum. A short length of wire attached to the enlarger upright, and running to a metal ground will do the job.

Negative Carrier and Easel. The next important part of the enlarger is the negative carrier. My recommendation is that you

have both types: glassless, and glass. The glassless carrier will be used for the bulk of your work; but there will be times when you have to make large prints that require long, time exposures, and you will be glad to have the glass carrier. This will prevent your negative from curling during the exposure and causing an out-of-focus print. There will be another inconvenience introduced with the glass carrier—four additional surfaces to pick up dust—but the insurance that the negative will lie perfectly flat during long exposures is worth the extra problems incurred.

The easel holds the enlarging paper flat during exposure. It should be heavy enough so that it doesn't "skid" (slide around) during exposure; and the blades must be parallel to one another so that the print is square.

Enlarging Lens. The heart of your enlarger system is its lens. It makes little sense to spend a great deal of money on precision optics for your camera, and then try to make enlargements through a poorly designed, cheap enlarging lens. The minimum acceptable quality for your enlarging lens is the best you can afford. Most photographers use a 50 mm enlarging lens for their work. A 60 mm lens delivers more even light over the entire negative. If you already have a 50 mm lens, stay with it; but if you are considering the purchase of an enlarging lens for 35 mm negatives, consider the longer focal length of the 60 mm. Look for click stops on the mount of the enlarging lens. This is a great convenience when you are working in the dark; it saves fumbling around with a small flashlight, or turning on the lights to change the lens

opening. Some of the newer enlarging lenses have built-in illumination for *f*-stops, which is another feature worth considering.

Keep both the enlarging lens and the condensers of your enlarger scrupulously clean. Dusty surfaces cut down on clean, crisp definition in the final print, and lengthen the exposure time.

Darkroom Accessories

Timer and Safelight. Another important accessory for the enlarger is the timer. The better timers have several outlets built into their back section. One of these outlets is for the enlarger, the other for the safelight. They work in sequential operation; when the timer is set for the amount of seconds desired, you simply push the start button. A simultaneous action takes place the moment this is done. The safelight plugged into the timer goes off, and the enlarging light turns on and begins the exposure that has been preselected. After the selected exposure time has been reached, the timer shuts off the enlarging bulb, and turns the safelight back on again. The reason the safelight is turned off during exposure is to prevent possible paper fogging. Some of the newer timers offer the option of audible clicks at 1-second intervals. This valuable feature enables you to count off dodging and burning-in operations at the same time that the print is being exposed.

The second timer you need is one for timing developing, fixing, and washing operations. The most convenient place for this one is on the wall, right over the processing trays. The usual timer for this operation has a large second hand, and a minute

hand that keeps track of elapsed time up to one hour. The second hand is valuable for timing the print in the developing solution; the minute hand for the fixing and washing cycles. The faces of these timers should be large enough to be seen at a distance of several feet; some have dials that glow in the dark, or there are the self-illuminated digital types. Electric timers are more reliable than the spring-wound variety, and are less apt to stop in the middle of an important timing cycle.

Safelights should be exactly that—safe. Use the filters in them only for the recommended papers with which you are working. Be sure they are placed far enough from the easel holding the sensitized paper, and from the developer tray to avoid graying the tonal values of the enlargement with fog.

Magnifier. Many people think they can focus a negative in the enlarger with their naked eye. I ran a test some time ago with a professional printer who claimed that he could focus any negative without the aid of a magnifier, and had been doing it for years. We put a good negative in the enlarger, and he carefully focused by eye. I checked his score with a grain-focus magnifier, and he was out of precise focus *ten* out of *ten* times. There is no substitute for a high-power magnifier for critical focus. This is most important when working with 35 mm negatives. Magnification of the image will be on the order of 10–15×; and the only type of magnifier that will be on target every time is the grain-focusing type. These magnify the grain 20–25×, and leave no room for error; either you are in focus or out. There will never be any doubt.

Cleaning the Negative. There are several ways to clean the dust from negatives before printing. One way is with a camel's hair brush that has a built-in plutonium strip, which effectively neutralizes static electricity. Without the strip, brushing would cause dust to gravitate toward the negative like iron filings to a magnet. Another method is compressed air, which is usually available in pressurized cans. The best way is a combination of both methods. Start with the antistatic brush, and brush off the loose particles that may be on the surface of the film. This action will at the same time neutralize the static electricity charge built up by the act of brushing. Finish with the compressed air, which will blow away any remaining dust particles without building up a new charge.

Printing Techniques

Dodging and Burning In. Dodging and burning in portions of the print during enlarging are two of the more important control processes in the darkroom. There are several inexpensive tools made for this job. The dodging (holding back) device is a simple strip of firm wire with a small, solid circle on the end. There are several circles in sizes ranging from ¼ to 1½ inches. These are interchangeable, depending on the size of the area that needs dodging.

For burning in, there is a vignetting device with an infinitely variable opening that can be shaped to the configuration of the area to be burned in. Both these devices are available from most local camera stores with a darkroom supply department.

Other Printing Necessities. The remaining basics you will need before starting to print are:

1. Trays. These should be at least 2 inches larger than the maximum size print being made. For example, a tray size of 12″ × 16″ or 14″ × 17″ should be used for an 11″ × 14″ print. White plastic trays are easiest for viewing the prints in the developer, and evaluating them in the hypo.
2. Print tongs. These should be made of bamboo, plastic, or stainless steel. The type is not too important; but the ends of the tongs should be sheathed in plastic or rubber to avoid scratching the emulsion. Use one set of tongs for the developer, and one for the hypo.
3. Graduates. Graduates are used for mixing chemicals, and come in a variety of sizes. There should be markings in both U.S. and metric systems. Capacities should range from 1 gallon down to 4 ounces. Stainless steel is preferable, but some of the new plastics are good, and much less expensive.
4. Siphon. Kodak makes a simple siphon that is fitted to a tray, and makes an excellent print-washing device.
5. Squeegee. A 12–15-inch squeegee is used for getting the excess moisture off print surfaces before drying them.
6. Blotter roll, or dryer. A blotter roll, electric dryer (for fiber-based papers), or a simple plastic drying frame (for resin-coated [RC] papers) can be used to dry prints.

7. Thermometer. The accurate, dial-type thermometers are easiest to read and to use. They are made of stainless steel and have a clock face.

With all the accessories and enlarger in place, you are ready to print.

Some Pointers

The function of this chapter is not to explain the ABC's of making a print; that would take a book in itself. There are, however, some aspects of printing that should be discussed and studied. For example, try to keep printing exposures somewhere between 10 and 30 seconds, whenever possible. The theory that holds here is that light rays passing through the paper base during exposure reflect through the back of the paper and degrade the tonal values somewhat. Most easels have a white or bright yellow surface. The purpose is so that you will focus the image on the easel, insert your paper, and make the print. The error behind this reasoning is that photographic papers have thickness. When making a large-size print, the image will not be precisely in focus if this procedure is followed. The solution to this problem is to use a second sheet of paper of exactly the same thickness as the paper you will be exposing; focus on this, and then substitute the paper that will be used.

Prints should be fully developed. Many papers call for immersions ranging from 90–120 seconds in the developer. (This does not hold true for *all* papers.) While the print is in the developing solution it should be kept moving all the time for even

developing action; and it should be reversed every 30–45 seconds until developing time is completed. After 15 seconds in a stop bath, and 2 minutes in a fresh, fast-working hypo, the print is ready to be washed. The washing procedure for fiber-based papers is a terrible drain in these ecology-conscious times. Use a hypo eliminator, which cuts wash time to minutes.

Photographic Paper

There have been many discussions about the merits of variable-contrast paper versus graded papers. From the standpoint of economics, it is less expensive to keep a single box of variable-contrast paper than to stock six boxes of graded papers. Most photographers invariably watch the papers on the soft and hard end of the scale go out of date, and replenishment becomes necessary. A compromise that works for many is to keep a box of variable-contrast paper along with a 10-sheet package each of soft (#1) and hard (#5) papers for the negatives that require papers outside the range of the variable-contrast stock.

Should prints be dried glossy ferrotyped, or glossy unferrotyped? This is another controversy that's been going on for a long time. The most popular finish for most photographers is the glossy unferrotyped, which gives a rich sheen without the characteristic shine of the other. The matte and semi-matte papers are less than satisfactory for most photographers. Too much tonal range is lost, and contrast suffers.

At the present time, Kodak's RC papers come in glossy or matte finishes. The glossy surface is fine; the matte less so. Ilford

recently introduced a superb RC paper called "Pearl." The paper has a high luster, beautiful black-and-white tones, and a magnificent range of values. There have been continuing rumors that the fiber-based papers will be discontinued at some time in the near future, and the only papers available will be RC papers. If the evolution of these papers continues in the direction that Ilford has recently taken and their permanence is improved, photographers may choose RC papers because they prefer them.

The prints for this book were selected because they demonstrate ways of handling different situations in which RC paper works for me. It may not work for you; only you can be the judge of that. The technique of your fine print can only be articulated by you; so follow your instincts. The art of creating is a lonesome road, and you are the one that must find the road, and have the courage to follow it.

Archival Processing and Print Storage

No discussion of the fine print would be complete without some information about archival processing and proper print storage; in other words, the complete elimination of residual chemicals that would cause deterioration of the image in a short space of time. According to photographic standards, that would mean 1–10 years. For archival treatment, the time standards lengthen to periods in excess of a century.

After going through the trouble of making a fine portrait, processing the negative with painstaking care, and using your

best creative efforts to turn out a magnificent print, you would like to see the print last. The only way to insure its durability is to adopt careful working habits, and take certain precautions.

One of the prime sources of contamination is the chemicals that are left in trays from the previous working session. You must make it a point, after each session, to thoroughly clean and dry all trays, print tongs, graduates, and work surfaces that have been involved in wet processing. The work surfaces of the darkroom should also be scrubbed and scoured until they are completely free of all traces of chemical residue. Leftover solutions should be discarded; any attempt to utilize weakened solutions for the next printing period will surely result in stained and faded prints. Paradoxically, fixing the print is the only way to preserve the image; however, unless these same chemicals are thoroughly eliminated, they could act as the most destructive causative factor in print impermanence.

One of the common practices in archival fixing for fiber-based papers is to use a two-tray fixing bath. The used fixing solution is usually carried over to the next work period, where it serves as the first fixing bath. The second tray contains a fresh fixing solution. When the first print has been through the developing and stop-bath solutions, it is placed in the first bath. When the second print has been through the same process, it is placed in the first fixing bath, and the first print is transferred to the second fixing bath (which is the fresher of the two).

My own method is to follow the same procedure, but to set up *two* fresh fixing baths. It is very important not to overfix prints.

After a certain period of time a bleaching action begins, which destroys the tonalities you have labored so hard to achieve. The importance of careful timing at this step cannot be overstressed. When the print has reached its optimum time in the solution, it must be immediately transferred to the wash tray. Washing the print must also be carefully timed. Overwashing will weaken the internal structure of the print and make it more susceptible to various forms of damage.

Drying prints between blotters is another procedure that I do not recommend. These surfaces soak up chemicals, and retain them. Frames made with plastic or fiberglass screening are much safer, because these materials will not absorb chemical solutions, and can easily be cleaned.

Throwing archivally processed prints into a cardboard box or mounting them on an ordinary mat board are two more ways of courting disaster. Both the boxes and boards contain chemical impurities that will affect the prints in a comparatively short time. There is only one way to safely store or mount prints. We must resort to the use of acid- and chemical-free boxes and mat boards. These are readily obtainable from Light Impressions Company in Rochester, N.Y., or the Hollinger Corporation in Ohio.

5. Color

Color is rarely photographed as it is seen. The reasons for this apparent anomaly are a complex combination of esthetics, physics, and the compensation of the eye; versus the literal interpretations of the film and the variations built into these interpretations.

To the untrained eye, a person's face seen in an outdoor setting may appear to be the same color throughout the day. The trained eye will see infinite changes in the color of the skin, and hues reflected from it. The rising sun of early morning will be the first of many color changes. The green cast of a wooded glade, the purple reflection from a nearby sign, the orange tinge of late afternoon sun, the blue tint of open shade—there are a multitude of variations and they all have an effect on the film.

To make the situation even more complicated, all films are biased toward certain areas of the spectrum, and each film will give its own interpretation of what it sees. Complicating the lot of the color photographer even further, all color films will shift color in one direction or another as they stand on dealers' shelves awaiting your purchase.

This will occur with so-called 35 mm professional color films that are stored in refrigerators. The "aging" of films is somewhat retarded by cold storage, but the shifting of color balance goes on. The one certainty that emerges from this list of *un*certainties is that much good color photography is produced despite this proliferation of inexactitudes.

The technique for producing good color portraits is not the same as it is for black and white. Heightened dramatic impact,

**Things
You Should Know
About Color**

usually achieved in monochrome portraiture with good contrast, would be ruinous in color. At this stage of its development, color film simply does not have the capability of black-and-white film to handle long tonal scales and good tonal contrast. In color photography, contrast is achieved by the juxtaposition of different color values. Lighting must be kept frontal or flat, in order for color film, with its more limited tonal scale, to reproduce what it sees.

Exposure

The importance of correct exposure control cannot be emphasized enough. Without it, good color is an impossibility. Where clothing and background are important components of the composition, the reading and evaluation of these additional elements must be given proper weight in assessing the exposure as a whole. For example, a person standing in front of a very white background, or perhaps a brilliant yellow wall in bright sunlight, will affect the reading of an exposure meter, whether it be a handheld model, or one that is built into your camera; the reading obtained will cause noticeable underexposure of the skin tones. If that same person is standing against a very dark background, in the same, very bright sun, the face will be overexposed.

The exposure meter is attempting in the first case to take into account the very bright background, and compensate for brightness. In the second example, the reverse is taking place; the meter is attempting to allow adequate exposure for the dark background. In both cases, the most important value of the picture—

the skin tones—is receiving incorrect meter value. The solution to both problems is moving the meter (or camera, if the meter is built in) within 12 inches or less of the subject's face, being careful not to cast a shadow on the face, which will also throw the meter reading off.

Another frequent problem with color film is its tendency to pick up reflections from nearby walls or backgrounds. If these surfaces are brightly colored, they will inevitably throw reflections on the face. Light skin tones are most susceptible to picking up and reflecting any colors within their range. Great care must be exercised in choosing backgrounds, and placement of subjects within range of these disturbing reflective surfaces. In some instances when placement of the subject is beyond your control, a certain amount of after-correction is possible by copying or printing an affected portrait, and introducing corrective measures with filters; but when placement is optional, it is a lot easier to avoid this difficult situation.

Filters

Color-compensating filters come in dozens of colors, and hundreds of tints. They are generally useful in controlling, to a certain degree, lighting that does not fall within the color balance of the film. One of the most useful outdoor filters is a noncolor filter. When properly used, the polarizing filter (gray in shade) will greatly improve color values by increasing color contrast and depth (saturation) by eliminating most reflections from surfaces such as water, metal, sky, etc. In the process of doing this, the

purity of all colors is improved, and the finished appearance of transparencies and color prints is greatly enhanced. With a few basic color filters, you are in a position to handle most photographic problems as they arise. Following are some of the most useful filters:

Filters

FILTER TYPE	CORRECTIVE FUNCTION	EXPOSURE INCREASE
Polarizing	Better color saturation; eliminates reflections	1–2 f-stops
1A, 1B, 1C UV (0) (¼) (½)	Corrects, eliminates, blue in photographs made in open shade, high altitudes, and beach scenes near large bodies of water, or in rain scenes.	None to ½ f-stop
85B	Corrects color film balanced for tungsten illumination, in daylight.	⅔ f-stop
FL-D	Corrects (to a degree) daylight color film used under daylight color fluorescent lighting.	1½ f-stops

Filters may be used to *add* color to certain photographs for special effects. For example, to increase the blue effect of a rainy or overcast day, there are gelatin filters available in a wide variety

of tints and shades of blue. Adding a red or orange filter will increase the intensity of portraits made under sunset conditions. A pie-shaped filter made of segments of different colors can be used to obtain psychedelic effects; vaseline, colored with transparent dyes, and smeared around the circumference of a skylight filter (with the center left clear) will produce fascinating photographs, particularly at night, or against highlighted hair.

The most convenient way to support gelatin filters is with filter frames and holders. Kodak, Tiffen, and Hoya make these devices, and most photographic dealers can order them for you.

It is a good idea to do your experimenting with these various filters when you have the time to try different combinations. When you have accumulated the know-how, try them on a portrait for unusual pictures.

The photographer who decides to specialize in location portraits, and works most of the time outside a studio situation, might consider adding a color-temperature meter to his equipment list; the photographer who shoots portraits occasionally will fare pretty well with the aforementioned filter list, and some judicious testing.

Color Film

Choosing the right color film will be determined by your final intentions for its use. If you are shooting for publication in a magazine or book, or you plan to use your work for audiovisual or teaching purposes, color slide film should be your choice. For making color prints, color negative material is best, although

many photographers are now using printing materials designed for making color prints directly from color slides. On the other hand, color negative film is much more flexible than transparency film. From a good color negative, it is possible to get an excellent color print, a very good black-and-white print, an excellent color slide, or an excellent black-and-white slide, with an ease that is beyond the capabilities of the color transparency material. Color negative material is considerably more forgiving of photographer error than is slide film.

One of the first color films introduced to the American public was Eastman Kodak's Kodachrome. To this day the film, which is greatly improved from its original form, and now known as Kodachrome 25, is still the best color film available. Color brilliance, contrast, and saturation are unsurpassed, and it has the finest grain of any color film on the market.

A companion film to Kodachrome 25 is Kodachrome 64. With an ASA of 64, as opposed to 25, this film gives the user increased film speed, which means more flexibility, at the cost of a lower contrast and saturation level than the Kodachrome 25, and slightly larger grain size.

There has been a technological explosion in the recent introduction of high-speed color films. Kodak's new E-6 Process, daylight Ektachrome 200 is a superb outdoor color slide film that is perfect for lesser lighting conditions, and ideal for portraits of children and sports figures. In color negative films, Kodak, Fuji, and Sakura have all introduced ASA 400 materials that permit the user to work as well outdoors in sunlight, as indoors in tungsten

without changing film. Considering the high speed of the film, the color balance is excellent; and grain size, although moderate, is quite acceptable in prints up to 8″ × 10″.

What makes color portraiture more complex than black and white is the element of color itself. Heads posed against monotone backgrounds in color can be more effective than black and white; but they achieve fullest effectiveness when rich, colorful backgrounds are selected. When using the slower color films for maximum quality, the ASA ratings cause problems in the form of slower shutter speeds and wider apertures. Slow shutter speeds can mean blurred images caused by camera or subject movement; larger apertures can be the cause of unpleasant images caused by the drastic diminution of depth of field. The photographer must juggle various factors, such as the kind of image he wants, and what sort of price he is willing to pay in terms of good color rendition, quality, grain, convenience of exposure, and brilliance of the final result. Loss of control of any one of these elements can cause failure in the final result. Often, there are no easy answers, only difficult questions; but by working continuously with all the materials, and by making unending test pictures, you will gradually build up a repertoire of techniques that will stand you in good stead when you are faced with a difficult photographic problem, and little time to solve it.

Many of the great painters were continually experimenting. Picasso, right up to the time of his death, was always searching

Technique

for new and more exciting ways to interpret what he saw. Photographers seeking to improve their skills and techniques must do no less. Color does not have to be expressed in rule-book fashion all the time. Bending and breaking the rules will often produce good photographs, or ideas for future photographs. Failures are keys that open the doors to successes. Don't be afraid to fall on your face once in a while; you might stumble onto gold, while you are down there.

6. The Confrontation

Most formal portraits begin as psychological confrontations between photographer and subject. The subject may or may not know the photographer; but as soon as he faces the camera, an entirely new relationship comes into play. The first few minutes of the meeting often predetermine the success or failure of the portrait. Initial impressions set off conscious and subconscious reverberations that, for better or worse, will have a profound influence on the final image. One will try to dominate the other. The photographer must win this encounter if he is to be free to exercise his skills and creative talents. Once he has gained control, he must retain control. If there are any signs of wavering, he will lose the battle he has just won.

This initial phase of the encounter is followed by another. Setting up the lights, arranging background details, choosing lenses, and all technical phases must be handled with deftness and surety of purpose that will in turn give the subject confidence in the photographer. This is as much a part of executing the portrait as lighting, composition, and technical excellence.

The photographer himself must be totally relaxed; this will not only be communicated to the sitter, but it will bring to the photographer an ease and fluidity of motion that will make it easier to bring into play the creative aspects of the sitting. At this point, the photographer must exercise dual control—domination of the subject, and the creation of the fine portrait. This duality of performance must be developed through constant practice.

In time, this kind of control becomes second nature to the photographer, and as much a part of his equipment as his photo-

Photographer and Subject

graphic apparatus. After the sitting has been concluded, the end is by no means in sight. The critical processing of the negative must be done with an exactitude that precludes error. Any slipshod or careless action at this point could wash the entire project down the drain with the wash water.

Making the final print represents the important pivotal conclusion in the process. A bad final print is only disastrous if it is delivered. Finished prints must be the very best product of the photographer's craft. Here, tonal qualities can be refined with knowledgeable use of the full panoply of sensitized papers available to the creative darkroom worker. The finished print must be crisp and clean, and as free of errors as is possible. Composition can be strengthened by cropping; and corrective actions such as dodging, burning in, and holding back must not be glaringly evident to the eye.

Portrait Psychology

Putting the subject at ease is one of the most important first steps to take. An informal flow of conversation, a relaxed manner, and unhurried movements all help. The first roll of film I shoot is to familiarize the subject with the camera, lights, and logistics of the operation. These pictures are rarely used, but they serve a purpose. There is an almost hypnotic sound in the click of the shutter, and in the euphonious sound of the motor drive whirring; but the real action starts with the second roll of film.

When a person regards himself in a mirror, the face he sees is reversed from left to right. As a result, his face does not look the

same to him as it does to you, or to the camera. The photographic print he sees of himself is the opposite of his mirror image, and as a result, has a certain alien quality that he finds difficult to comprehend. Getting back to that magic mirror . . . the average person looking at his mirror image also does a psychic retouching job on his face. His mental processes automatically block out all defects; a large nose becomes smaller, a weak chin develops strength and character, a bad complexion becomes smooth as silk, and so on. Unfortunately, neither the photographer nor the camera has this unique insight. The camera will report literally what it sees. The photographer, by judicious use of perspective, lighting control, and good printing technique can do wonders with any face; but rarely can he come up with the mind's eye image that the subject has of himself.

The portrait photographer must picture the subject as he sees him, and stand firm with his interpretation. This usually results in a monumental ego battle, because the subject wants his image to appear as *he* sees himself. The photographer who has produced a fine, creative portrait must stand on his integrity; he will be judged by his interpretation, not by what the subject thinks of it. If false pride and conceit were among original sins of man, the mortal sin of the photographer would be to indulge these conceits.

"Smile!" "Say Cheese!" What an affront to the intelligence are these inane directions used by so many photographers. What an inadequate, inept way of attempting to put a subject at ease. A person-to-person dialog that establishes rapport between two people is more effective. It is much easier to elicit desired re-

sponses from the person being photographed when your manner is easy and professional.

Retouching the negative was never a desirable art, even when the negative was 8″ × 10″ in size. The professional photographer uses light and lens as his retouching tools with 35 mm film. Is the nose too prominent? Get the camera below the chin line and shoot upwards. Does the chin jut out too far? Placing the camera level with the chin, and shooting head on will help tremendously. Too much poundage around the torso? Part of a table, or an interesting piece of sculpture masking a portion of the figure will help. Is the subject's skin too sallow for a color portrait? A color-compensating filter on the lens will give the skin a nice, healthy glow.

There are so many easy, effective ways of putting a sitter in the best possible light, without sacrificing or frustrating your creative thrust. A little study of the subject as you work will reveal what has to be done, and the easy solutions will suggest themselves. This will leave you free to work out lighting, expression, composition, and the full interpretation of the subject's personality. As you continue to exercise these judgments, your skills will improve, and decision making will be facilitated.

The Successful Portrait

The most successful portrait is one that pleases both photographer and subject. How do you arrive at this happy state? More often than not by setting out to please yourself. If you manage to

photograph the subject in a way he has never seen himself before, the results will intrigue, and probably please him. If lighting is good and expression spontaneous, a fine portrait will result. The chances are excellent that the subject will like what he sees; and if the picture is for publication, the client certainly will.

What about composition in portraits? Forget about formal rules. Don't bother with S-curves, 1/3 to 2/3 proportions, Tatum's Law, and the mathematical ratios between blank spaces and those filled with subject matter. In short, concentrate on making pictures that please you, without sweat, tears, or formulae. Better pictures will naturally follow.

Photographic portraits of people are one of the most satisfying aspects of photography. Concentrate on expression and interpretation; most cameras today will take care of the f-stops and shutter speeds. The portrait is the thing. Follow your instincts; go with your gut reactions. Don't copy other photographers; do your own thing. You will feel more comfortable and so will your subject. If you have confidence in yourself and your abilities, you will be sure to please yourself. The best way to improve your picture taking is by taking pictures. It's exciting, challenging, and it will keep you on your toes; and best of all, you will be doing exactly what you want to do.

Photographing people—portraiture—is a complex art form requiring solid psychological understanding of human nature, mastery of photographic techniques, and a full measure of self-discipline. Unless the photographer has a firm grasp of these purposes and concepts, and the artistic flexibility to break his own

rules, he is destined to fail. After these learnable skills have become part of one's repertoire, they will demonstrate their value in all areas of photography. It's easy to lump people into comfortable categories, and treat them as replicas of one another . . . but it is a bad mistake. People are like fingerprints; no two are alike. Each one must be approached as a new challenge, requiring a different solution. The correct solution will become a good portrait; and the correct, *imaginative* solution will resolve itself into the fine portrait.

The portrait photographer must try to capture more than a superficial rendition of the subject. The inner self is revealed only to those looking for it; and it contains the spark that makes one person different from another, as well as the element of personality that makes each person unique.

We are all shaped by external life forces—our upbringing, our social background, our families, and our friends. They all leave their mark on us—form our personalities as well as the way we think and act. The accomplished portrait photographer must skillfully unite these diverse elements into a homogeneous statement that will say in one photograph what it would take many words to accomplish.

7. Selling

Is there a good market for portraits? There is indeed! In fact, it is probably much larger than you would imagine. Following is a list of areas where portraits are in continual demand—sources that are constantly searching for fresh, new images:

1. Business portraits
2. Personality portraits
3. Travel portraits
4. People in the news
5. Theatrical portraits
6. The arts: painters, sculptors, and artists of all kinds
7. Medical portraits: doctors, psychologists, dentists
8. Men of science
9. Documentary portraits
10. Portraits for book illustrations and encyclopedias
11. Authors and publishers
12. Sports figures
13. Musicians, conductors, composers
14. Satirical portraits
15. Magazine covers
16. Museums and galleries
17. Public relations
18. Advertising
19. Babies and children
20. Men and women
21. Weddings
22. Schools: elementary, intermediate, university
23. Political portraits

The Portrait Market

24. Newspaper portraits
25. Society portraits
26. Business executives
27. Diplomatic portraits: UN, ambassadorial, royalty
 (major and minor)

In every walk of life, in every trade and profession, and in every area of human and social contact, there are demands for photographic portraits. The popularity of photography has put a camera into everyone's hands. You might think that this makes it more difficult to sell pictures. Nothing could be further from the truth. The average person can never produce the kind of finely composed, beautifully printed photographs that the talented professional can give them. From the very beginning, when films became fast enough to record faces in a fraction of a second, people lined up in front of photographers' studios by the dozen, waiting patiently to have their photographs taken for family, friends, and themselves.

In the early 1900s Edward Steichen photographed J. P. Morgan seated in a chair. It was to become one of the celebrated portraits of all time. An accidental reflection in the wooden arm of the chair made it seem that the financier was pointing a large dagger at the photographer. At first Morgan didn't think much of the picture; but as word spread, and the picture literally became the talk of New York City, he decided to buy it. Steichen asked $5000. Morgan was astonished at the audacity of a photographer asking more money for a photograph than well-known painters were receiving for large oil paintings. The photograph was even-

tually purchased, and may be seen to this day at the Morgan Library in New York City.

There are some photographers who command $1000 and more for a portrait sitting. Advertising agencies regularly pay more than that for portraits used in national ad's; and portraits on the covers of some magazines are priced at that figure. *The New York Times* paid $1000 for a portrait of Richard Nixon writing his acceptance speech at the Republican Convention in Chicago. The photograph, made by David Douglas Duncan, was one of five offered to *The Times* at the same price for each one.

Sittings by society photographers usually bring more than that amount. An album of portraits by Julia Margaret Cameron recently brought $120,000 at auction; and a portrait of Edgar Allan Poe by an unknown photographer realized more than $35,000 at auction. A well-known photographer told me that he worked just as hard on a $100 portrait as he did on a $1000 portrait. So, why not go after the $1000 portrait? Before you try, there are certain preliminary steps to be taken.

The Presentation

The art of presentation of your work is as important as the taking of the picture, when you are trying to sell the product. Carrying prints around in a soiled envelope; or displaying a print that is not of the very best quality; or one that is dotted with dust spots and dog-eared, is the worst possible way to make a presentation. Quality control must be exercised at all levels, from the making of the print, to your own manner and appearance.

The first step in your presentation should be the acquisition of a good loose-leaf binder. Why loose-leaf? Loose-leaf format gives you the option of changing your presentation. When you are trying to sell to show people, you may not want to show portraits of business executives. Or when making a presentation to a society client, pictures of rock superstars, no matter how famous they are, will not be too well received. The loose-leaf binder has another advantage. You can continually change your presentation as you add new work to your collection. It's a very portable format, and it is easy to look at.

Tear sheets of your published work should be interleaved with your original portraits. A full-page portrait in *Fortune* or a portrait on the cover of *Newsweek* magazine won't hurt your image. In fact, even if the potential client doesn't like the sample you are showing him, the cachet of publication in a national weekly may sell him. Be sure to include any experimental portraits that you have done. It might give the prospective client an idea that he himself would like to try; and it demonstrates that you are a creative and imaginative photographer who is not lodged in a trite style, and one-way methods.

We live in the age of the big sell; and when you have finally launched yourself professionally, it's a good idea to sink back into the business some of the money that is coming in. Start on a small scale with local newspaper advertising and radio spots, and as your business grows, use TV exposure. Another avenue of self-advertising is exhibiting your work at suitable locations. If you are selling your talents as a photographer who does executive por-

traits, a location such as the lobby of the World Trade Center, with its heavy flow of Wall Street brokers and bank executives, is ideal. If it's show people you are aiming at, a restaurant like Sardi's, largely frequented by theater people, would be ideal. An exhibit at one of the heavily traveled air terminals at JFK International Airport would expose your work to all kinds of people.

The big ad agencies are constantly looking for new photographic talent. Most of them offer wall space for shows by photographers; and in the bigger agencies your work will be seen by art directors who spend hundreds of thousands of dollars a year for photography. After you have had a show at a big ad agency, don't sit back and wait for the work to roll in. Get a list of the art directors at the agency, and keep after them. Call them with ideas; send them examples of your latest work; immerse them in every kind of experimental work you are doing, as well as examples of some of the best work you have done in the past. Send them color dupes of your black-and-white work, too. They all have projectors, light-viewing boxes, and lively curiosities. Keep at it. If nothing else, the law of averages has to be on your side. A percentage of everyone you contact will eventually contact you.

Now you have the big assignment. No matter what kind of portrait it is, handle it the same way. That means extend yourself. You not only do what the job calls for, but you think of every possible way to improve upon, and expand the job before you. Of course you do the best you can; but if it is a black-and-white assignment, try some color anyway. If a close-up portrait is required, try everything from tightly cropped head shots to full-

length figures. Try horizontals, and some wide-angle views with pertinent background. Vary the take as much as you can. Your client will be pleased, and may suggest your services to others; and he will probably order more pictures than he had planned on.

Delivery and Pricing

Delivery of the finished job is very important. The prints *must* be handed in on, or before, the promised date. The back of every print should have your name, address, and phone number in large, easy-to-read type. Prints delivered in envelopes, or mailed, must be well packed between corrugated boards larger in every dimension than the print itself. If you are sending slides by mail, *do not* send them in glass holders. The thin, glassless, plastic transparency holders make a better impression than the cardboard holders that are returned from the finisher. These too should have your name, address, and phone number. Work destined for publication should also carry the legend that the fee paid is for one-time use only, and only in the publication for which it is contracted. Some photographers add the legend that the fee will be doubled if the photographer's credit line is omitted.

Do not underprice yourself out of the market and onto the welfare rolls. Charge a fair price for your work, and be businesslike about arriving at that price. Remember, your studio rental, darkroom costs, advertising, help, and your own fee must all be added to the price you charge for a portrait. Selling a photograph that costs you $50 for $48 is the quickest way I know for a photographer to exit from the photography field.

Index

Aarons, Slim, 164
Acid-free paper, 156
Aging of film, 179
Agitation, of print, 174
Akhmadulina, Bella, 104
Albee, Edward, 36
Amado, Jorge, 50
Antistatic brush, 172
ASA ratings, 185

Backlighting, 157, 158
Baehr, Harry W., 137
Balanchine, 34
Baldwin, James, 18
Bare-bulb strobe light, 162
Barnack, Oscar, 139
Barzun, Jacques, 24
Beame, Abe, 20
Beaton, Cecil, 165
Bleaching, 178
Blotter roll, 173
Bounce light, 161–163
 bare-bulb, 162
 ceiling, 161
 chest, 161
 side-wall, 162
 single, 161
 umbrella, 162
 umbrella, three, 163
 umbrella, twin, 163
 wall, 161
Brassai, 84
Bunuel, Luis, 98
Burning-in, 165, 172, 188
Byrne, Kathy, 128

C-clamp, use of, 144, 159
Camera, choosing a, 142
Camera movement, 148, 152
Cameron, Julia Margaret, 195
Carey, Hugh, 20
Caricature, 30
 use of fisheye for, 144
Cartier-Bresson, Henri, 165
Castro, Fidel, 108
Chemicals, residual, 176–177
Close-up work. See: Lenses, macro
Color film
 ASA 400, 184–185
 color balance, 185
 Ektachrome 200, 184
 Kodachrome 25, 184
 Kodachrome 64, 184
 negative, 183

slide (positive), 183
Color lighting, 180
Color portraiture, 185
Color shift, 179
Color temperature of quartz bulb, 163
Composition, 180
 in portraits, 191
Condenser lenses, 167
Contact sheet, 166
Contrast, color, achieved by, 180
Contrasty lighting conditions.
 See: Diffusion attachment
Credit line, 198
Cropping, 165, 188

Daguerre, Louis Jacques Mandé, 4
Darkroom, 155
Deadlines, 198
Depth of field, 144
Developers, film, 153–155
Developing paper, fogging of, 170
Developing time, 149
 increased, 154, 158
 standard, 154
Diffusion attachment, 146
Distortion, 30
Dodging, 165, 172, 188
Donaldson, Norma, 112
Dryer, print, 173
Drying frame, plastic, 173
Duvall, Shelley, 74

Easel, 169, 174
Enlarger, 167, 168
Enlarger head, 167
Enlarging lens, 169, 170
Environmental portraits, 140, 142
Exposure, 150–153, 180–181
Exposure control, 180

Fellini, Federico, 76
Fiber-based paper, 176
Fill-in light, 157
Film
 agitation of, 155
 black and white, 147–150
 contrast of, 147
 development of, 153–156
 fast, 147, 148
 grainy, 147
 Kodak Panatomic-X, 148
 Kodak Plus-X, 148
 Kodak Tri-X, 148
 latitude of, 147, 148

medium-speed, 147
resolving power of, 147
slow, 147
soft, 147
washing of, 155
Filters, 181–183
 color chart, 182
 color-compensating, 181, 190
 factor, 148
 frames and holders, 183
 green, 148
 polarizing, 181
 skylight, 146
 "star" attachment, 146
Fixing, 178
Fisheye lens, 30
Flare, elimination of, 141
Foil reflector, 158
Fresnel lens, 163

Goldin, Harrison, 20
Grade, Chaim, 54
Graduates, 173
Gossett, Carl, 30
Gross, Chaim, 52

Hellman, Lillian, 122
Hemingway, Margaux, 86
Hitchcock, Alfred, 100
Hypo eliminator, 156, 175

Kodapak, 156

Leica, 139
Lens, choosing a, 142
Lenses
 distortion, 142
 fisheye, 144
 flare, elimination of, 141
 macro, 145
 medium telephoto, 142
 normal, 142
 types and their use, 143
 wide angle, 142, 143, 144
 zoom, 144
Life magazine, 140
Light source, single, 158
Lighting, 157–164
 single source setup, 159
Lights, 160
Loren, Sophia, 10
Love, Kermit, 110

Magnifier, 167
 grain-focus, 171
 2×, 145
Main light, 157, 160
Manipulation of print, 165
Manning, Jack, 32
Marash, Dave, 62
Martin, Mary, 16
Mazzola, John, 137
Mead, Margaret, 80
Merman, Ethel, 16
Meter, exposure, 180
 accuracy of, 149
 color-temperature, 183
Molnar, Ferenc, 8
Monopod, 144
Morgan, J.P., 194
Motor drives, 144
Multiple portrait, 16, 64
Mylar, 156

Negative
 cleaning of, 172
 processing of, 188
Negative carrier, 168, 169
Negative notcher, 167
New York Times, The, 164, 195
Newton-John, Olivia, 88

Onassis, Mrs. Aristotle, 70
Overwashing, 178

Paper
 fiber-based, 175
 graded, 175
 matte, 175
 semi-matte, 175
 variable contrast, 175
Papp, Joseph, 42
Parton, Dolly, 120
Past, Linda, 72
P.C. cord, 159
Photoelectric triggering device, 160

Photo-Flo, Kodak, 156
Photographer and subject, 187–190
Poe, Edgar Allan, 195
Portrait, 144–145
Portrait market, 193–195
Portrait photography, early, 139–140
Portraiture, candid, 139
Power winders, 144
Presentation by portrait photographer,
 195–198
Prince, Hal, 68
Print, The, 165–178
 archival storage, 176–178
 drying, 178
Printing, art of, 165–166
Printing exposure, 174
Printing frame, 166

Quality control, 195
Quartz bulb, 163

RC papers, Kodak, 175
RC "Pearl" paper, Ilford, 176
Reflecting surface, 158
Reflector, 158
Repairman, camera, 150
Resin-coated (RC) papers, 173
Retouching, 139, 190
Right-angle finder, 144, 145
Rockefeller, John D., 26
Rockefeller, Nelson, 58
Rostropovich, Mstislav, 116
Rothwax, Judge, 94

Safelight, 170, 171
Saud Al-Faisal, Prince, 102
Scharf, William, 46
Selling portraits, 193–198
Shade, open, outdoors, 158
Shutter release, "soft," 144
Shutter speeds, 149, 150
Single-lens reflex (SLR), 141
Siphon, 173

Skin tones, 181
Smith, W. Eugene, 106
Solzhenitsyn, Aleksandr I., 38
Special effects, 92, 146
Spotlights, 157
Squeegee, 173
"Star" filter attachment, 146
Steichen, Edward, 194
Stopping down, 148
Strobe
 color balance of, 157
 off camera, 159
 recycling capability, 158
 shoe-mounted, 159
 small, 157, 164
 thyristor type, 149, 158, 160, 161, 164
Studio flood lamps, 157
Sunlight, direct, 157–158

Technique, color, 185–186
Tele-extender, 145, 146
Thermometers
 accuracy of, 149
 dial-type, 174
 process, 150
35 mm camera, 140–141
Timer, 170, 171
Tonal qualities, 188
Tonal scales, 180
Tongs, print, 173
Trays, 173
Tripod, 139, 144, 152, 153

Umbrella bounce light, 162, 163
Urang, Sally, 128

Velez, Ramon, 124
View camera, 139
Vignetting device, 172

Warren, Robert Penn, 14
Washing, 175, 178
Weston, Edward, 166
Wetting agent, 156